GLACIER NATIONAL PARK

A REDISCOVERY

PHOTOGRAPHS BY EDWARD TYLER

COVER DESIGN AND PHOTOGRAPHS

EDWARD TYLER

TEXT AND INTERIOR PHOTOGRAPHS

EDWARD TYLER

FORNAX ADVENTURE

Mission - Explore less frequented regions, inspire others towards adventure, and encourage a profound appreciation and stewardship of Earth, our home in the cosmos.

Fornax is a seemingly unremarkable constellation in the southern hemisphere. During 2003 and 2004 the Hubble Telescope was pointed into the seemingly black space within this constellation. After completing an exposure equivalent to eleven days, an image known as the Hubble Ultra Deep Field was produced. This image revealed nearly 10,000 galaxies in otherwise black space. Exploration into the uknown beyond the horizon is the spirit behind Fornax Adventure.

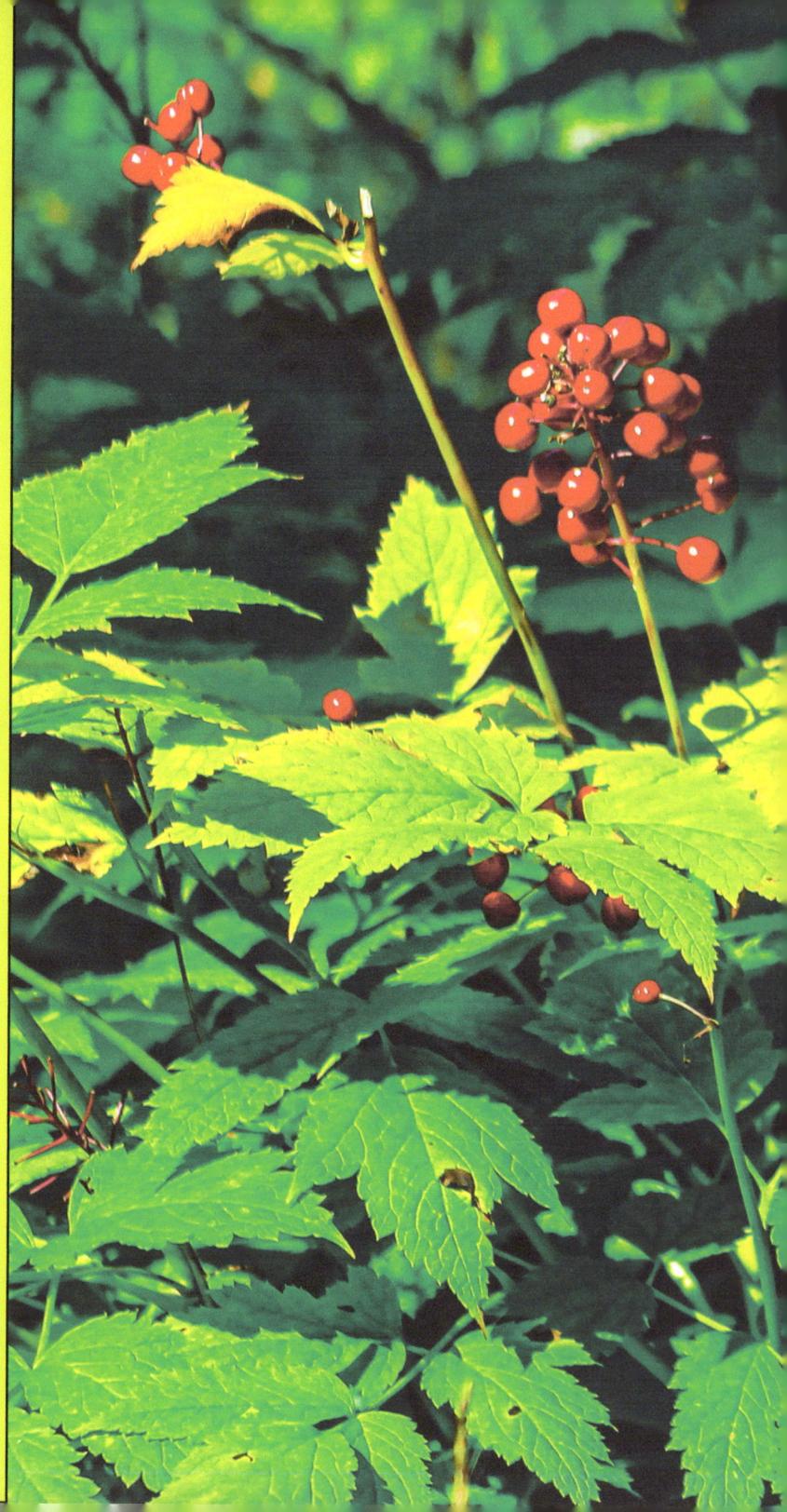

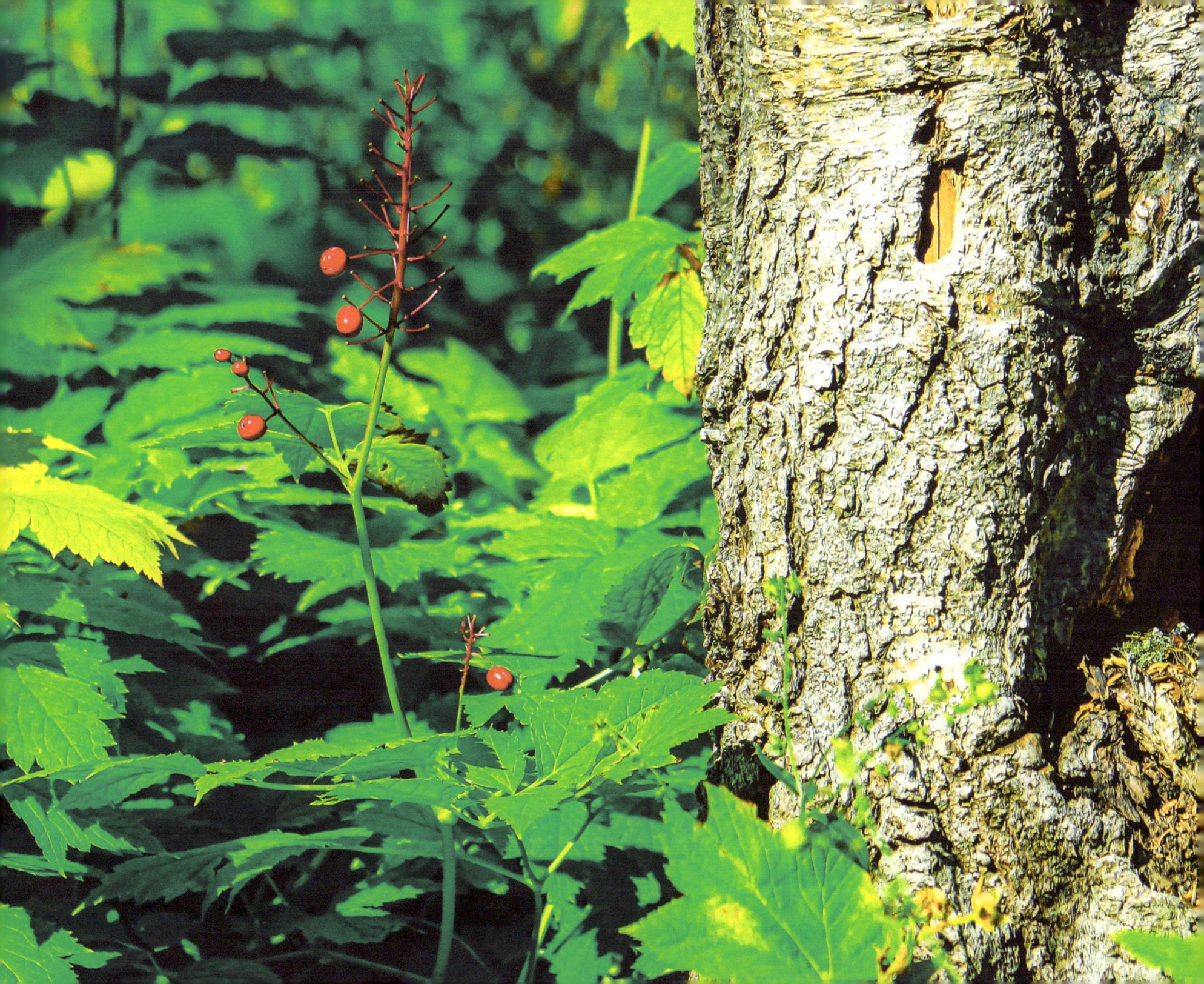

First Edition

Other books by Edward Tyler:
"Antarctica, Tales of the Explorers"
"Our Place, Time, and Purpose in the Cosmos"

Special thanks to Christopher and Heather Lehker for inspiring others to appreciate Montana for its big skies and its natural wonders.

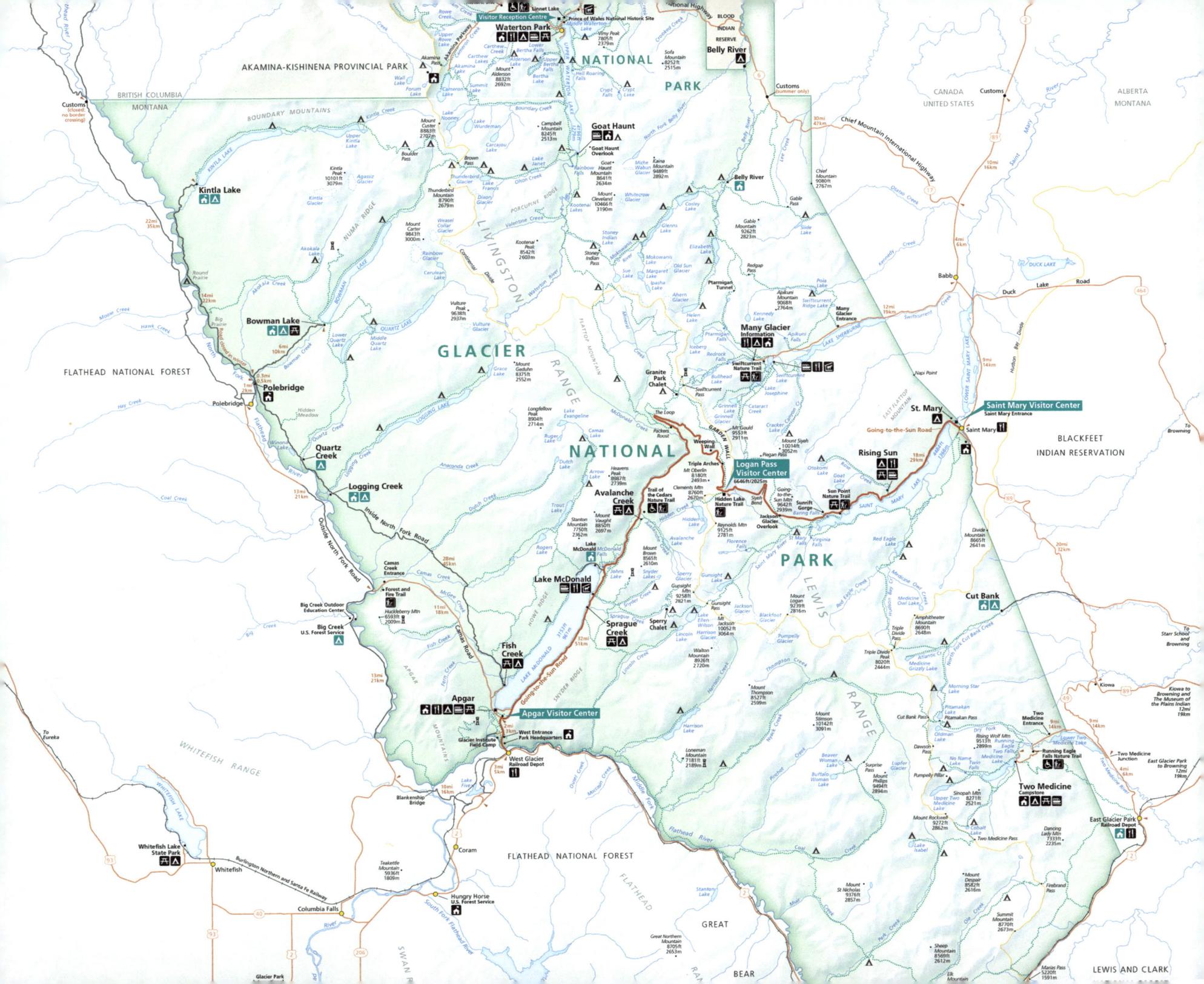

AKAMINA-KISHINENA PROVINCIAL PARK

Visitor Reception Centre
Waterton Park
Prince of Wales National Historic Site

BRITISH COLUMBIA
MONTANA

Customs
(closed; no border crossing)

BLOOD
INDIAN
RESERVE

Belly River

NATIONAL

CANADA
UNITED STATES
Customs

ALBERTA
MONTANA

Customs
(summer only)

BOUNDARY MOUNTAINS

PARK

Chief Mountain International Highway

30mi
47km

Goat Haunt
Goat Haunt Overlook

Kintla Lake

Belly River
Chief Mountain
9080ft
2767m

10mi
16km

Mount Cleveland
10466ft
3190m

DUCK LAKE

Bowman Lake

Babb

GLACIER

Many Glacier Entrance

12mi
19km
Swiftcurrent

FLATHEAD NATIONAL FOREST

Many Glacier
Information

Swiftcurrent
Nature Trail

9mi
14km

Polebridge

Granite Park Chalet

St. Mary

Saint Mary Visitor Center
Saint Mary Entrance

Quartz Creek

The Loop

Logan Pass Visitor Center
6446ft/2025m

Rising Sun

Going-to-the-Sun Road

BLACKFEET
INDIAN RESERVATION

Logging Creek

NATIONAL

Trail of the Cedars Nature Trail
Avalanche Creek

Hidden Lake Nature Trail

Sun Point Nature Trail

18mi
29km

Sunrift Gorge

Big Creek Outdoor Education Center

Forest and Fire Trail

Lake McDonald

PARK

Cut Bank

Big Creek U.S. Forest Service

Sprague Creek
Sperry Chalet

LEWIS RANGE

Fish Creek

Going-to-the-Sun Road

Apgar
Apgar Visitor Center

Glacier Institute Field Camp

West Entrance
Park Headquarters

Two Medicine Entrance

9mi
14km

West Glacier Railroad Depot

Two Medicine
Campstore

Running Eagle Falls Nature Trail

WHITEFISH RANGE

Kiowa to Browning to The Museum of the Plains Indian

Whitefish Lake State Park

Blankenship Bridge

East Glacier Park Railroad Depot

Whitefish

Burlington Northern and Santa Fe Railway

FLATHEAD NATIONAL FOREST

GREAT

Coram

Hungry Horse U.S. Forest Service

Columbia Falls

BEAR

LEWIS AND CLARK

CONTENTS

GLACIER NATIONAL PARK

"Old Man came from the south, making the mountains, the prairies, and the forests as he passed along, making the birds and animals also. He traveled northward making things as he went, putting red paint in the ground here and there -arranging the world as we see it today."
— Blackfoot Creation Legend

When we gaze upon a landscape such as Glacier National Park, it is easy to appreciate the majesty of the mountains, the open valleys, lush green forests, rivers and waterfalls, glimmering lakes, and wildlife. But what is not so obvious is the story of nature that led to the view we see today. It is as if we have opened the last page of a novel to discover how things end, without knowing the complete tale behind what we see. It is an epic tale of the battle between Earth and the forces that shape it. These forces are the authors of nature's story and include the obvious such as we see when we look upon a thunderstorm amidst a torrential downpour, or when gusts of wind blow by transporting dust and debris to new locations. Nature's authors also include the often less obvious forces exerted between land and ocean masses as they move and collide, and even Earth itself as it wobbles on its axis and shifts slightly in its orbit around the Sun. Through persistence, each author wrote the story of the landscape.

The first chapter of the story began 1.6 billion years ago, a little more than halfway into the 4.5-billion-year history of Earth. The area we now know as Glacier National Park was instead part of a great body of water - the Belt Sea. Year after year for millions of years, erosional forces deposited sediment from the surrounding highlands into this sea until, about 800 million years ago, the weight of the deposits themselves caused pressures and temperatures at depth to transform the deposits into various rock types. Mud, clay, silt, and sand were transformed into argillite, siltite, and quartzite. Iron-rich argillite reacted with oxygen in the atmosphere and turned reddish-orange. Argillite deprived of oxygen instead bonded with silica minerals and was transformed by heat and pressure into a green mineral – chlorite.

Tiny lifeforms in the shallows played their part in authoring the story. Cyanobacteria (blue-green algae) consumed carbon dioxide in water and respired life-giving oxygen from photosynthesis. Over time, calcium-carbonate secretions from algae accumulated and were transformed into limestone or dolomite.

The next chapter was written by land and sub-ocean masses (tectonic plates) as they shifed and collided. Lava rose from deep below Earth's surface and spread out over the surrounding area depositing dark black igneous rock (black basalt and diorite) over the Belt Sea. Where lava contacted limestone, the rock was transformed into a white marble.

As the landmass known as the North American Plate collided with an oceanic plate called the Farallon Plate, the result was the subduction of the latter plate. This subduction initiated a 90-million-year period of mountain building that gave rise to the mountains of Glacial National Park. During this period, a slab of rock several miles thick was uplifted and forced eastward over the surrounding land with the result being 1.6 billion-year-old rock lying over much younger 600 million-year-old rock.

The third chapter was authored by rainfall, rivers, and winds that combined to erode and sculpt the newly formed mountains. It was during this time that less resistant upper layers of rock were exposed and vulnerable to attack. Slowly, these less resistant layers were weathered away revealing the shape of the mountains largely, but not entirely, as we see them today.

In the fourth chapter, Earth itself was the author as it wobbled on its axis and shifted ever so slightly in its orbit around the Sun. The effect of Earth's movement was to usher in climate change where temperatures cooled and glaciers appeared further south. With each year of heavy snows exceeding the amount of seasonal melt, the glaciers grew and in their increasing weight were driven by gravity down the mountain slopes where they carved out the large open valleys we see today. Atmospheric temperatures continued to fluctuate and glaciers advanced and retreated until about 12,000 years ago when they completely disappeared with the end of the ice age.

The fourth chapter ends with the period known as "the little ice age" beginning about 6,000 years ago that ended only recently in history about 1850. During this time at least 26 glaciers appeared but that are currently being depleted in a warmer interglacial period. These are the same glaciers likely observed by native Americans for many centuries, in the early 19th century by explorers from the east who ventured into the area, and that are visible to a lesser extent today.

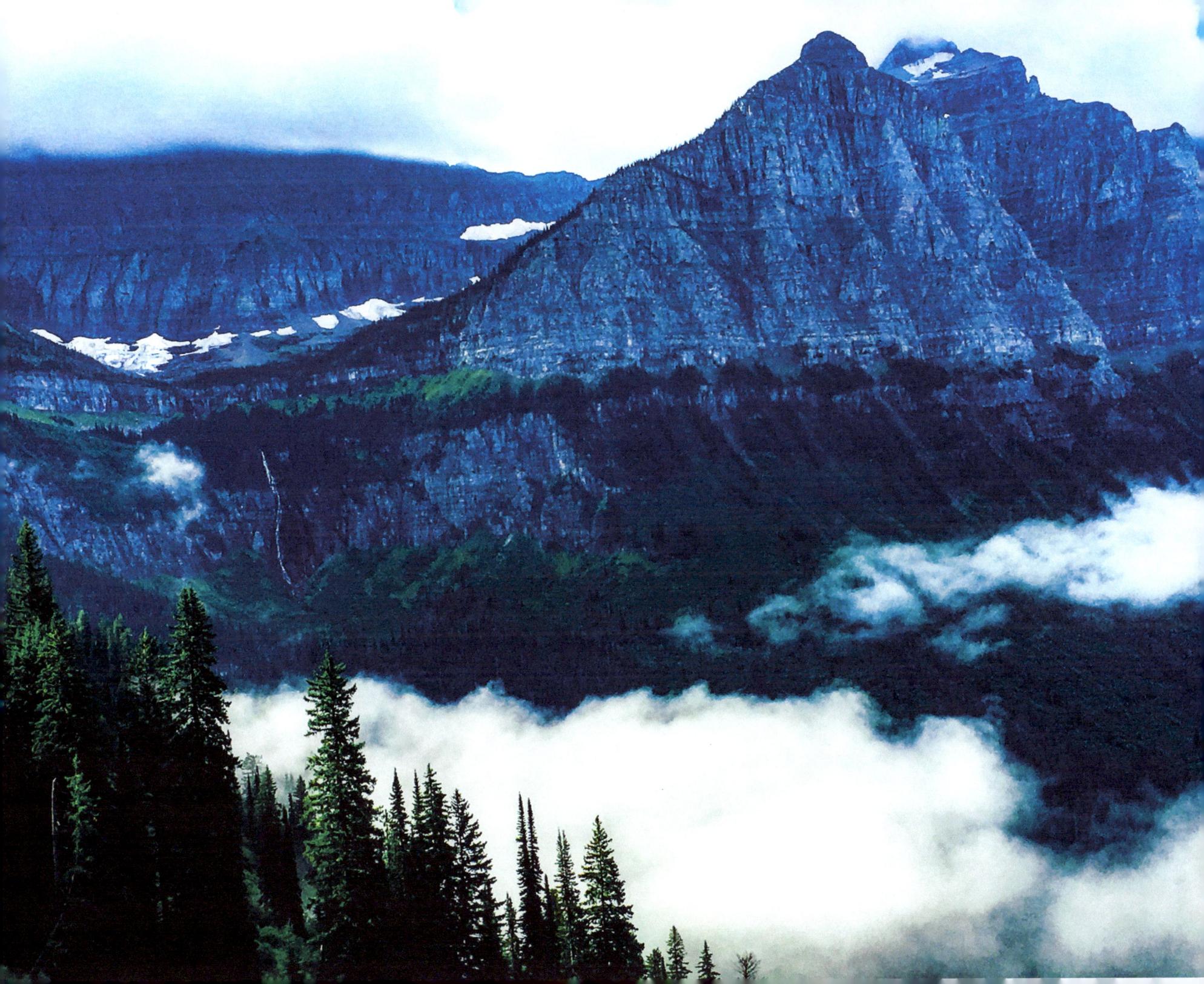

TO VISIT NATURE

~ IS TO ~

REDISCOVER

THAT WHICH WAS

LOST

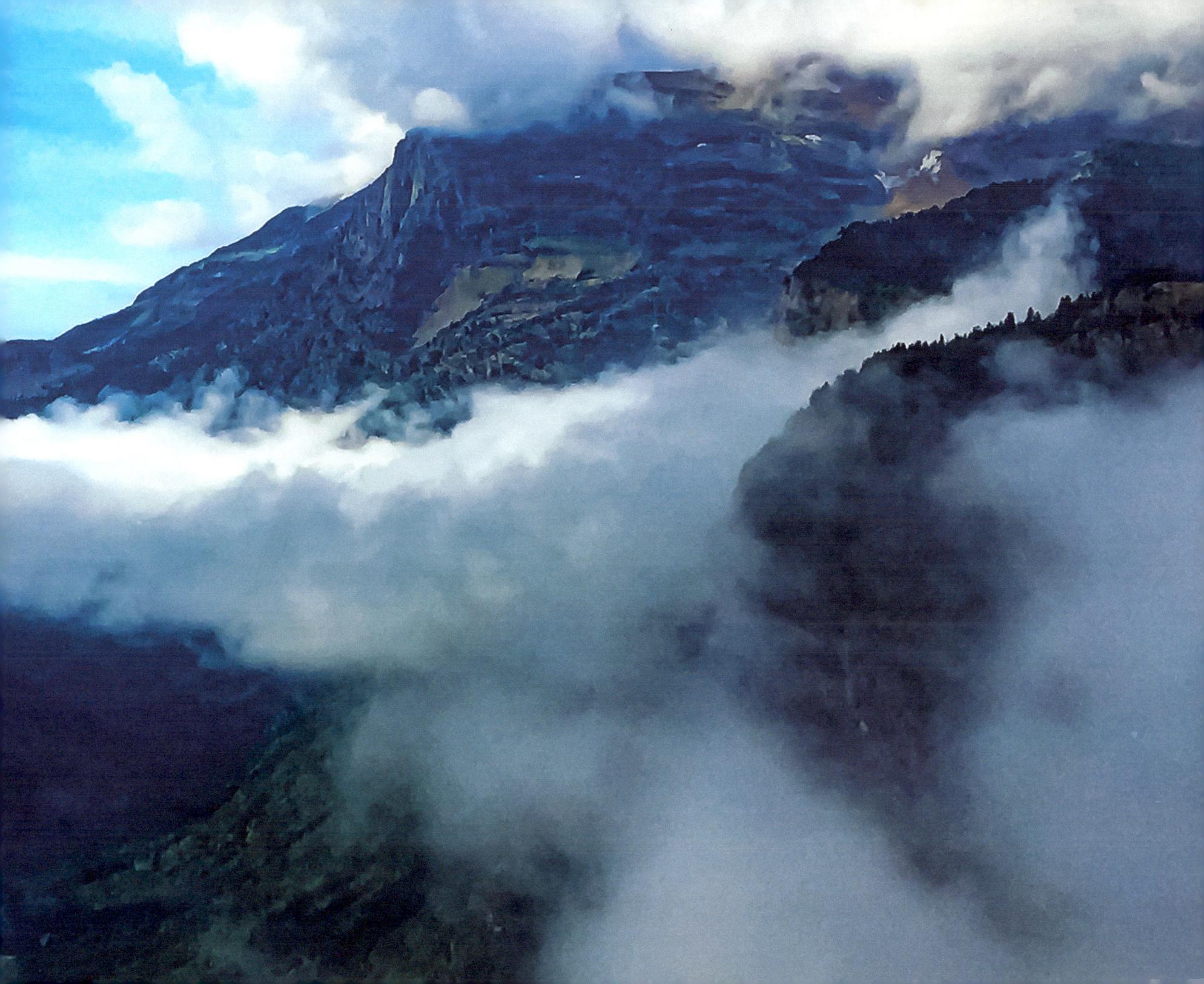

THE GREATEST
TREASURES
ARE OFFERED FREELY
TO THOSE WILLING TO
STOP AND
LOOK

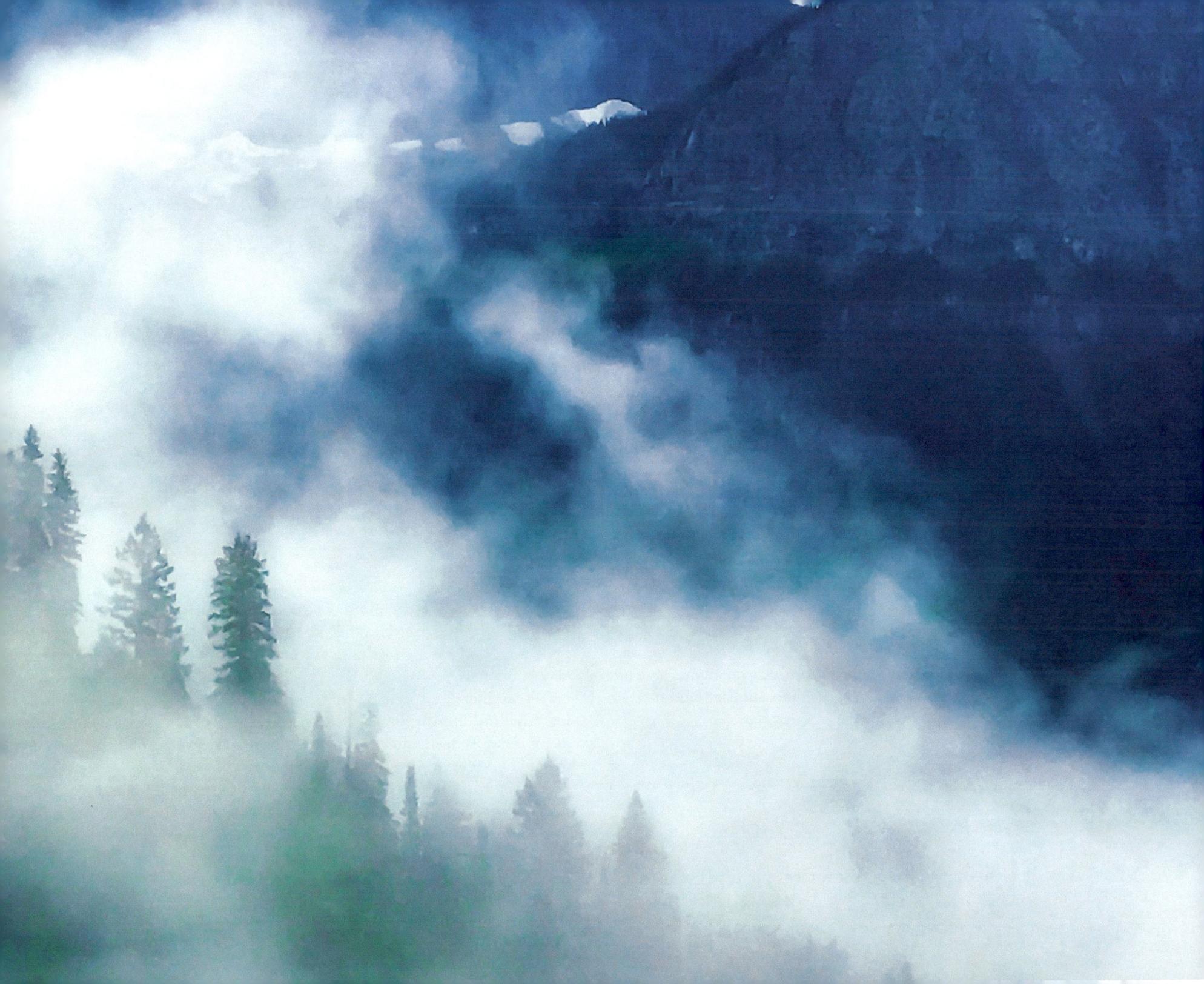

LOGAN PASS

In journeying through Glacier National Park, it is easy to become enamored with its natural beauty, but the casual observer may miss subtle clues telling tales of wildlife from the distant past. Logan Pass is one such area where the exposed limestone rock formations tell such a tale.

Within these rocks, and plainly evident to the trained observer, is a plethora of stromatolites – fossilized remains of blue-green algae that inhabited the shallow sea in this area 1.1 billion years ago. The Two Medicine area in the southeastern portion of Glacial National Park is another location where stromatolites have been found. However, at that location, within what has become known as the Two Medicine Formation, fossil remains tell another distant tale – that of dinosaurs.

The Two Medicine Formation tells the story of the depositional environment and wildlife from 74 to 80 million years ago, toward the end of the Cretaceous period which spanned from 146 to 66 million years ago.

At this time, the current area of Glacier National Park resided near the western boundary of a vast intercontinental sea. The semi-arid uplands to the west of the sea were characterized by rivers and deltas, with the surrounding land exhibiting layers of volcanic ash and vegetation including conifer, fern, and horsetail. Within the sandstones of the Two Medicine Formation, fossil evidence speaks of a time of diverse dinosaur populations that was distinctive and reflected the upland habitat preference of these ancient creatures.

Bambiraptor was a small carnivore that inhabited this region. Small for a dinosaur, it stood around 1 foot high, was perhaps 2 ¼ feet long, and weighed only 4 ½ pounds based on the juvenile fossils encountered. This was likely a very fast and reasonably intelligent dinosaur that fed on small mammals and lizards.

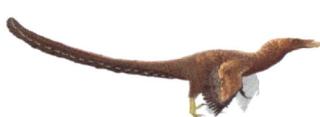
Bambisaurus

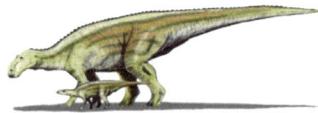
Maiasaurus

Maiasaura were plant-eating dinosaurs that moved in herds of as many as 10,000. They stood up to 8 feet tall, and were up to 30 feet in length

from head to tail. They were largely defenseless against predators, but for their muscular tail and their tendency to move in herds.

Edmontonia was a heavily armored herbivore dinosaur that stood around 7 feet tall, and was up to 23 feet long, while weighing around 3 tons. Lacking a clubbed tail as with many other armored dinosaurs, Edmontonia was likely more susceptible to predator attacks.

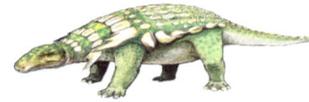
Edmontonia

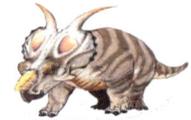
Achelousaurus

Achelousaurus was another heavily armored herbivore resembling the famous triceratops. This plant-eating dinosaur was around 8 feet tall, 20 feet long, and weighed around 3 tons.

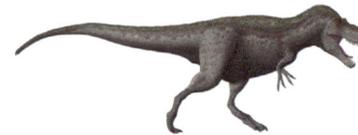
Daspletosaurus

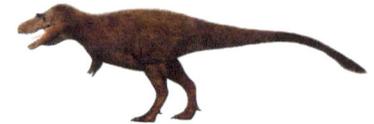
Gorgosaurus

Apex predators were also in the vicinity such as the Gorgosaurus, meaning "dreadful lizard". While not as big as the Tyrannosaurus Rex, this predator stood over 9 feet tall, was up to 30 feet in length, and weighed almost 3 tons.

Yet another apex predator in the region was the Daspletosaurus, meaning "frightful lizard". Similar in size to the Gorgosaurus, and comparable in appearance the Tyrannosaurus Rex, this predator stood up to 12 feet tall, was up to 33 feet long, and weighed upwards of 4 tons.

The end of the Cretaceous period, and the end of dinosaurs, came with what is believed to have been a 6 to 9-mile-wide asteroid or comet that appeared from outer space and struck Earth in the vicinity of the Yucatan Peninsula. The result of this collision was the mass extinction of three-quarters of the plant and animal species on Earth.

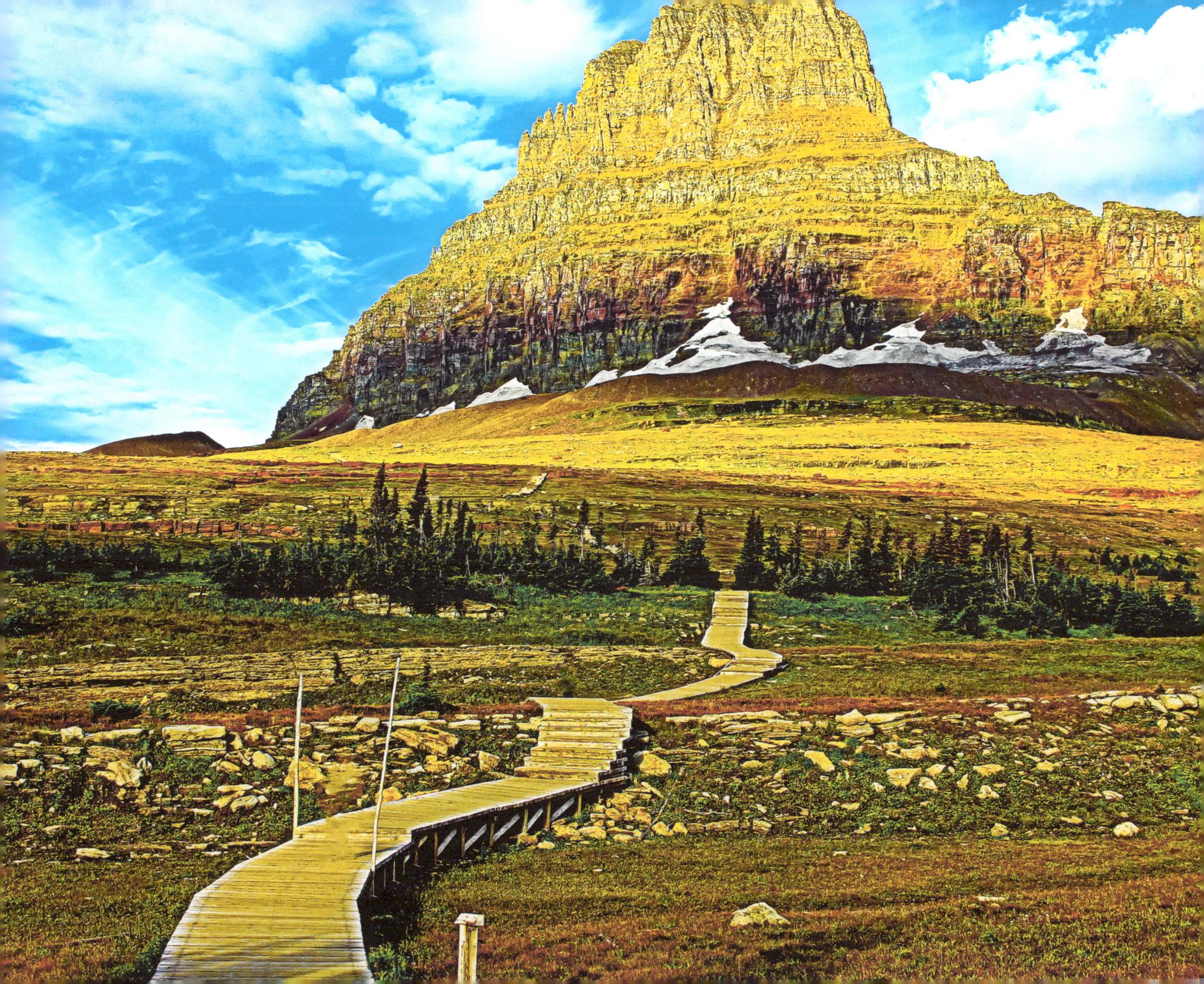

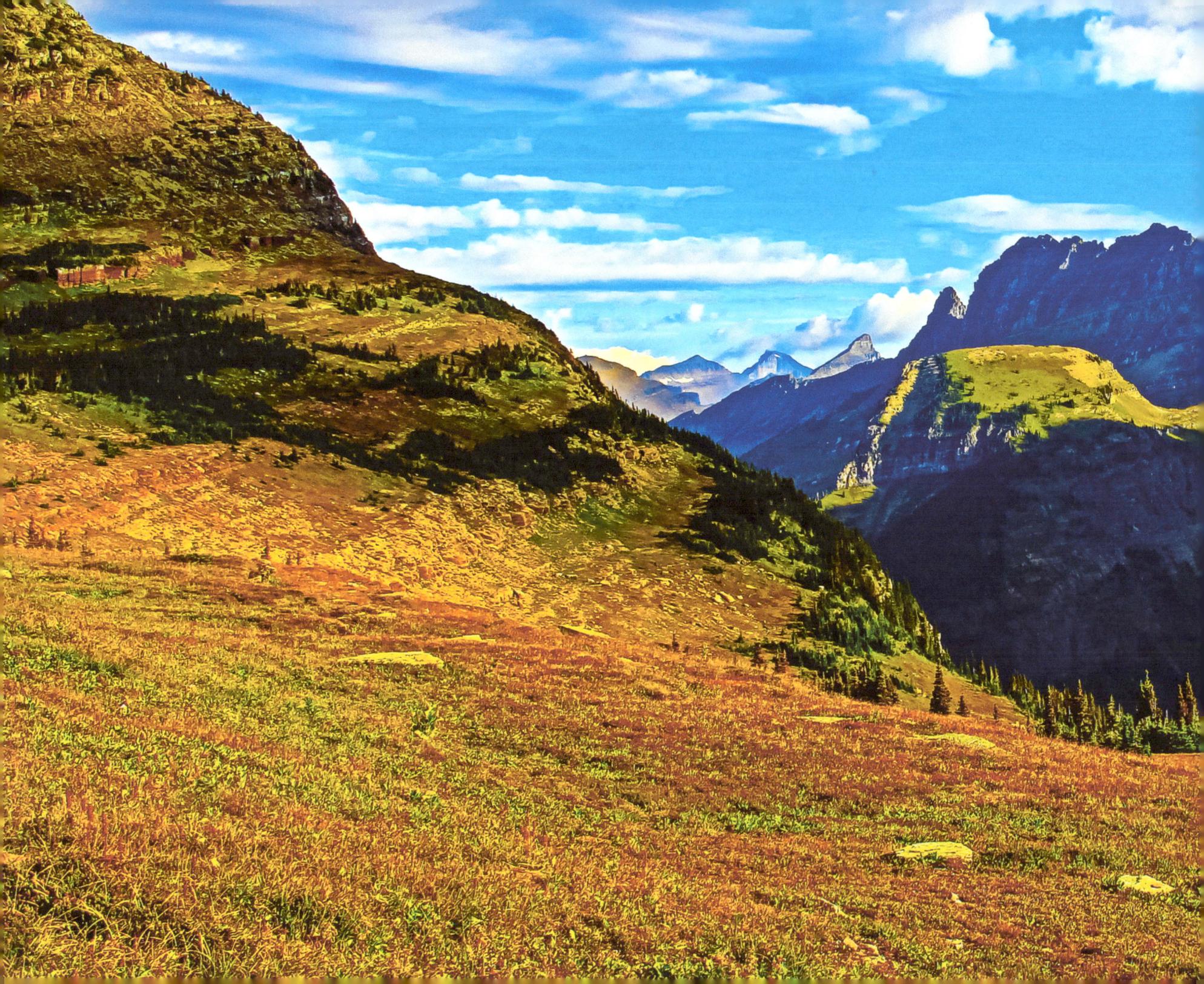

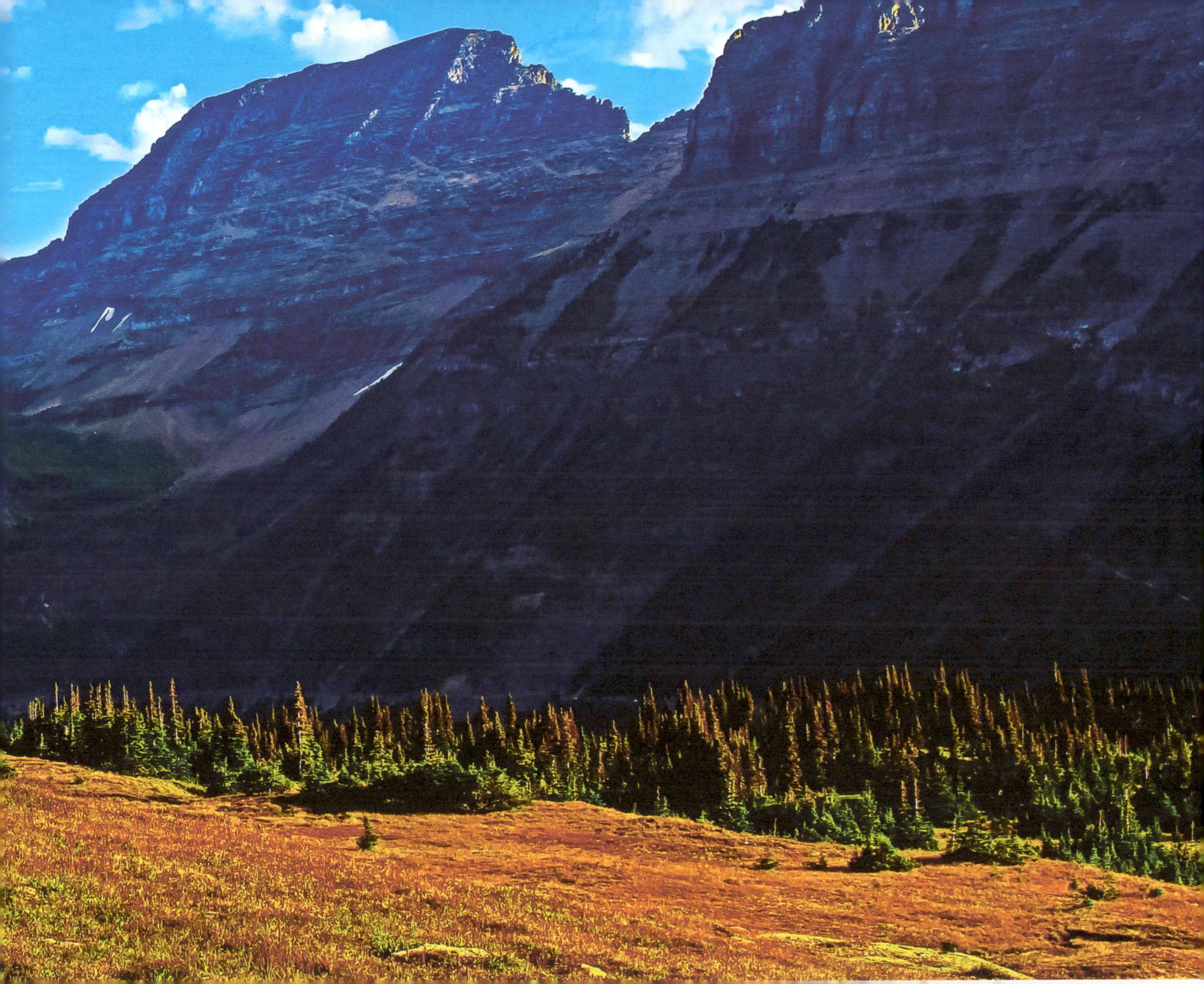

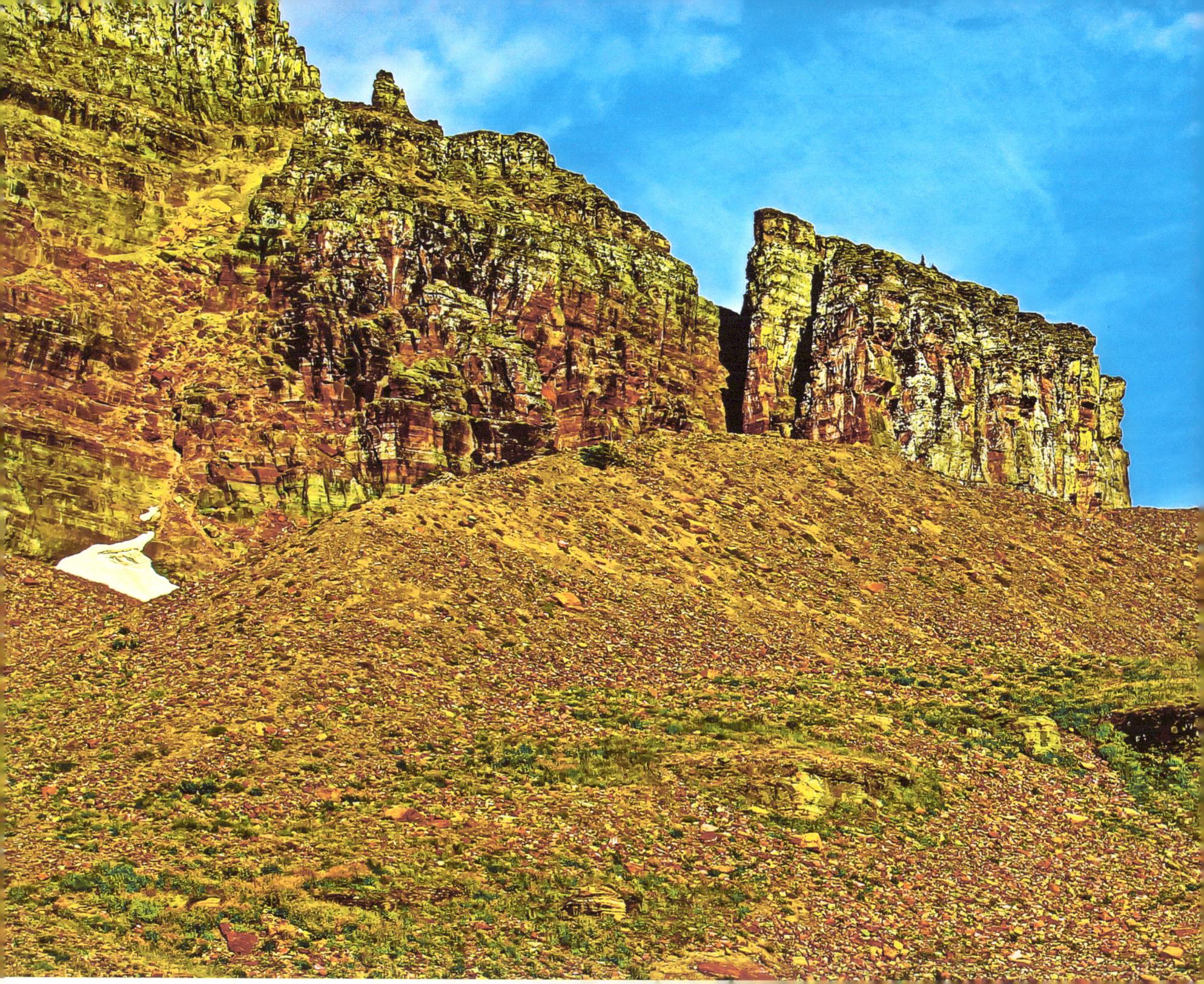

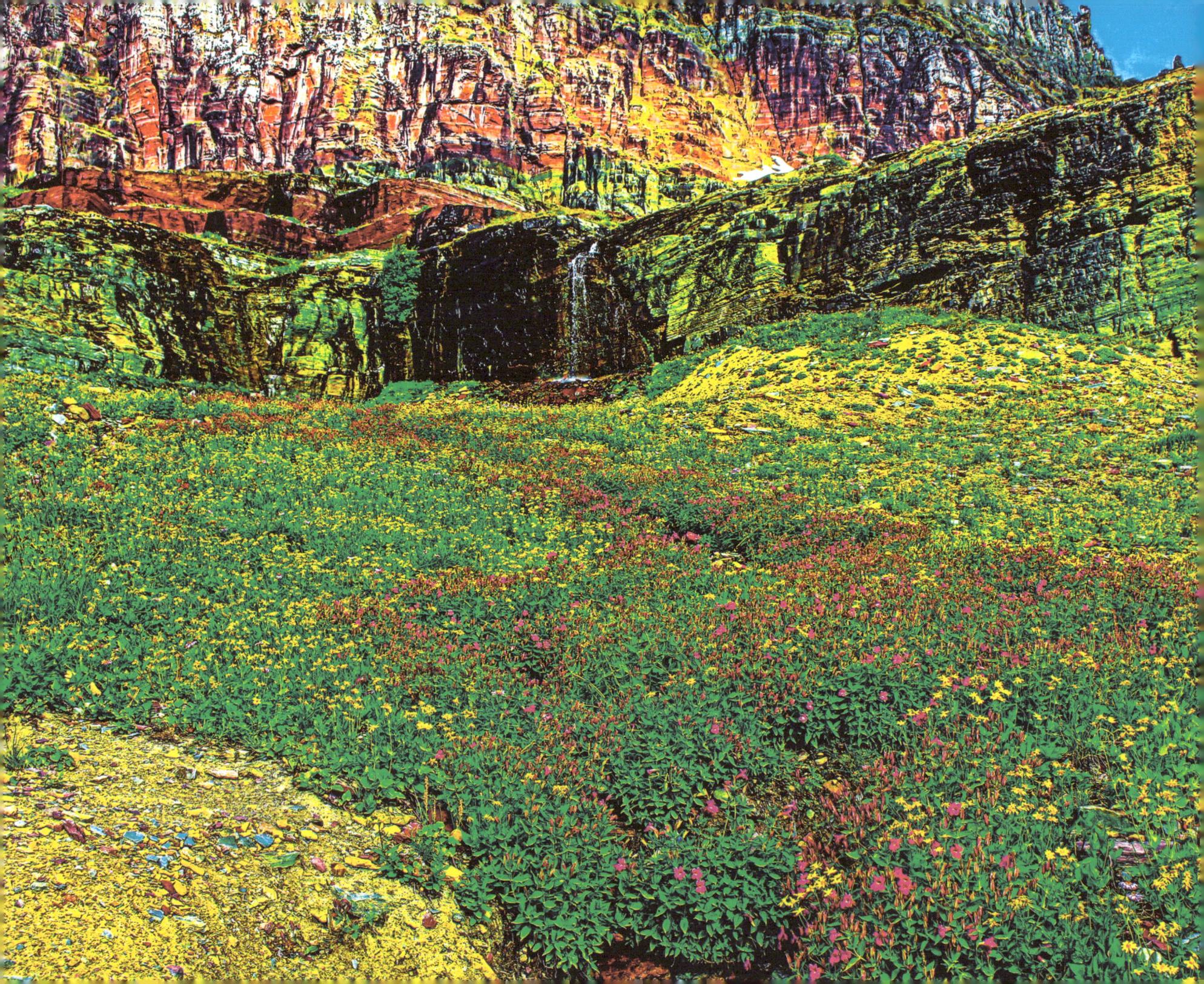

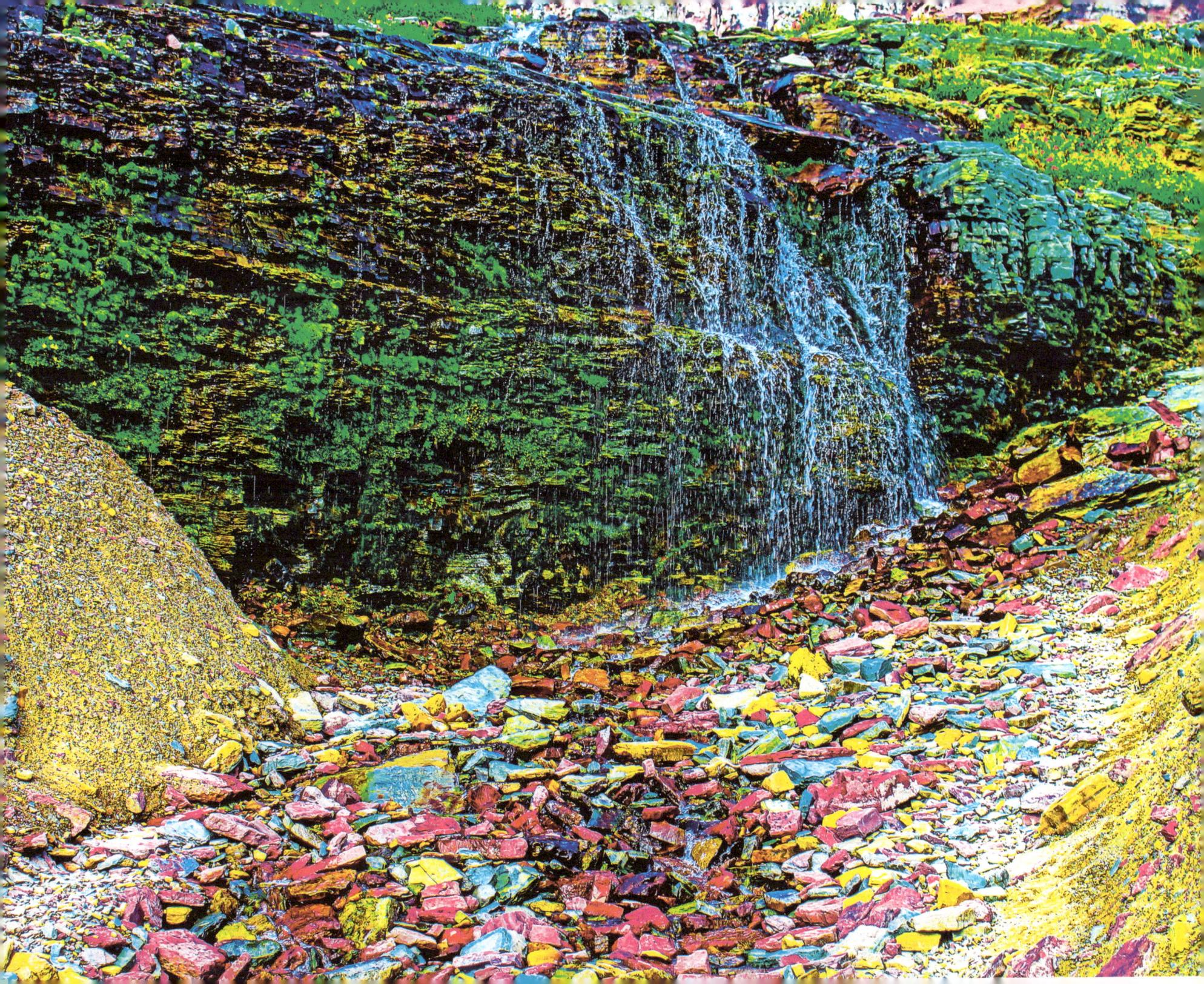

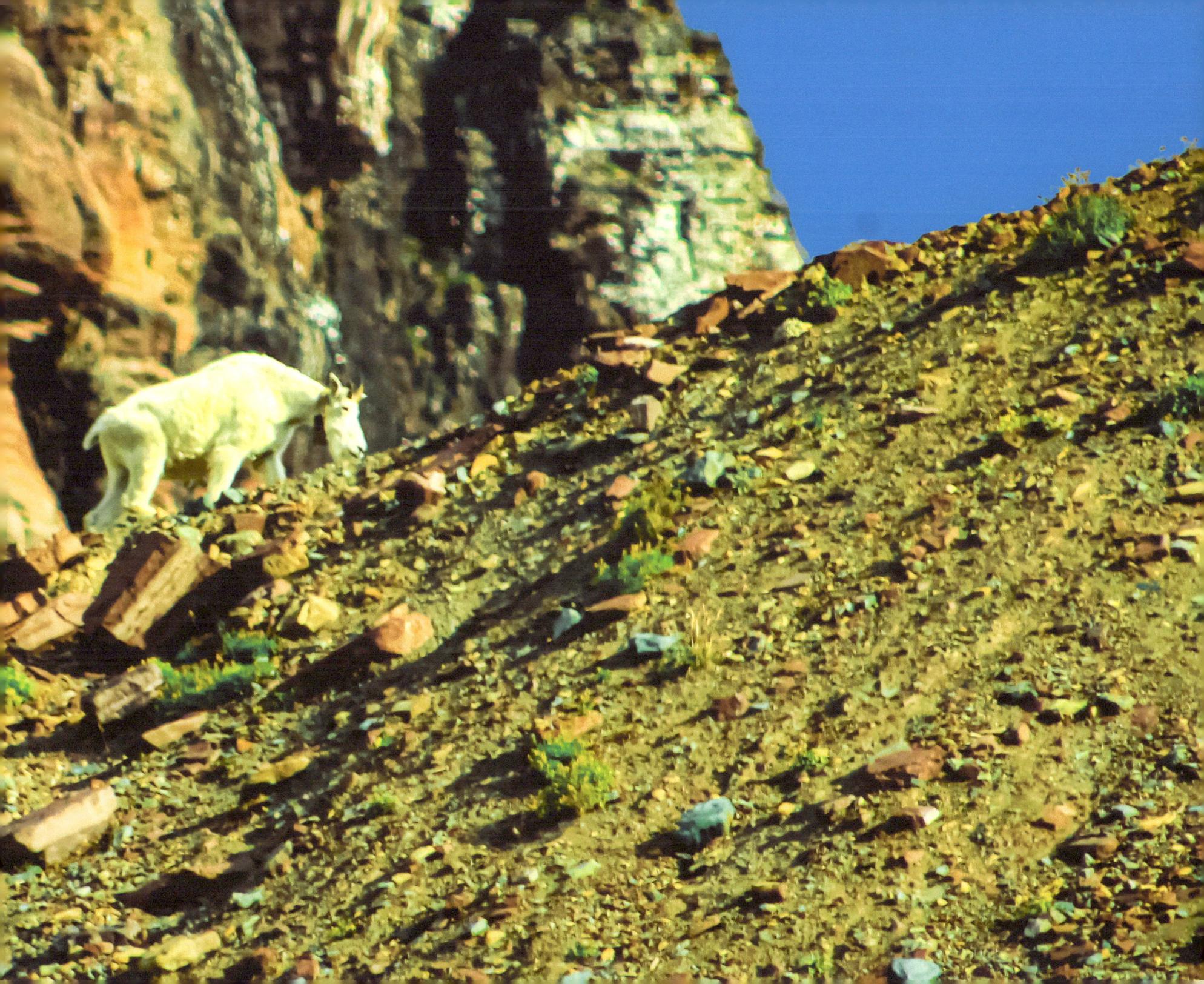

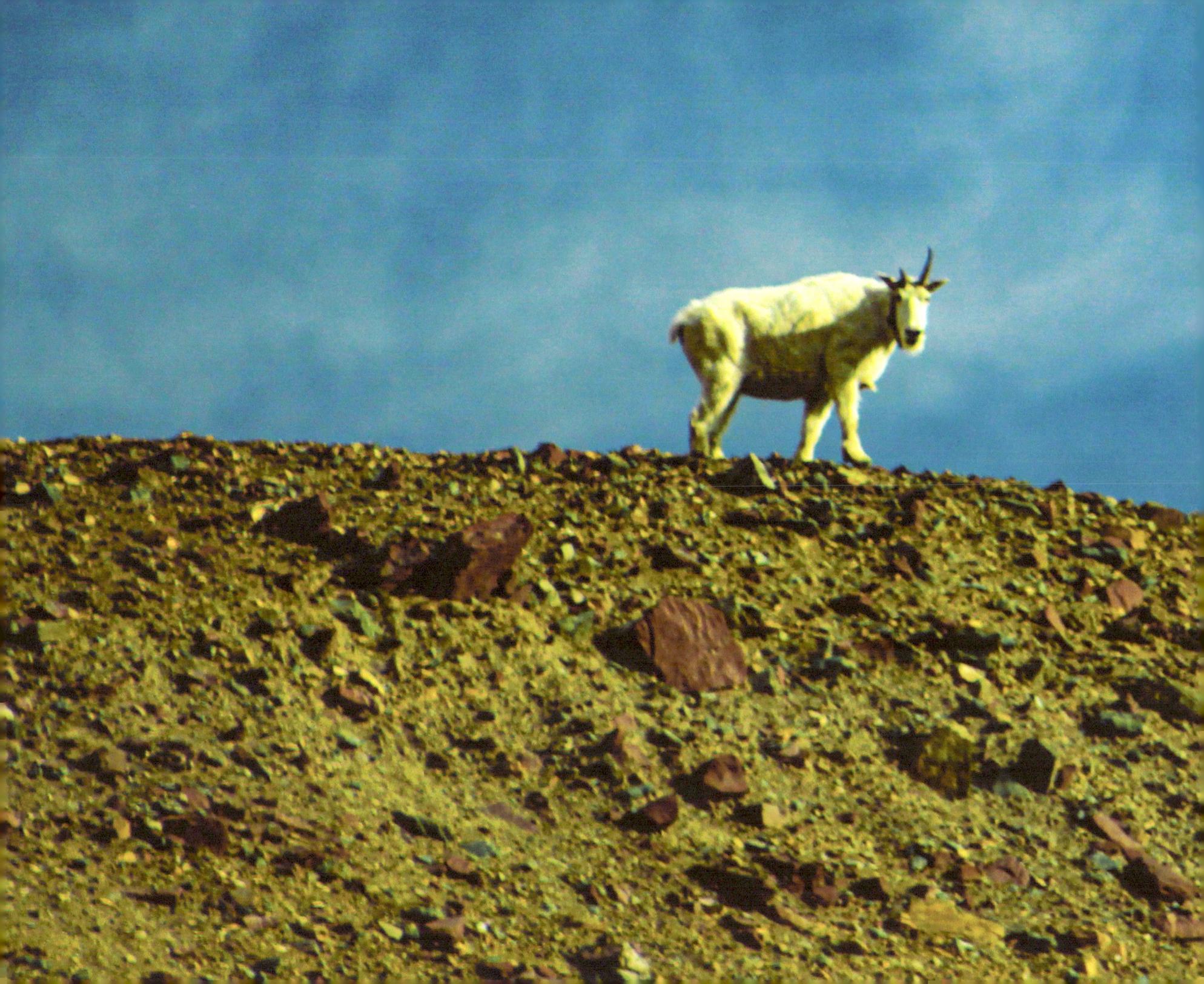

WILDLIFE

MUST LOOK UPON MANKIND WITH

WONDER

BUT IT IS THEY WHO ARE TO BE

ENVIED

FOR THEIR REALM

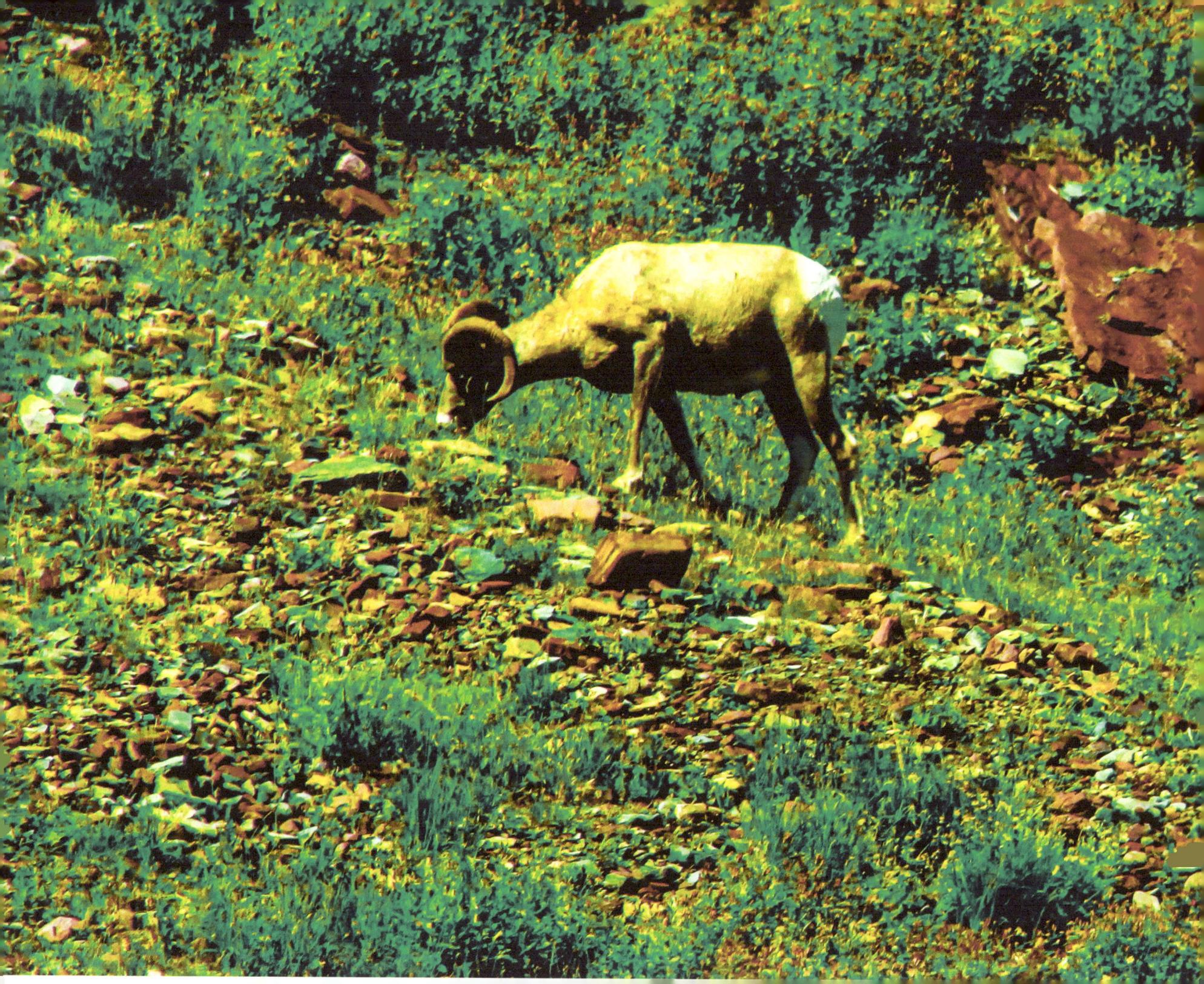

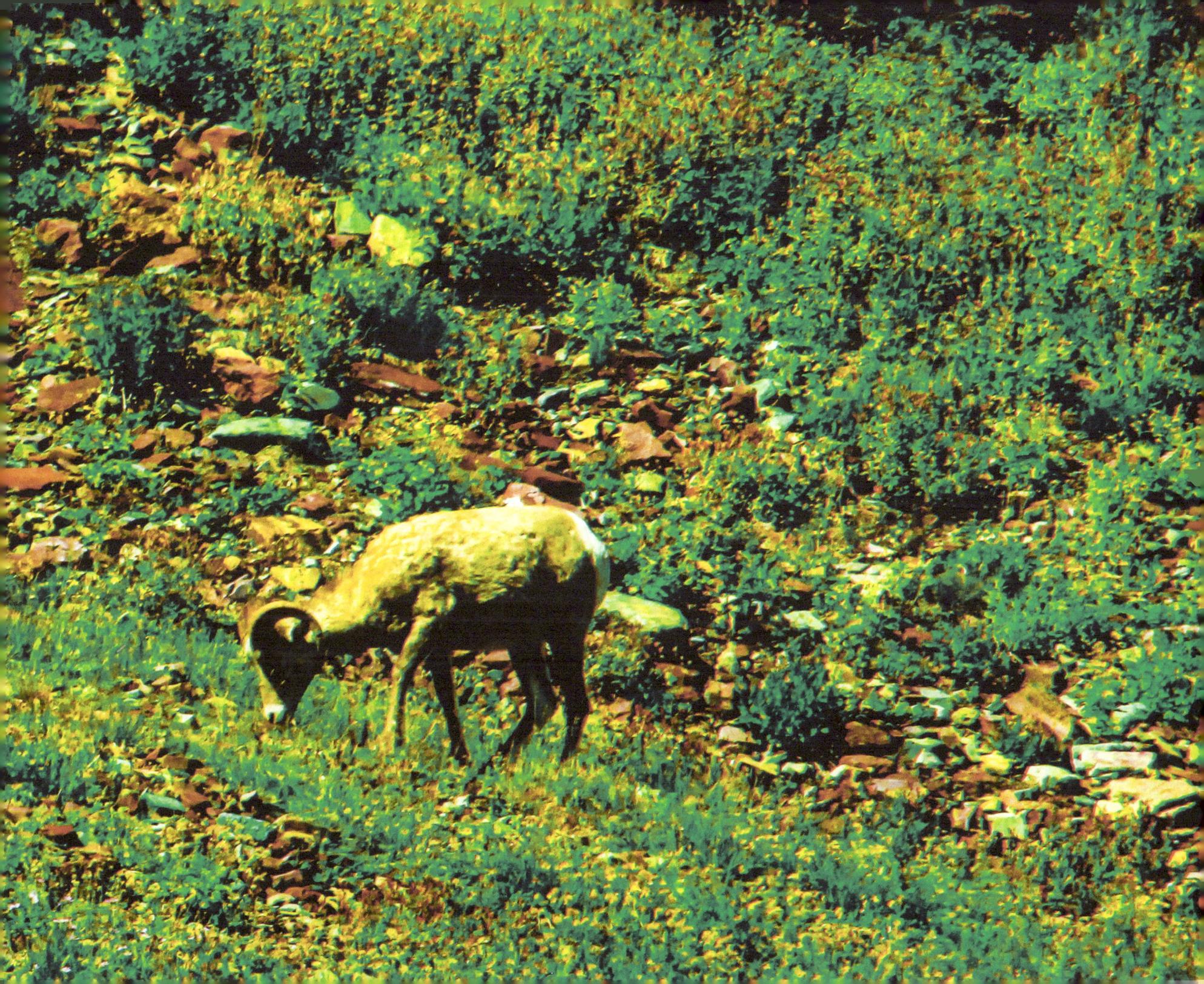

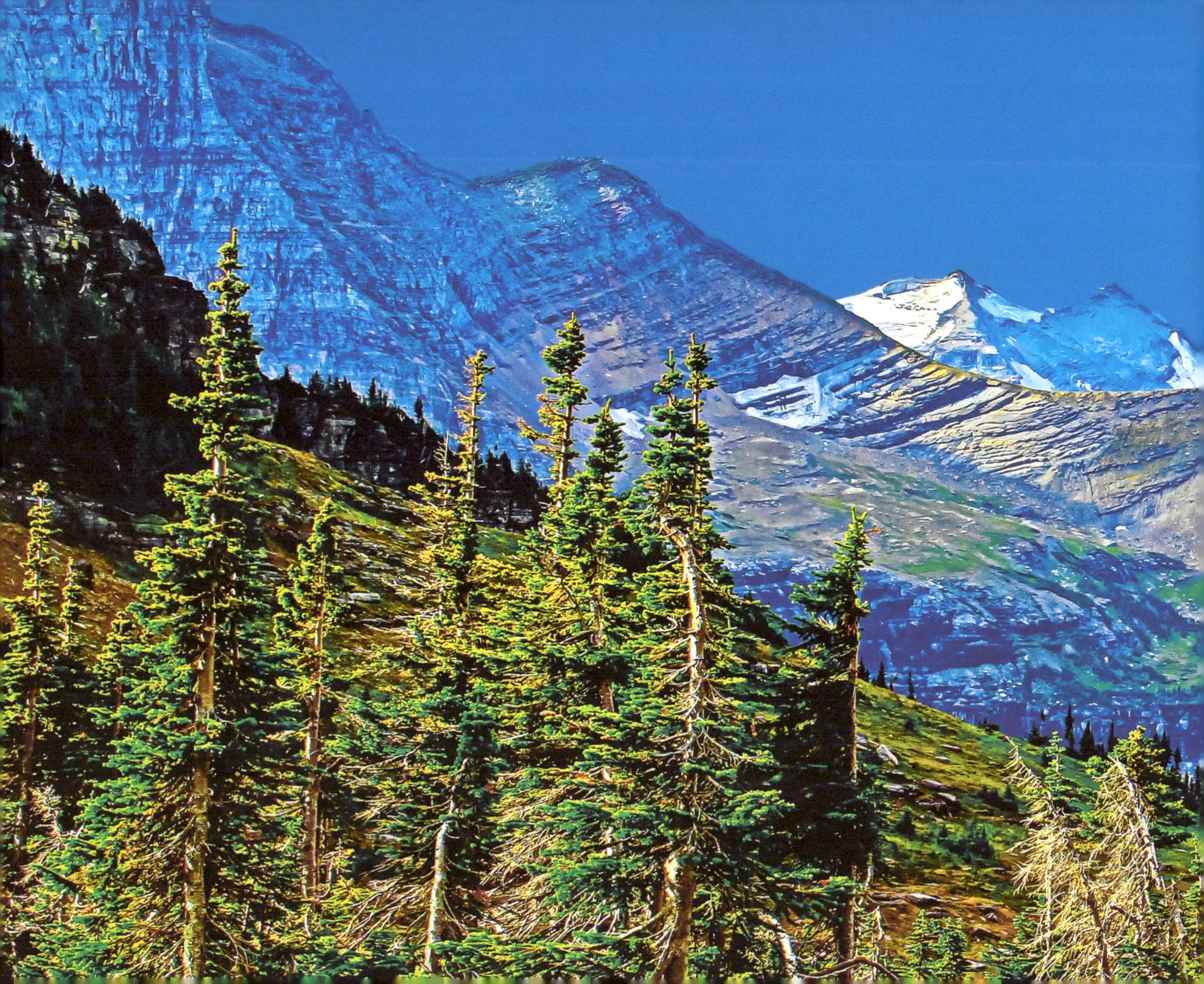

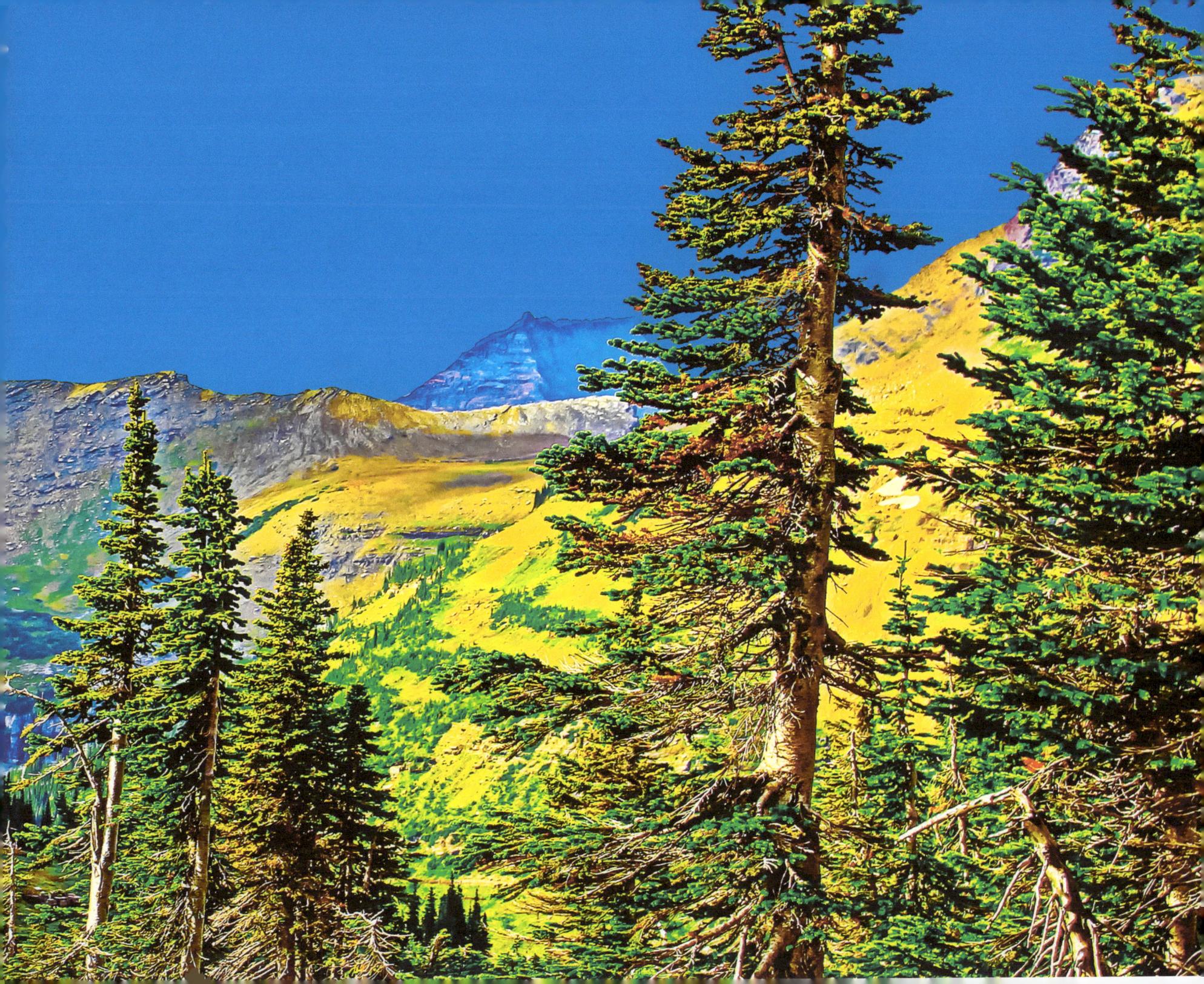

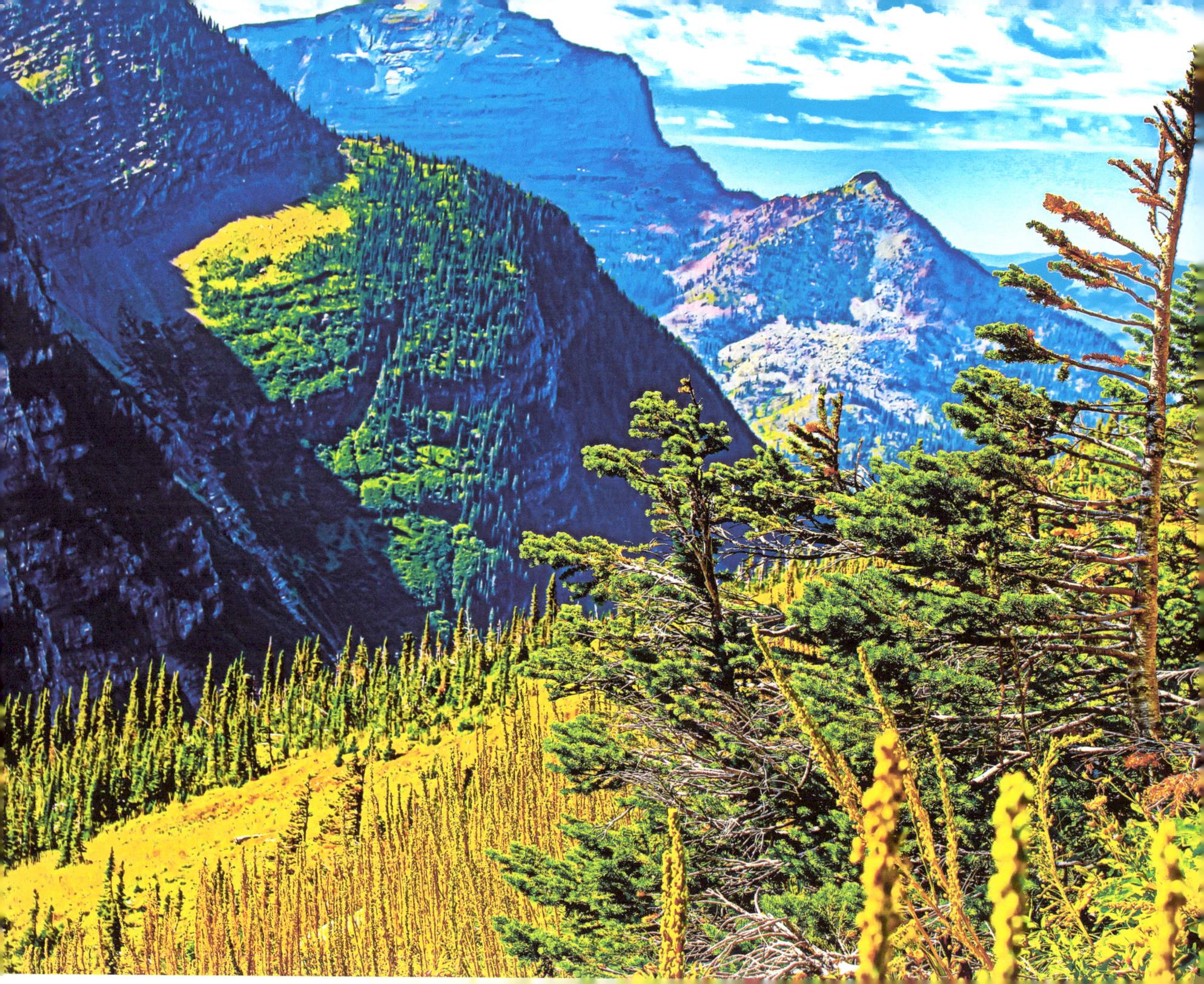

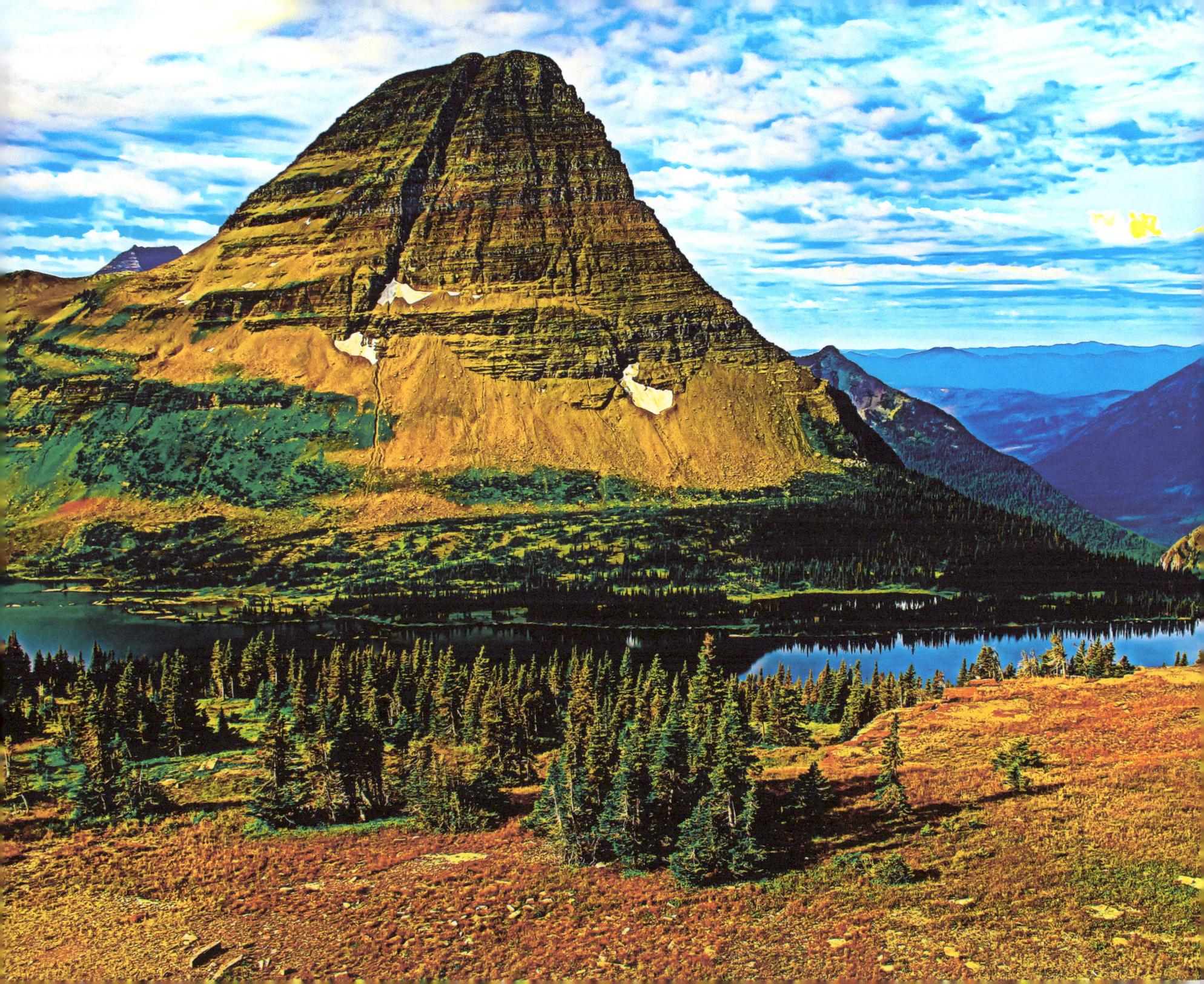

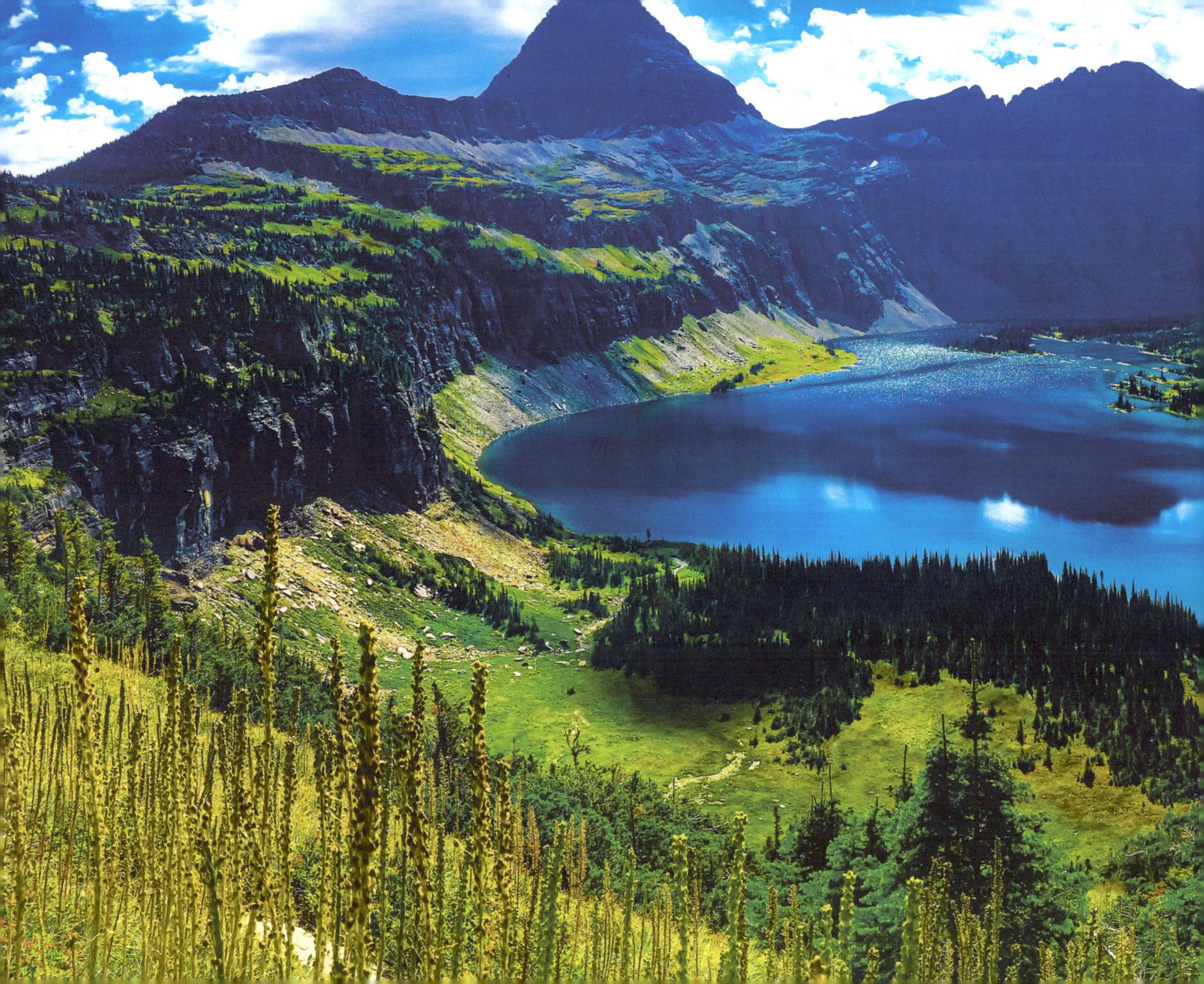

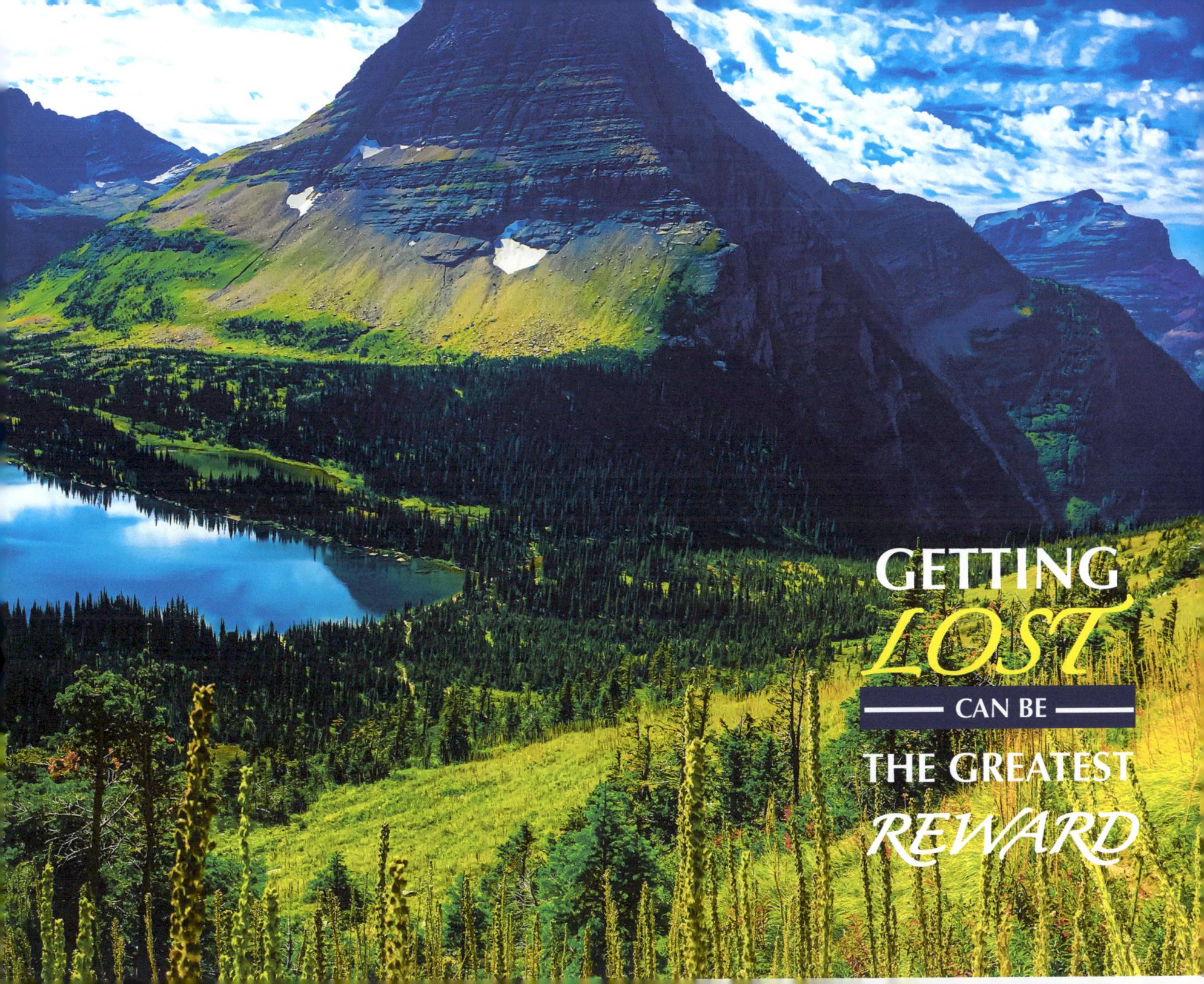

GETTING *LOST*

— CAN BE —

THE GREATEST *REWARD*

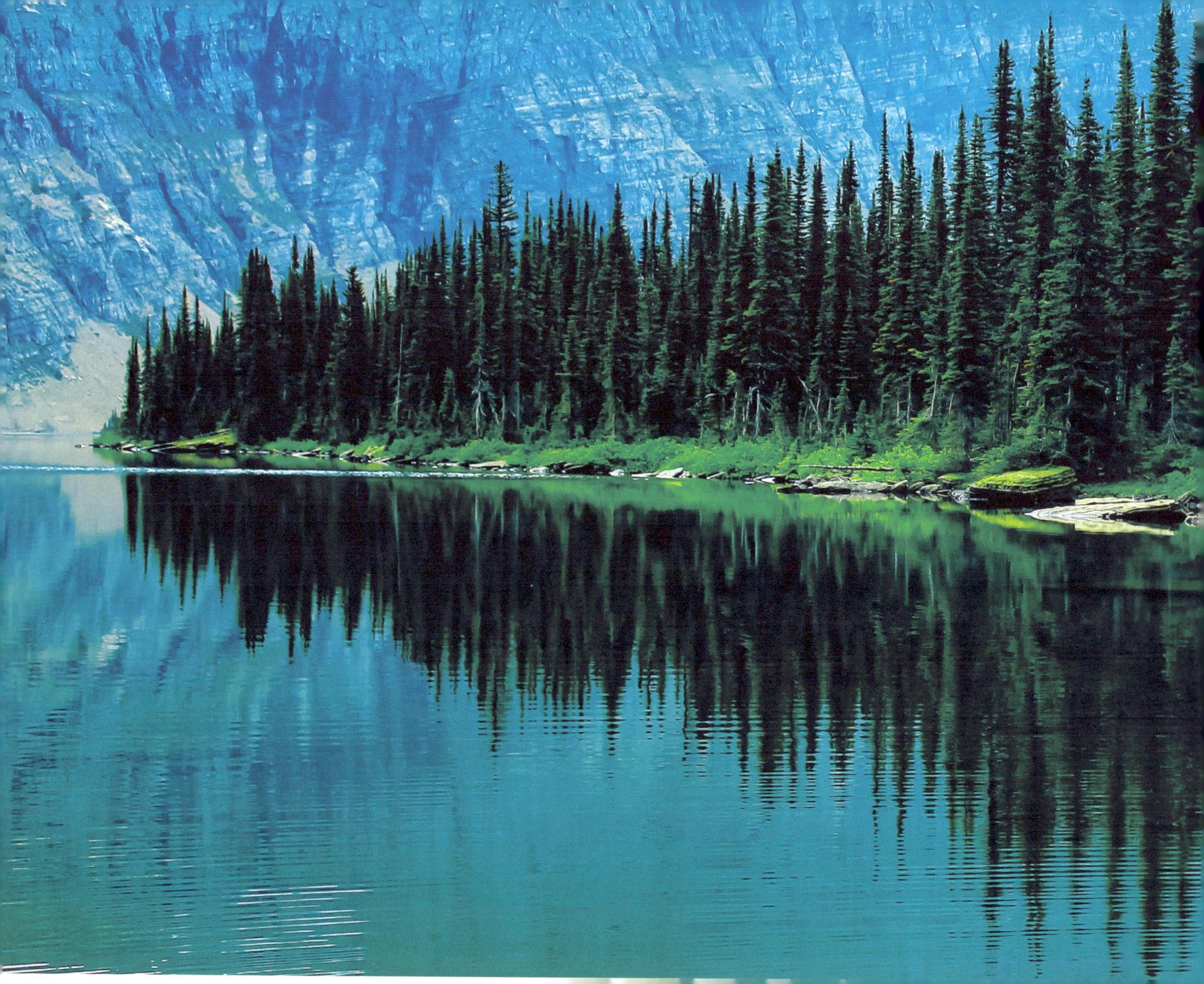

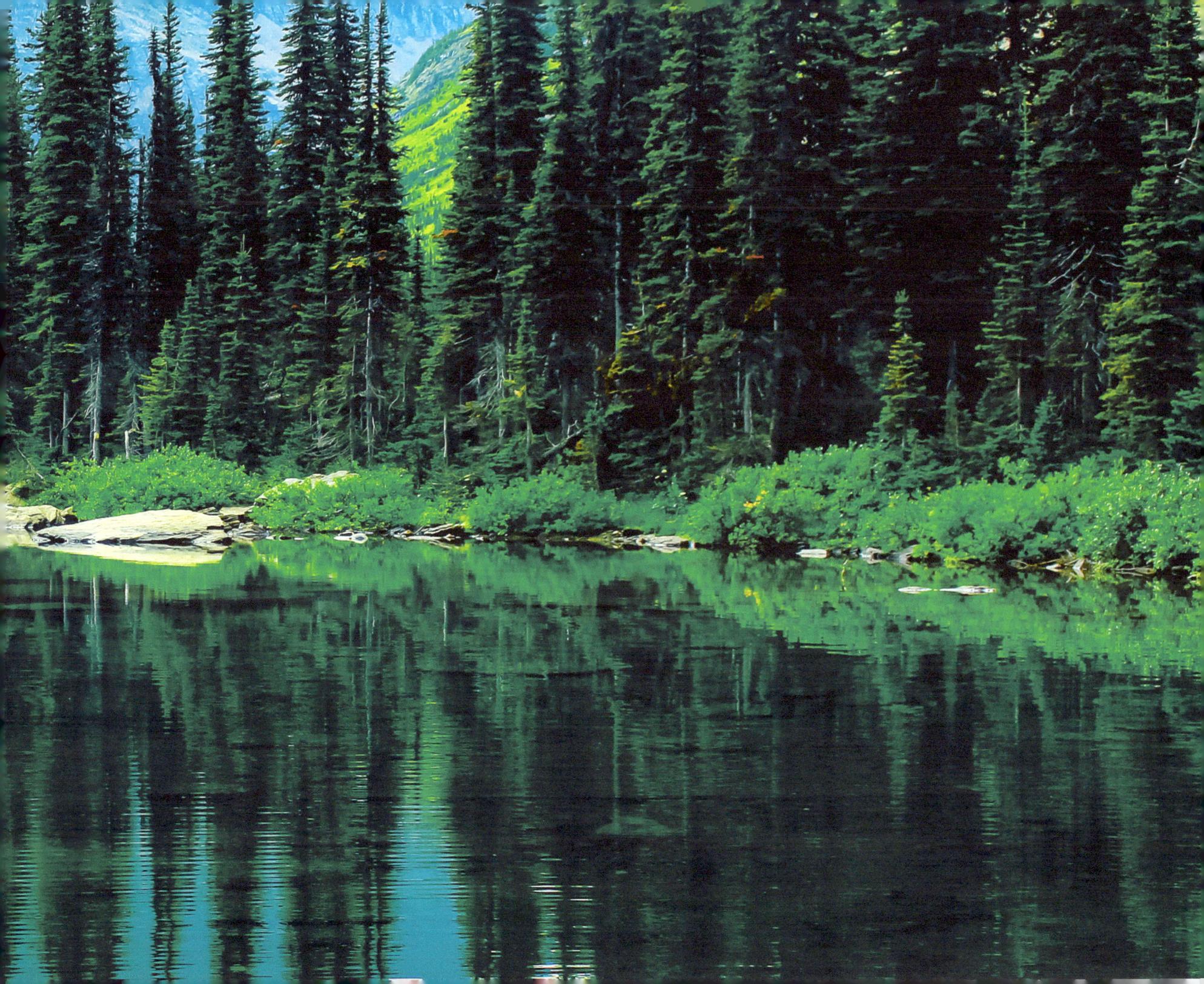

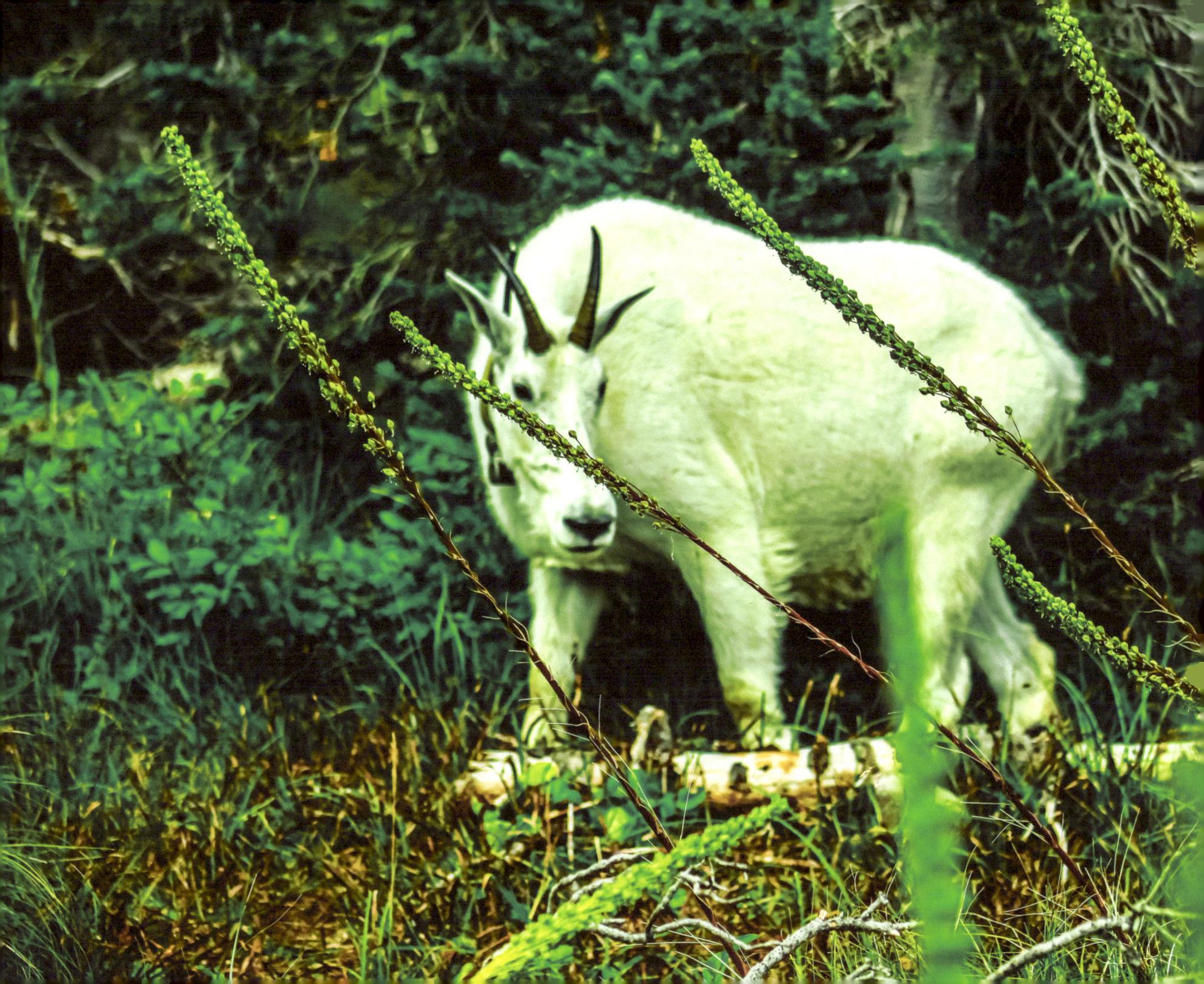

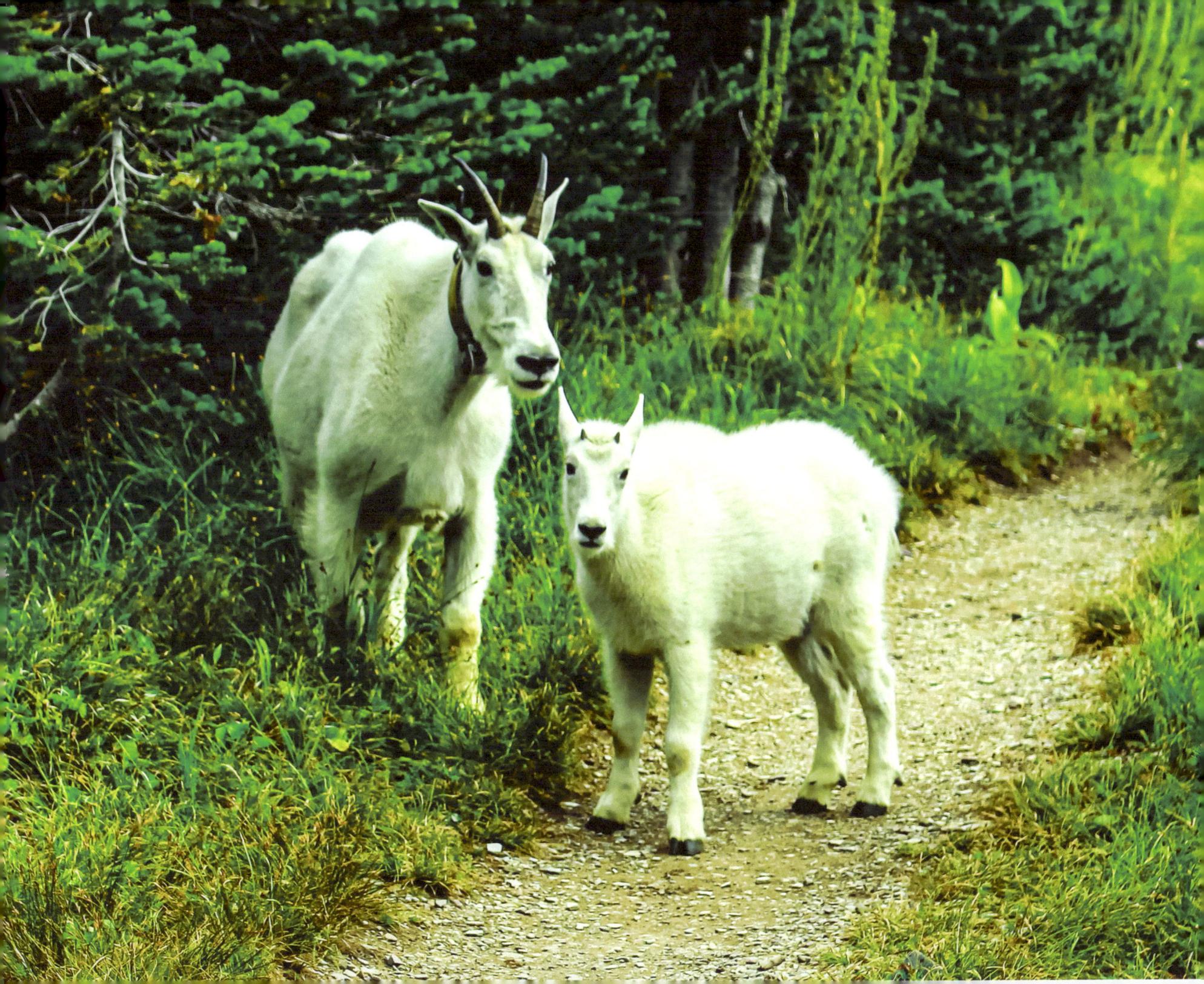

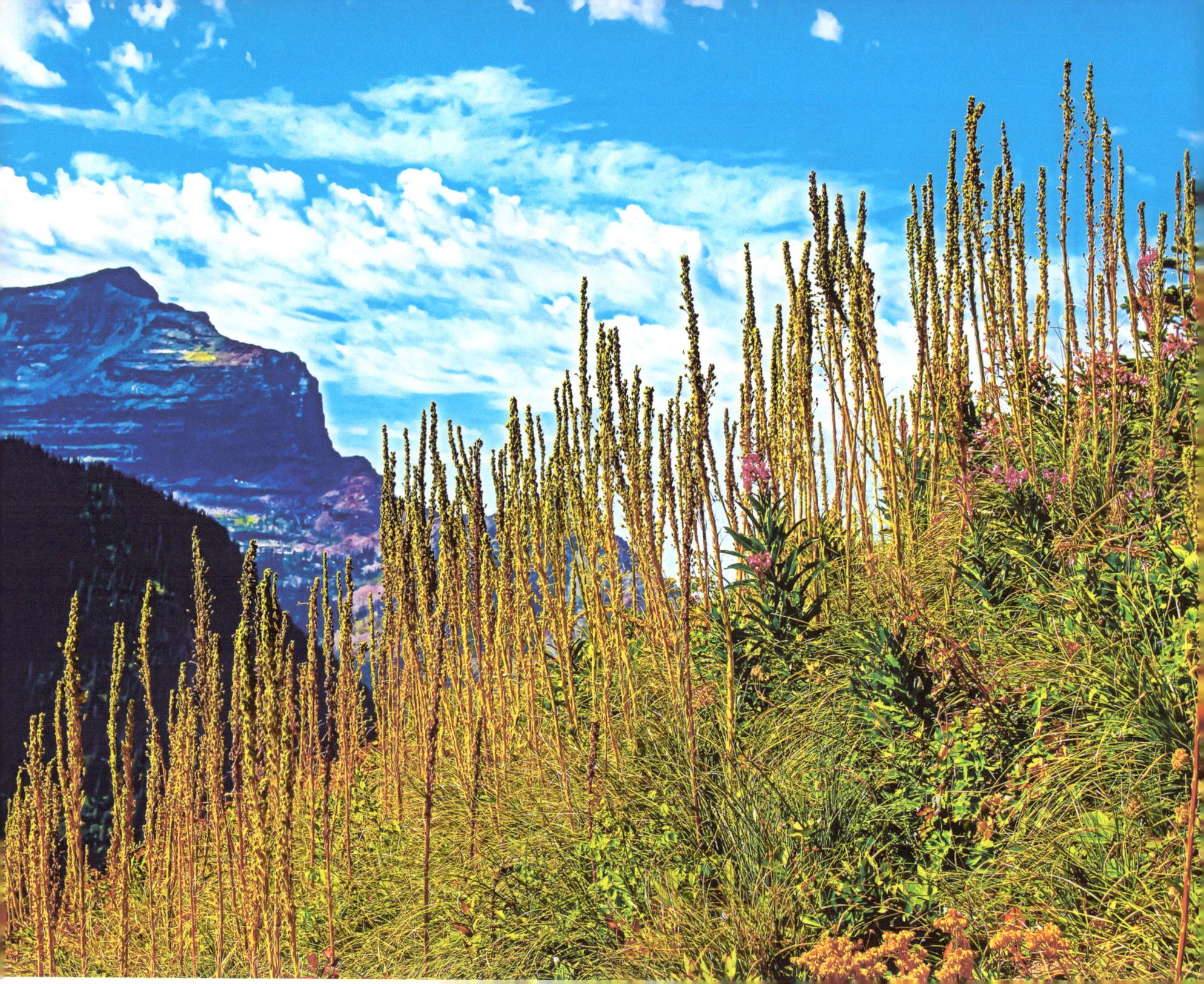

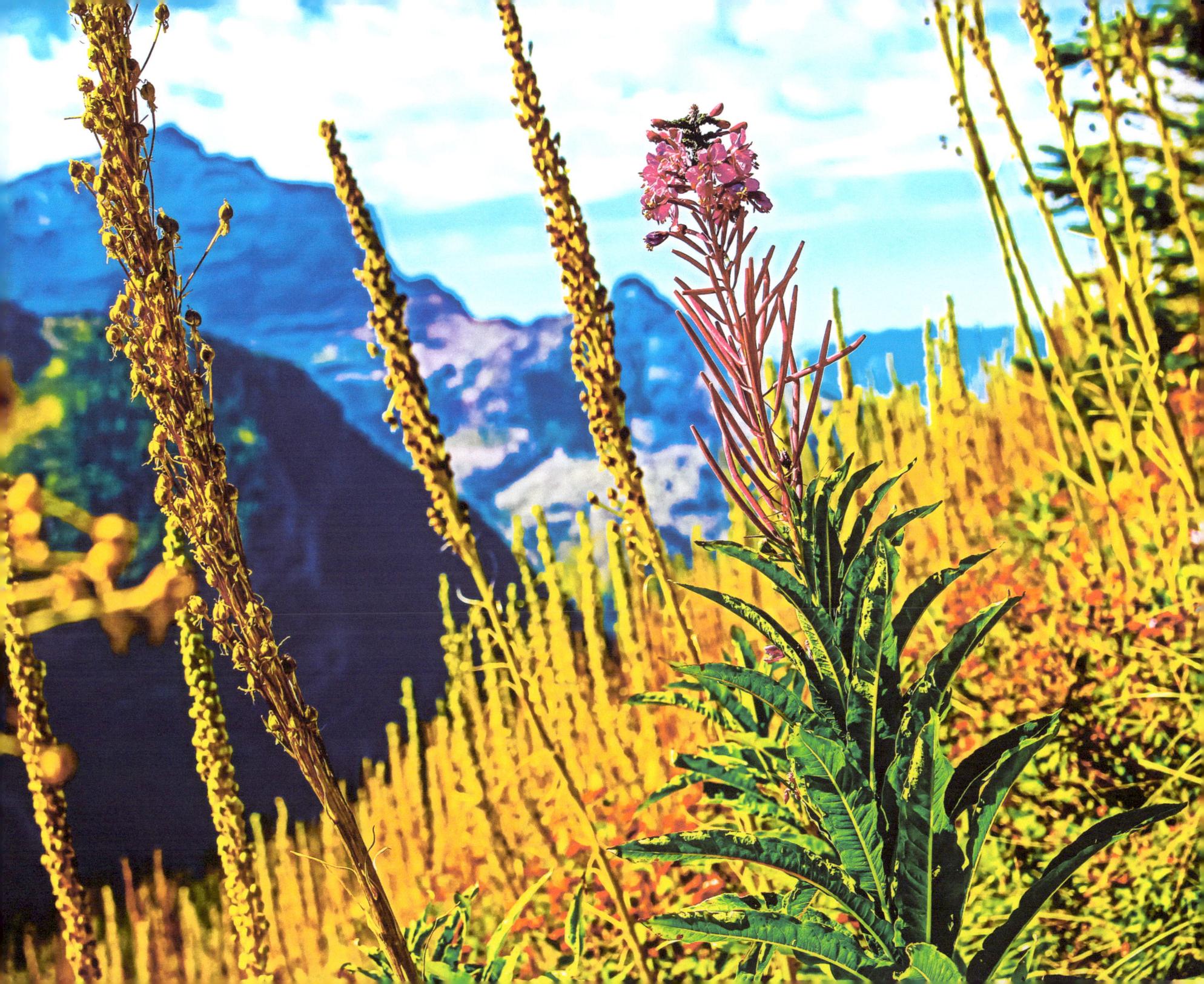

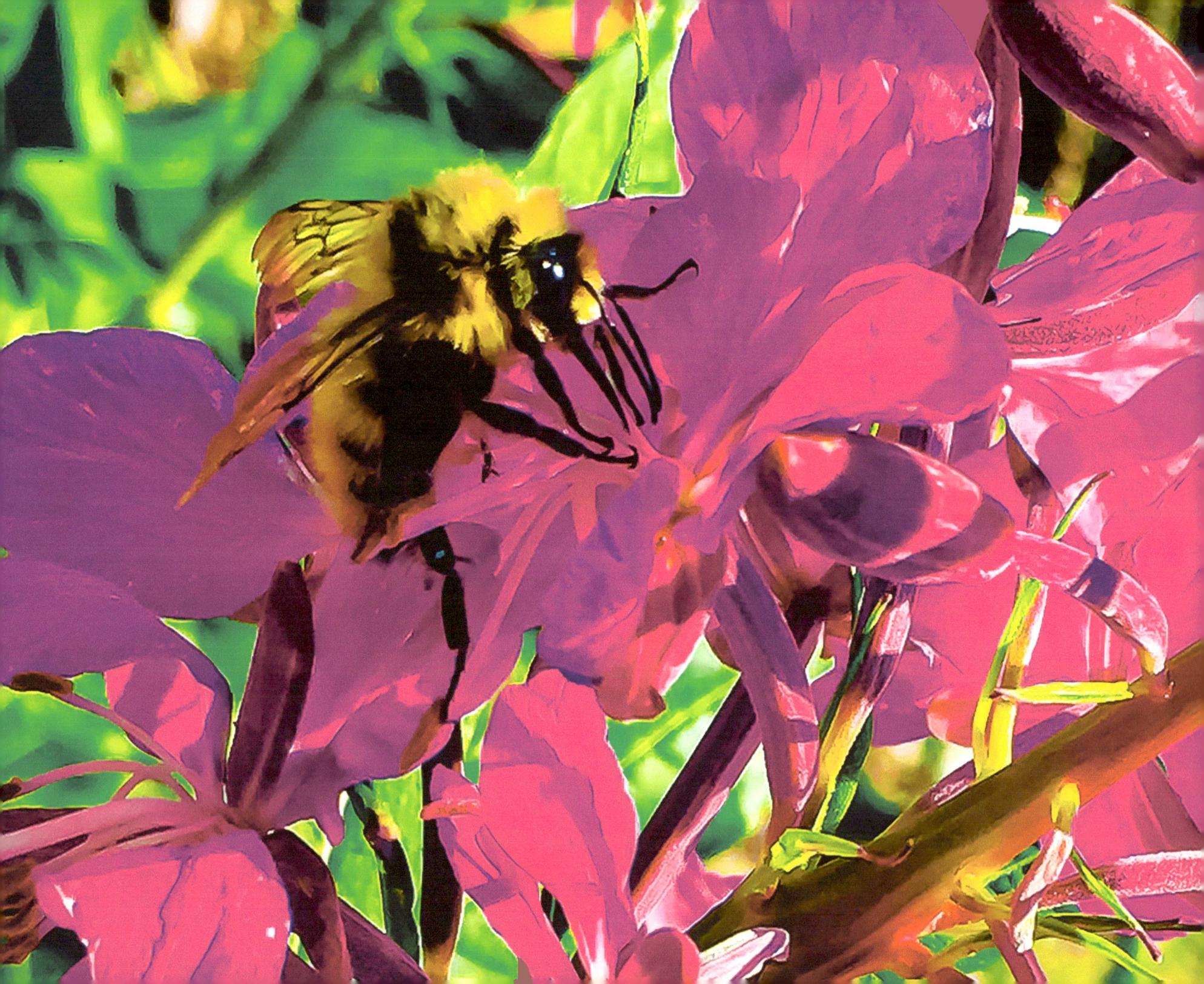

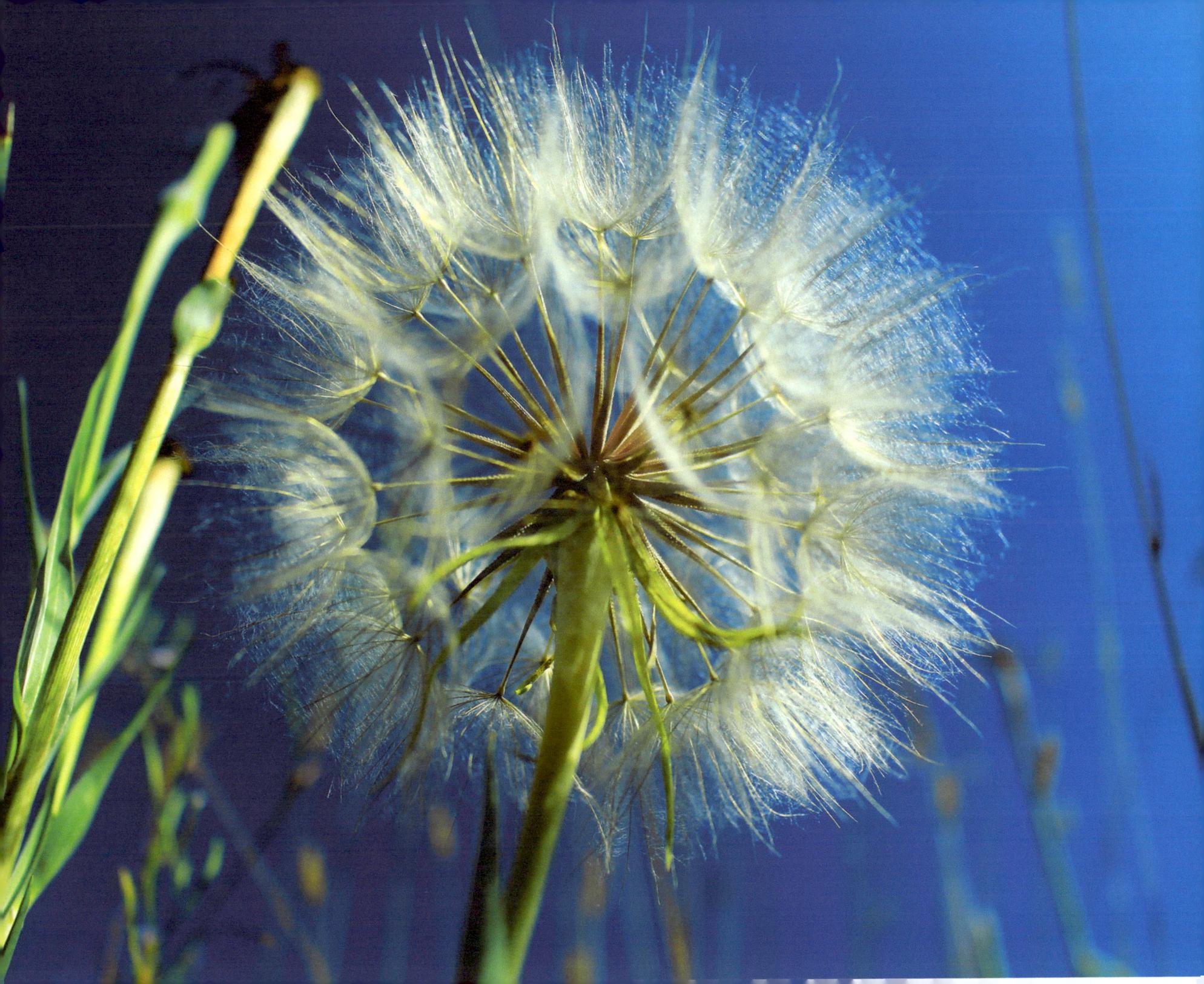

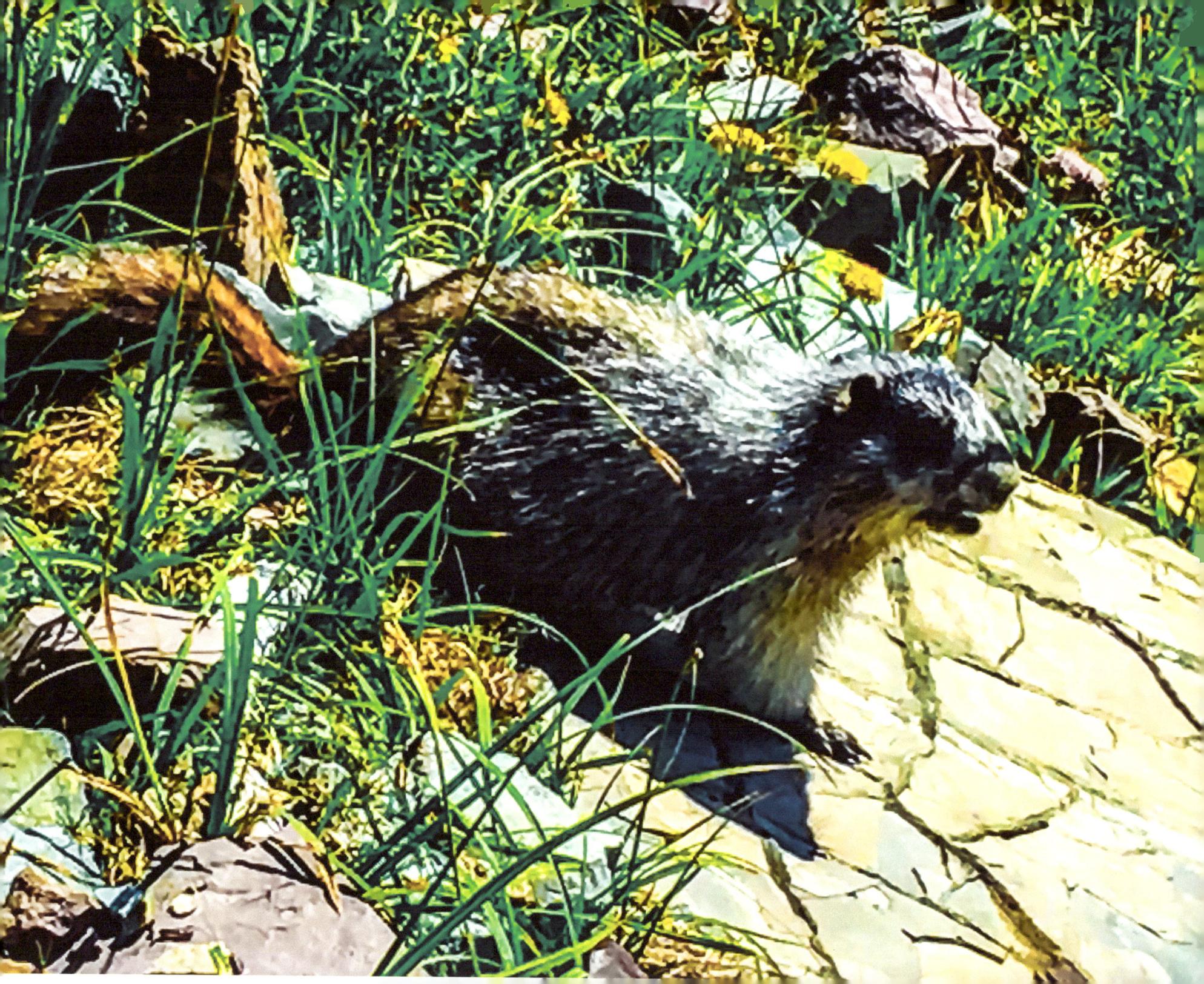

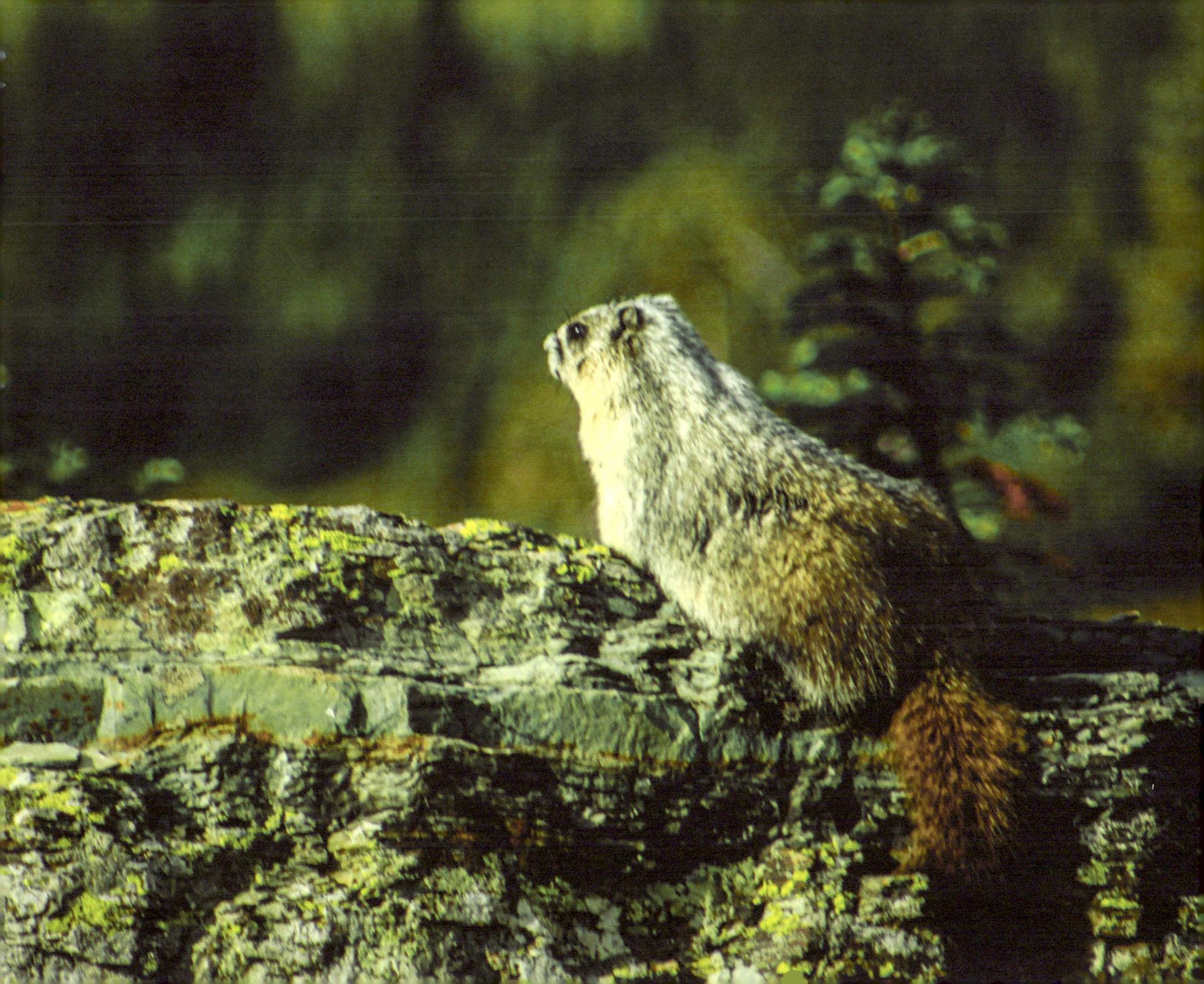

AVALANCHE CREEK

"Fifty years ago the name Blackfoot was one of terrible meaning to the white traveler who passed across that desolate buffalo-trodden waste which lay to the north of the Yellowstone River and east of the Rocky Mountains."
— George Grinnell, 1892

The first people to inhabit the region around Glacier National Park were the ancestors of modern Native Americans. While there are several theories about the origin of these indigenous people, one with strong consensus is that they migrated from Siberia during the last major ice age, which began approximately 2.6 million years ago, and ended around 11,700 years ago. No direct genetic link has been established between modern Native Americans and the people of ancient east Asia. However, DNA evidence from a late Stone-Age human skeleton discovered in Mal'ta in southern Siberia suggests a divergence in the population that began about 25,000 years ago, coinciding with the peak of the last major ice age. The Land Bridge Theory suggests that around 20,000 years ago, people from Siberia migrated onto lands that were exposed by declining sea levels in the Bering Strait. Beringia is the name ascribed to these lands that were exposed as vast quantities of freshwater were trapped as ice at Earth's poles. These same lands would be re-submerged as the ice age ended.

According to the Land Bridge Theory, those inhabiting Beringia migrated into North American around 16,500 years ago as they moved into the Alaskan interior. Archeological evidence of the first inhabitants of the North American continent date to approximately 13,000 years ago. The people that first inhabited the North American continent are identified by archeologists as Paleoindians. Archeologists believe that Paleoindians spread rapidly across both North and South America resulting in the first widespread human culture in the North and South American continents – the Clovis culture. The name originates from "Clovis points" that are distinctive bone and ivory tools first discovered in New Mexico in the 1920s. The people of the Clovis culture are believed to be the direct ancestors of most of the modern indigenous peoples of the Americas. The remains of a baby boy, thought to have been buried around 12,600 years ago, were discovered northeast of Livingston, Montana. Artifacts around the body connect the child to the Clovis culture. The boy's DNA suggests Asian ancestry, as well as connection to modern-day native peoples of Central and South America.

Prior to 1730, an Algonquin-speaking tribe – the Piegan, or Blackfoot - resided on the North Saskatchewan River. As history is told, invaders from the east drove the Blackfoot southward and westward. Over time and with the introduction of horses, the Blackfoot came to occupy a vast area of the North American Great Plains, stretching from the North Saskatchewan River, south into Montana to the headwaters of the Missouri River, and from the 105th parallel to the Rocky Mountains.

The Blackfoot were known to be restless, hardy, and untiring, but also aggressive and predatory. Their name is thought to have been derived from the black color on their moccasins, whether painted or darkened with ashes. Their lifestyle was nomadic, frequently moving from place to place, likely following herds of buffalo on which they were dependent for clothing and food. They resided in tipis and practiced minimal agriculture. Originally, they migrated and hunted on foot. However, they were introduced to both horses and guns from nearby tribes, which enabled them to migrate and hunt over greater distances. They amassed large herds of horses and were frequently at war with surrounding tribes, sometimes traveling a great distance in order to launch their attacks.

When the first explorers from the east wandered into the area, the Blackfoot resided in the prairies east of the mountains, and the Salish and Kootenai Indians resided in valleys to the west. The Hudson Bay Company moved into the region and trappers sought beaver and other pelts. Later others migrated with mining interests. By 1891 the Great Northern Railway was completed that opened the door for many more settlers to the area.

In 1790, the Blackfoot population was about 9,000. As a result of migration from the east, the Blackfoot population suffered periodic losses from smallpox, and in 1864 by a measles outbreak. From 1883 to 1884 many more died from starvation as buffalo herds were depleted and approaching extinction. By 1909, the Blackfoot population was officially reported to include 4,635 persons.

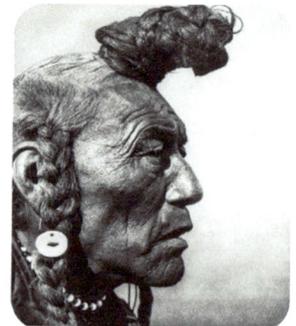

Blackfoot Translator
Bear Bull (1926)

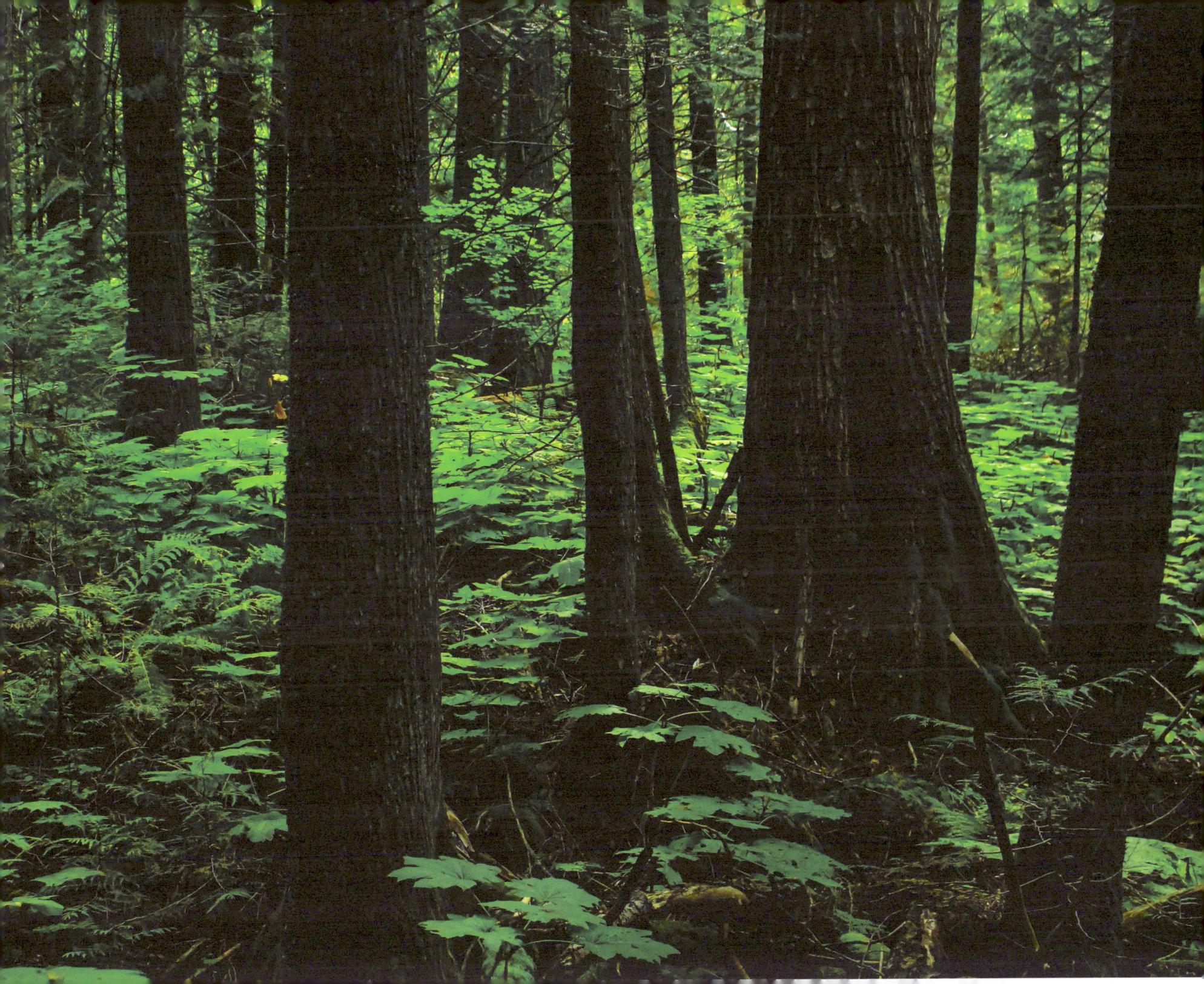

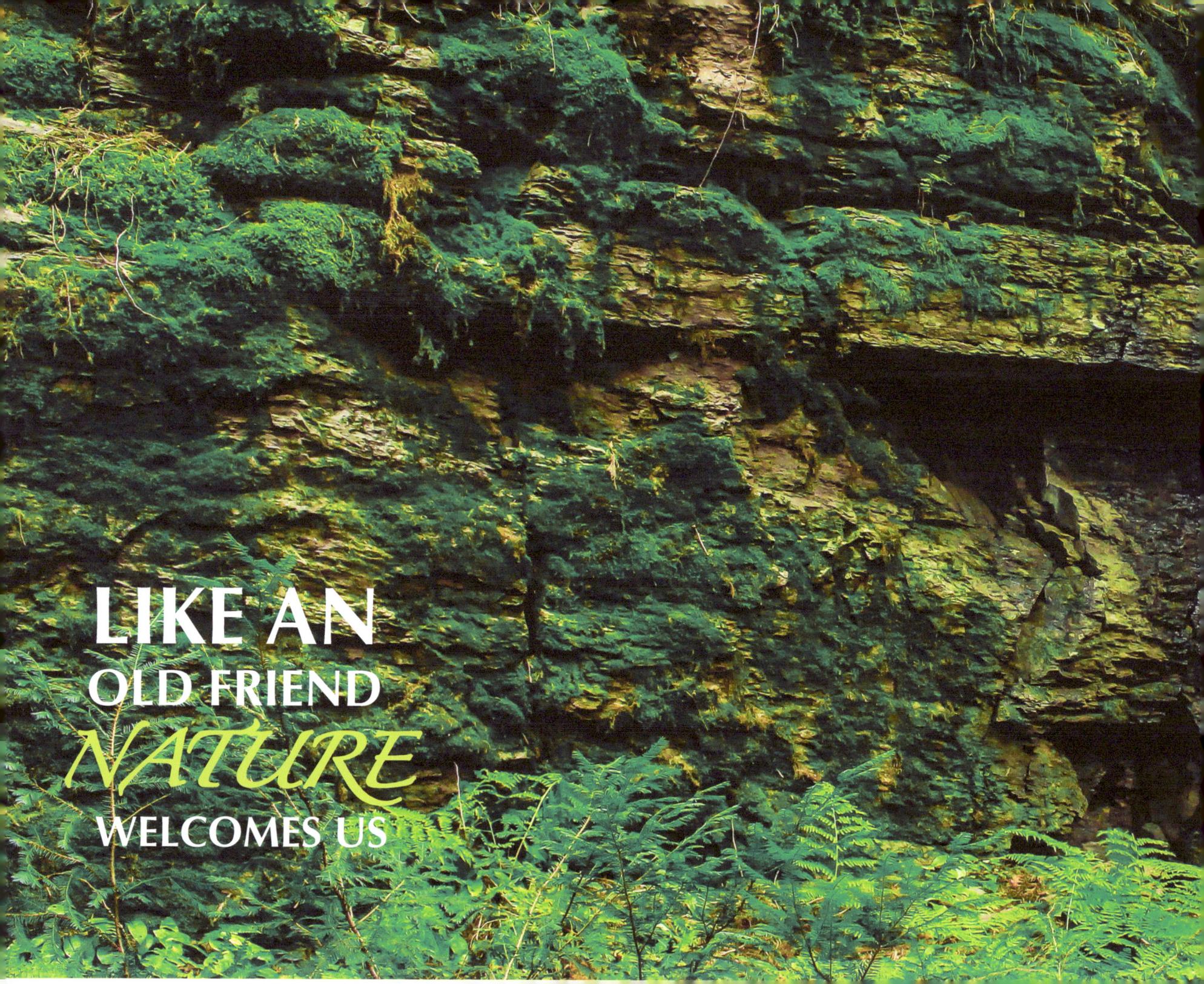

LIKE AN
OLD FRIEND
NATURE
WELCOMES US

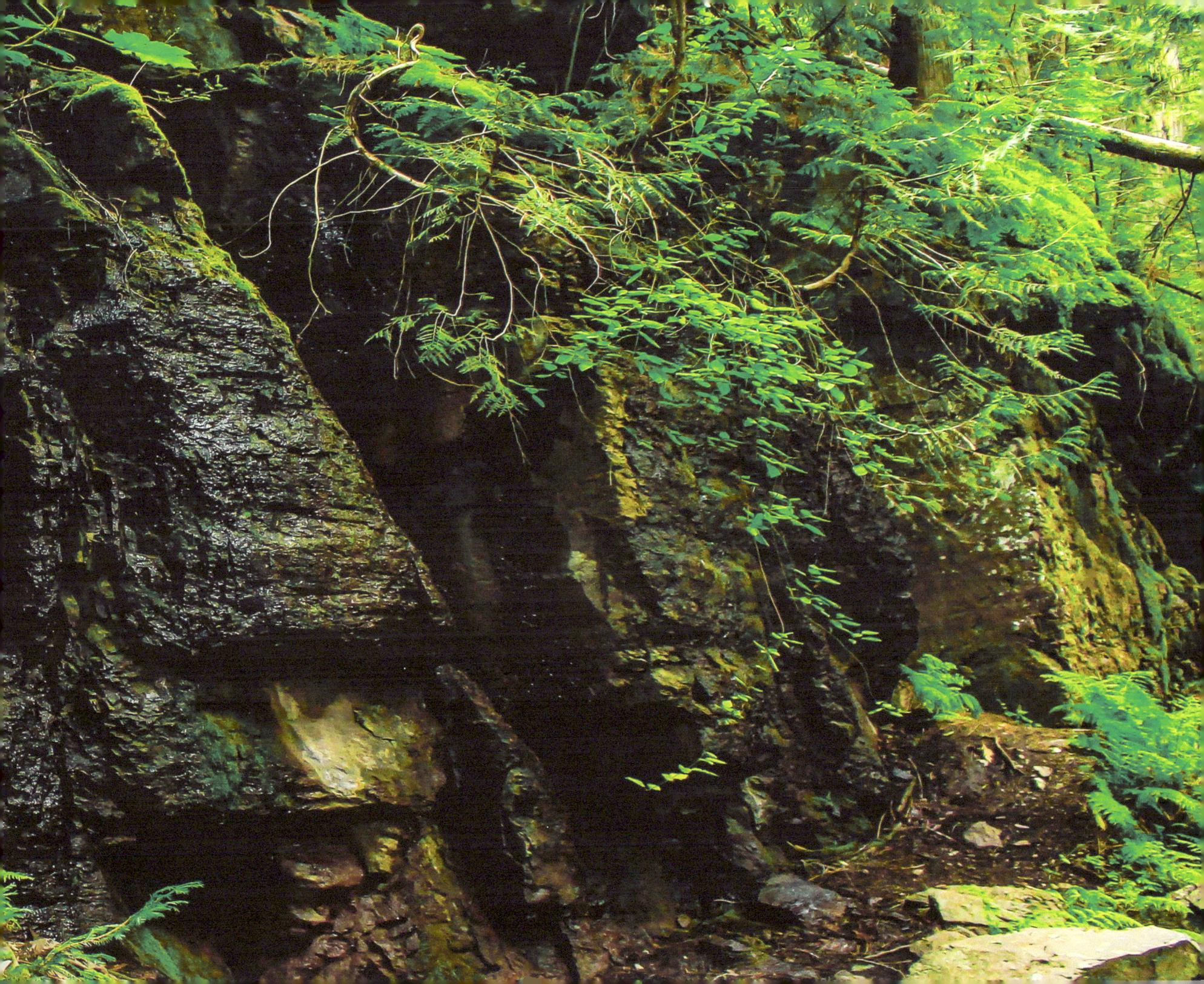

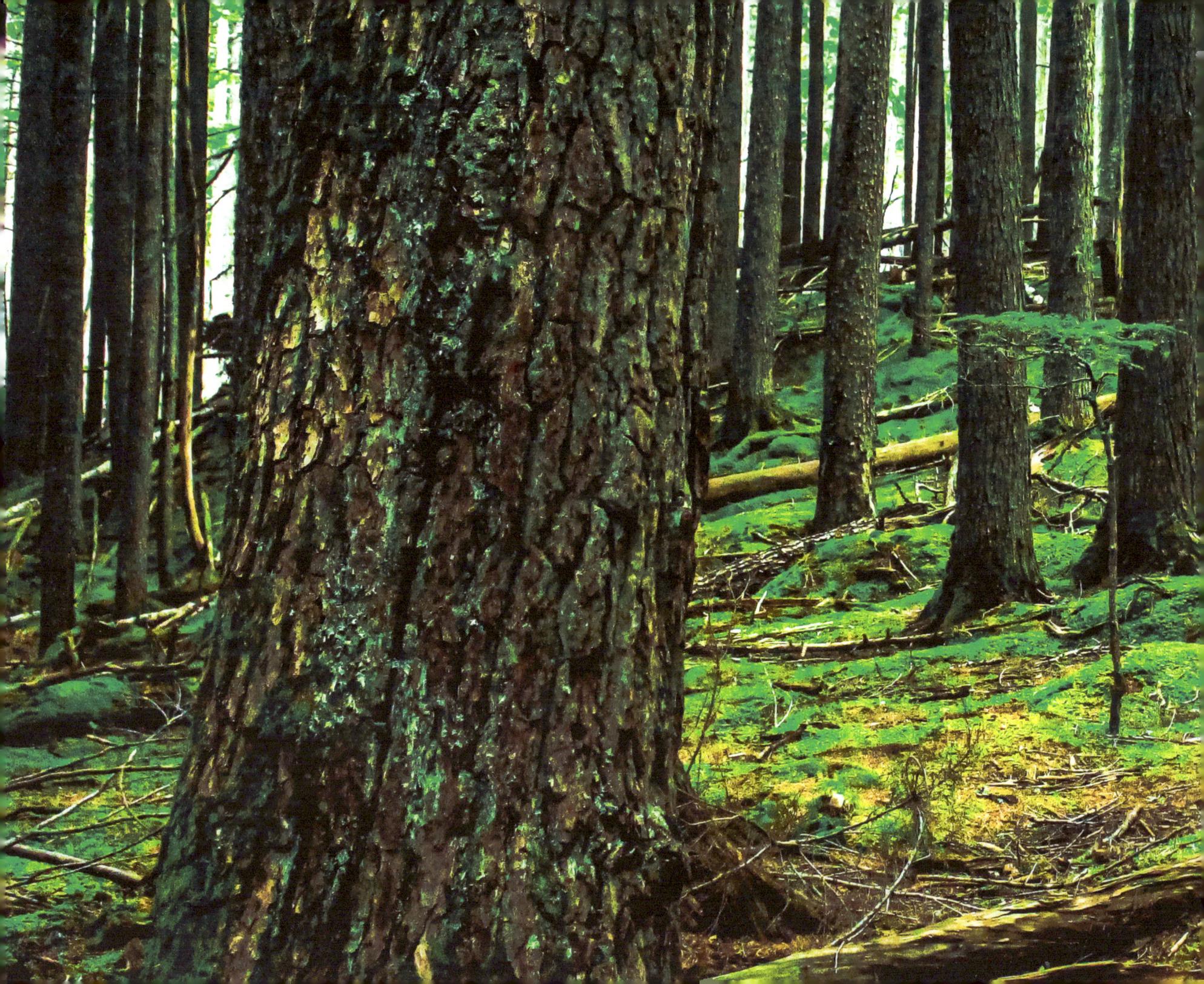

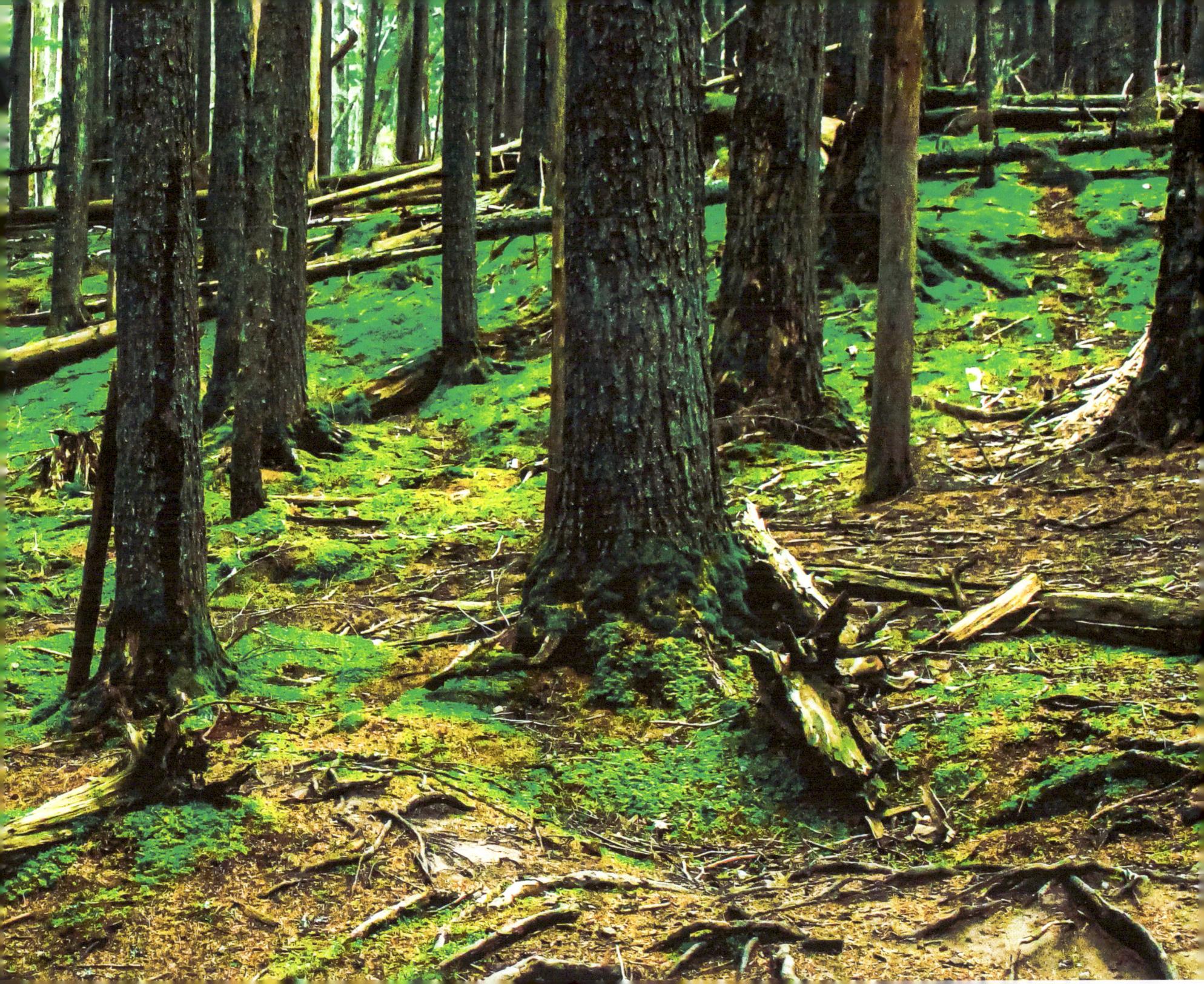

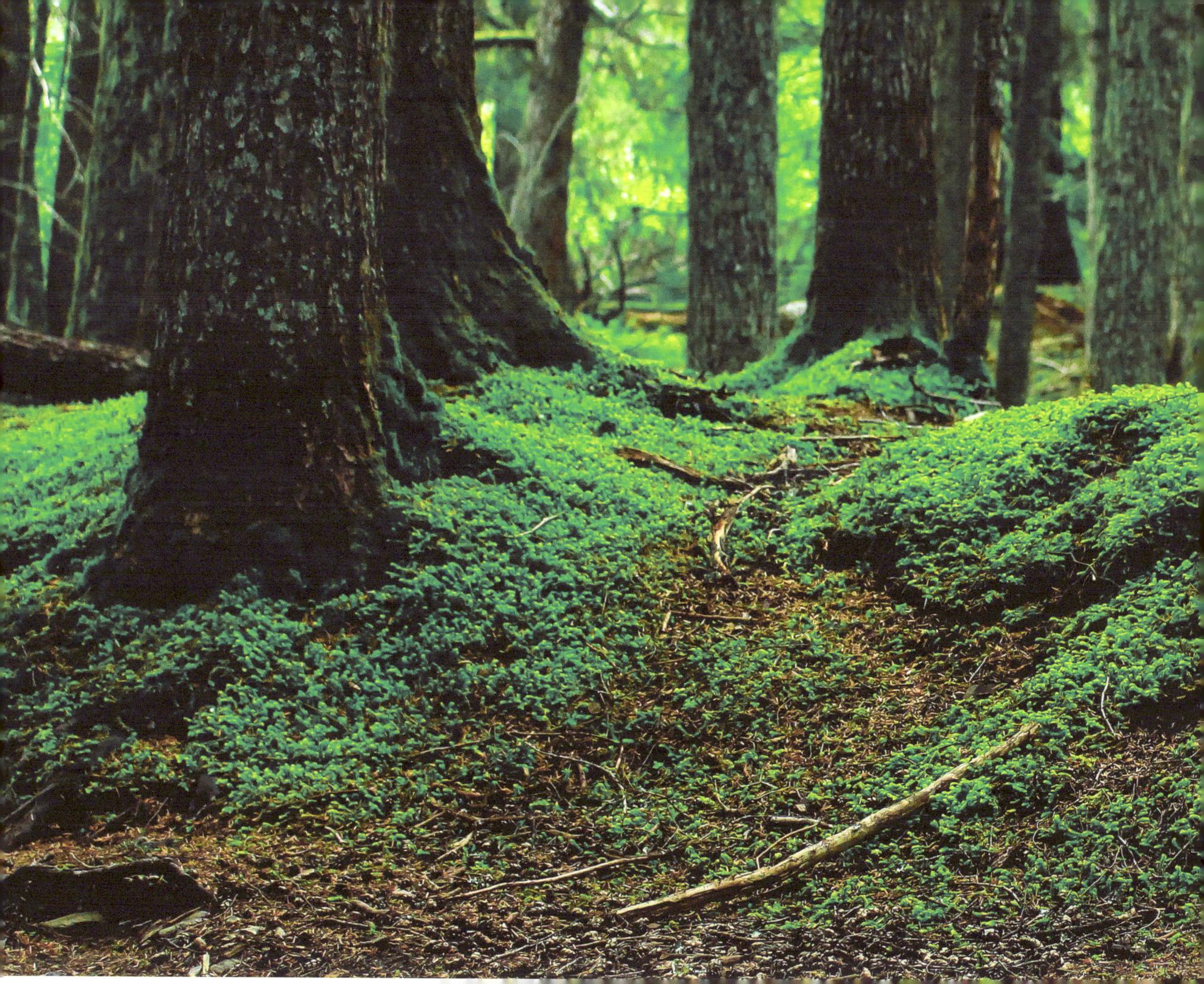

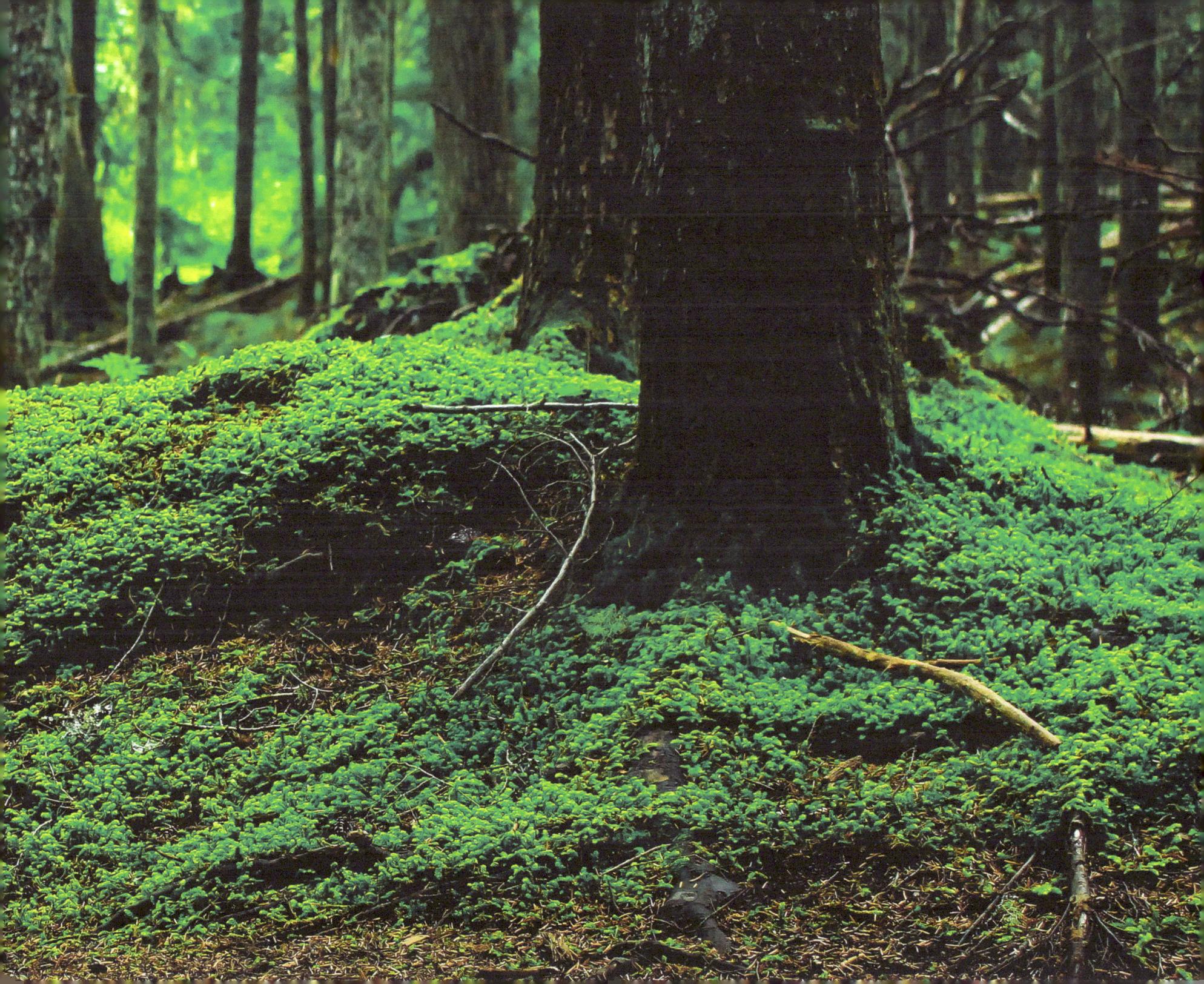

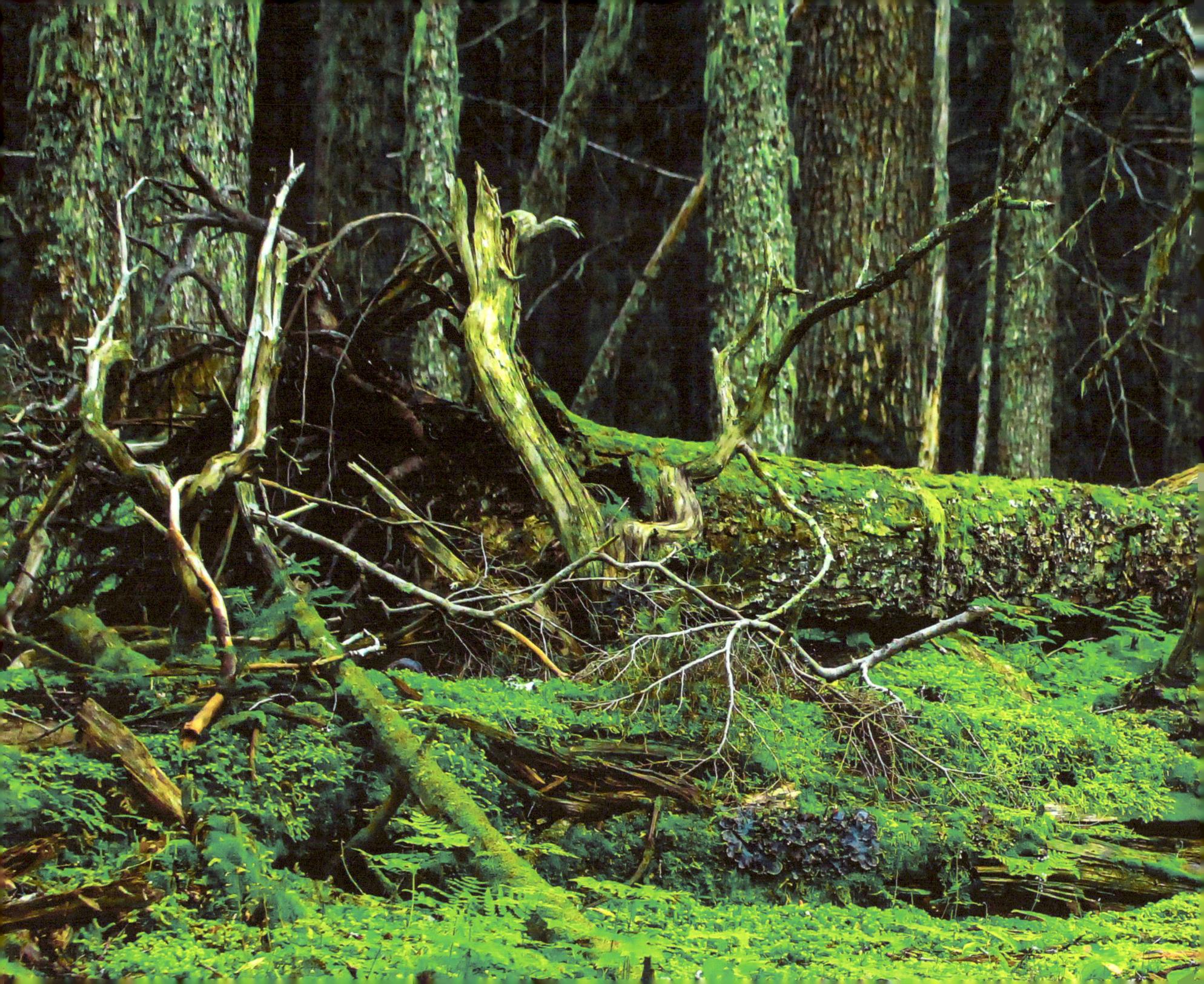

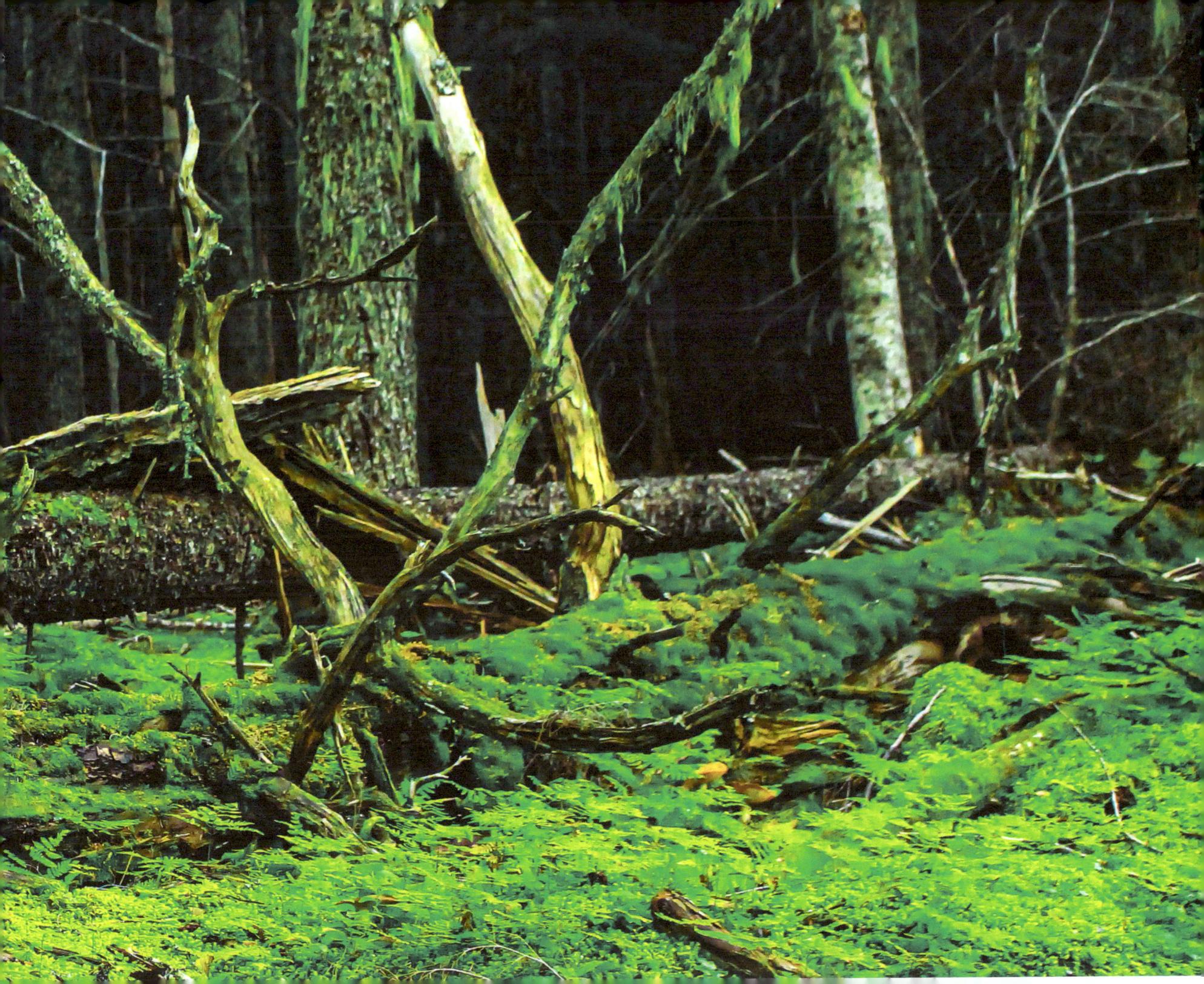

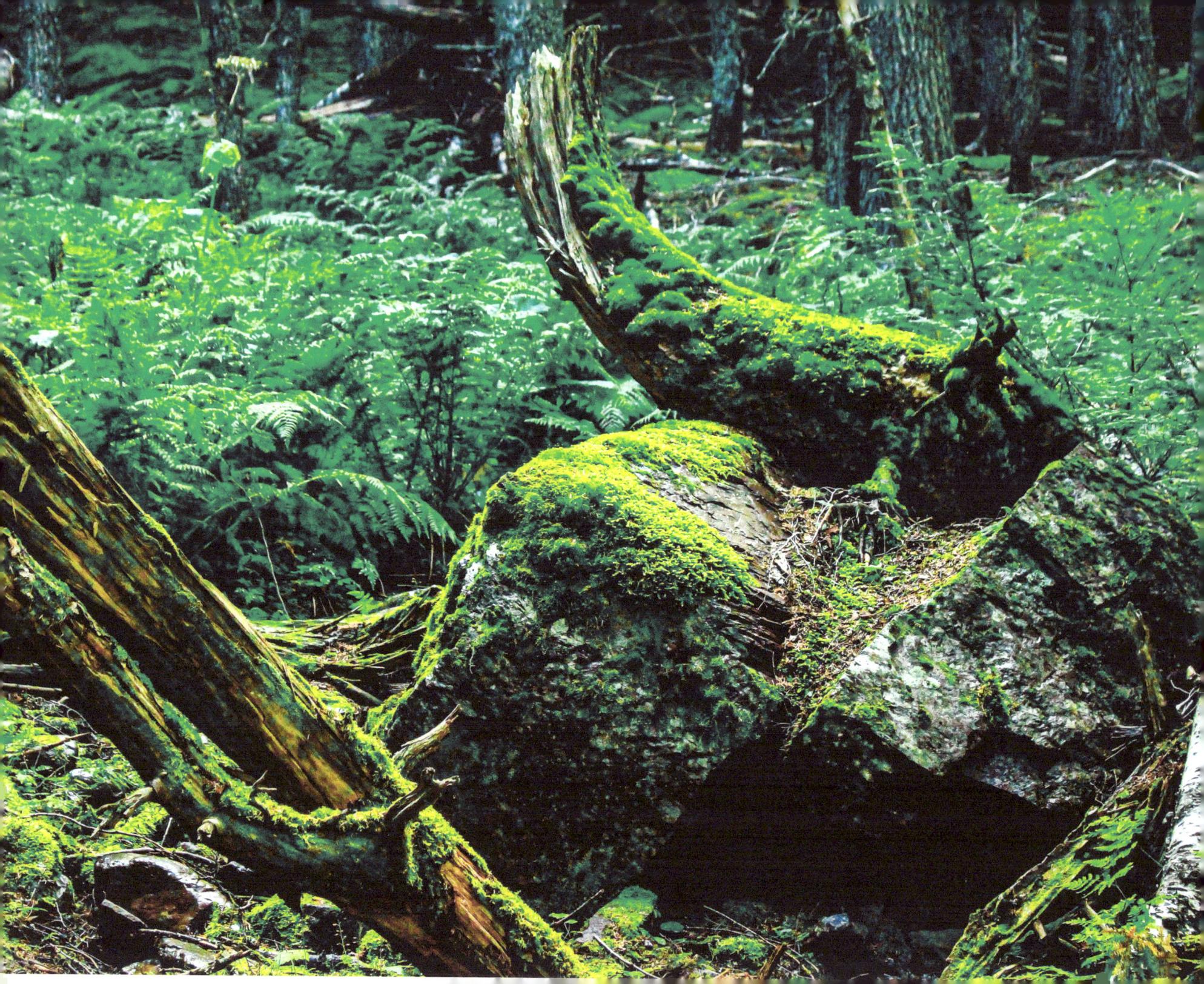

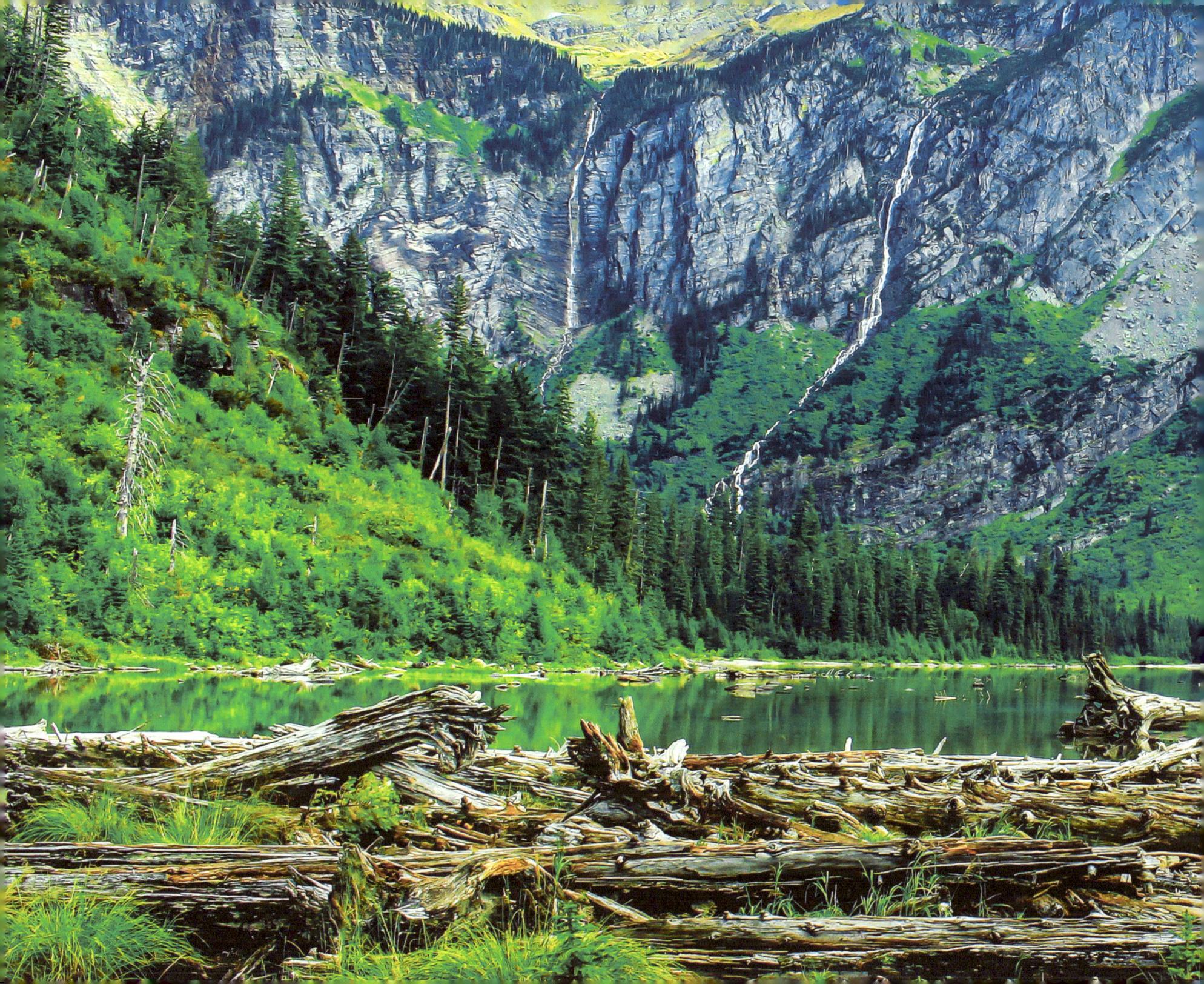

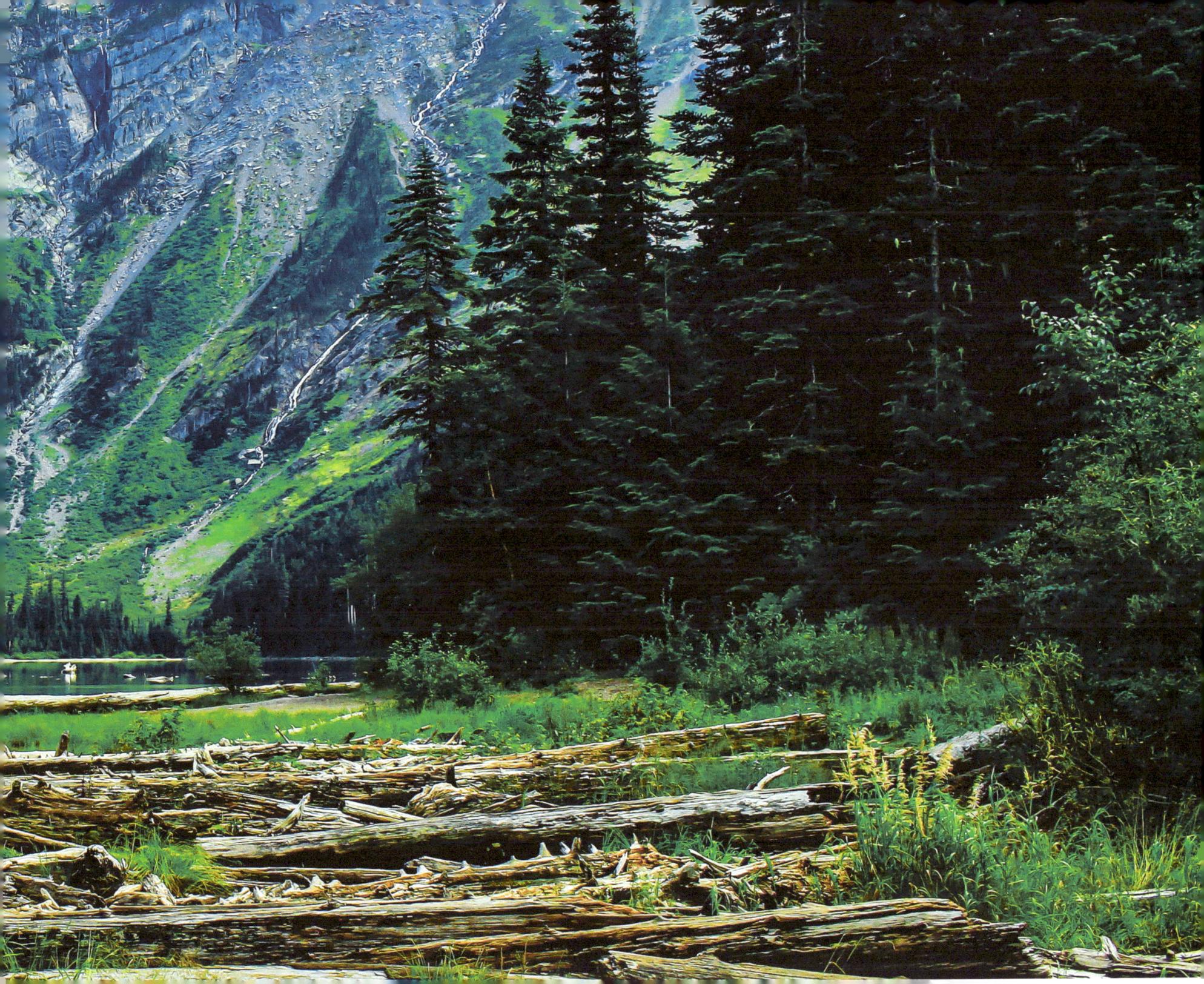

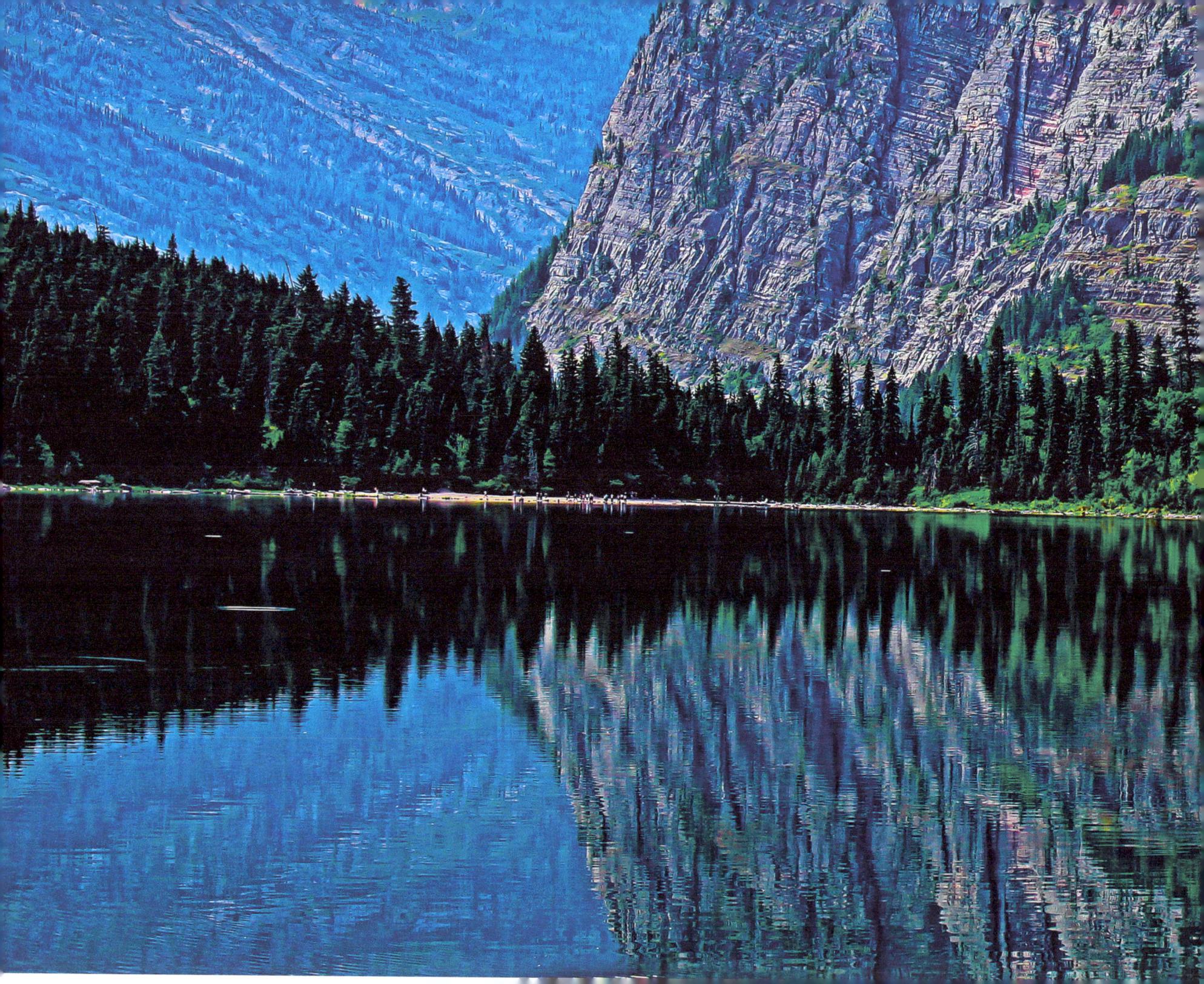

THE ABSENCE OF
TECHNOLOGY
REVEALS THE ABUNDANCE OF
NATURE

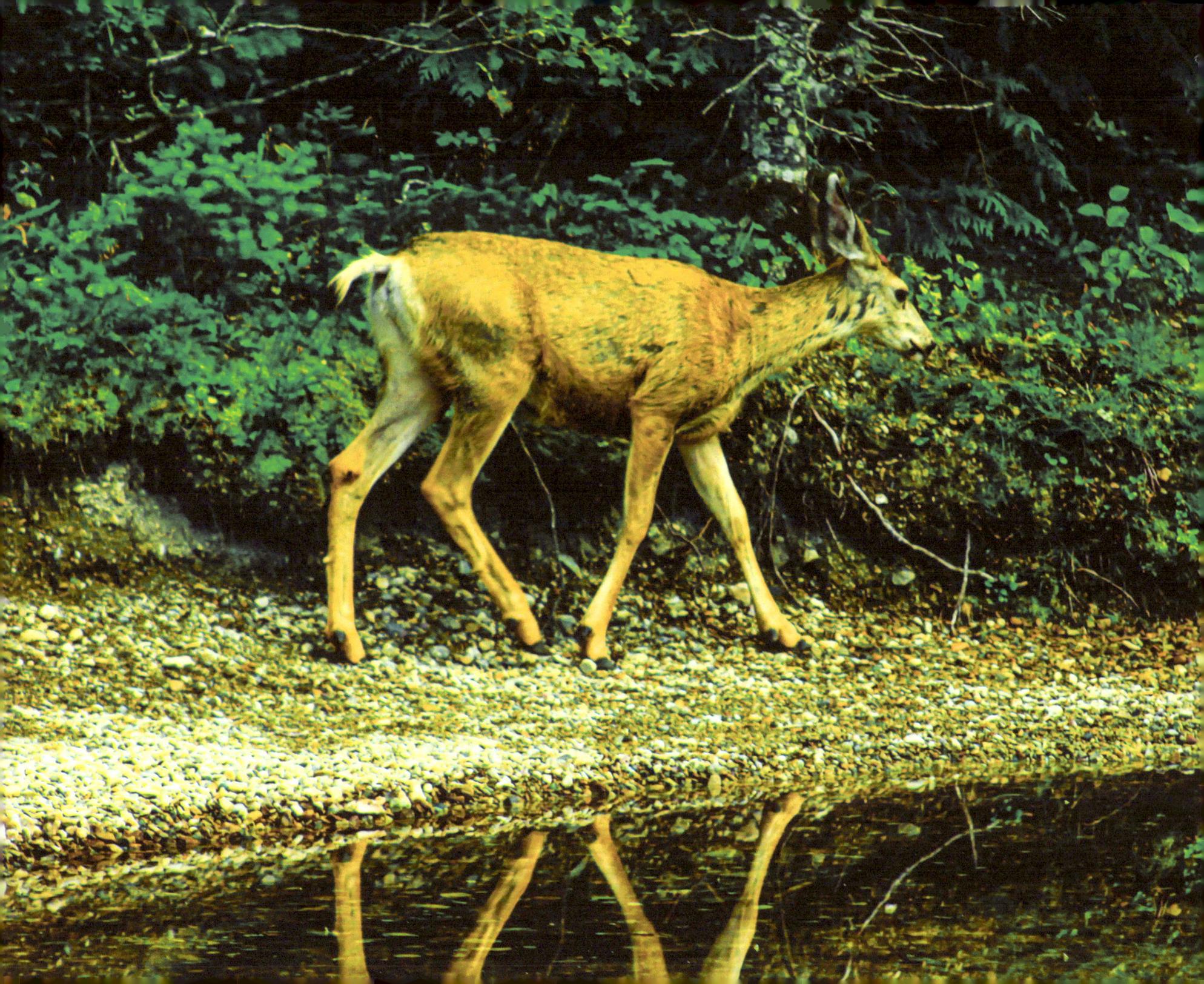

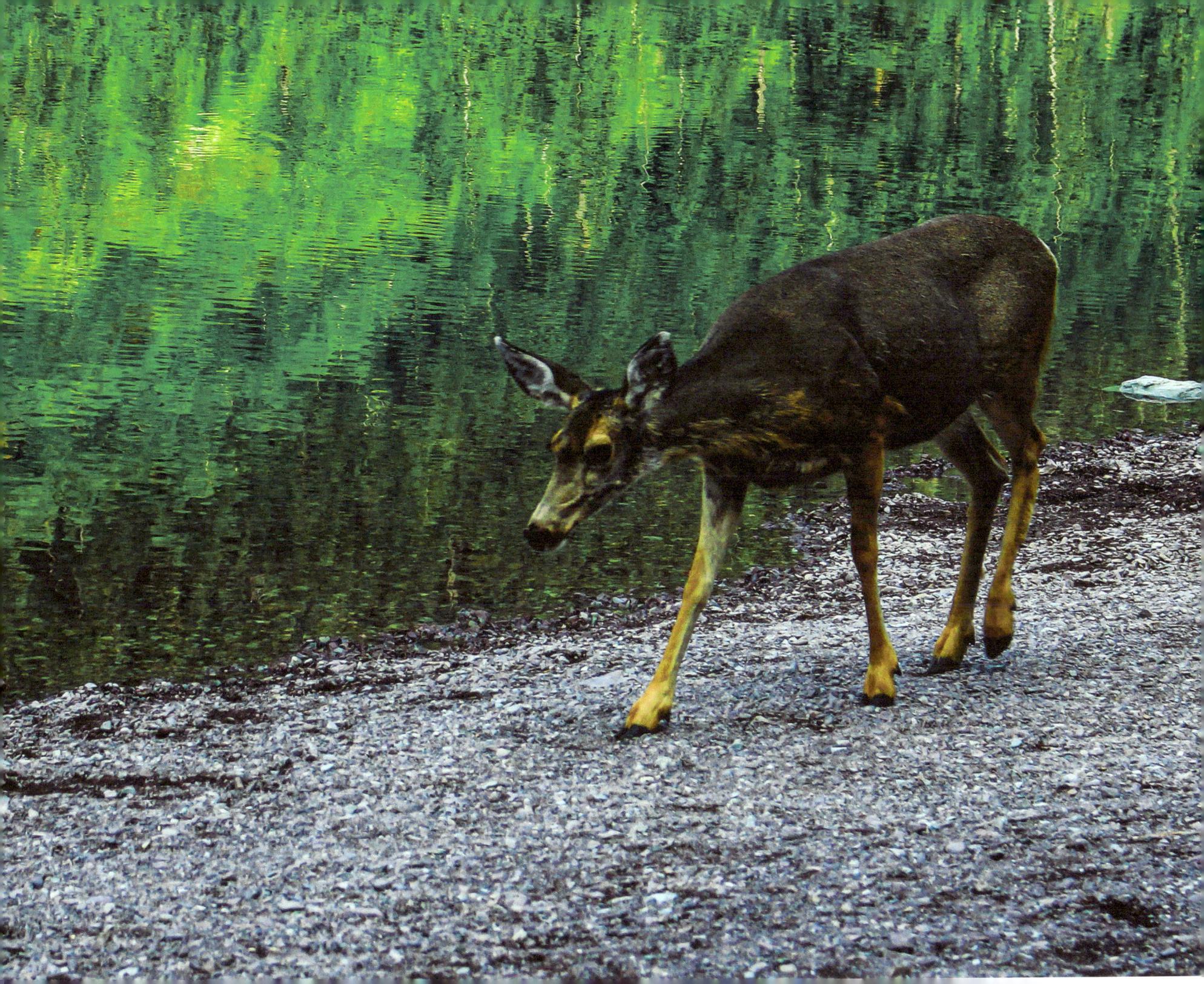

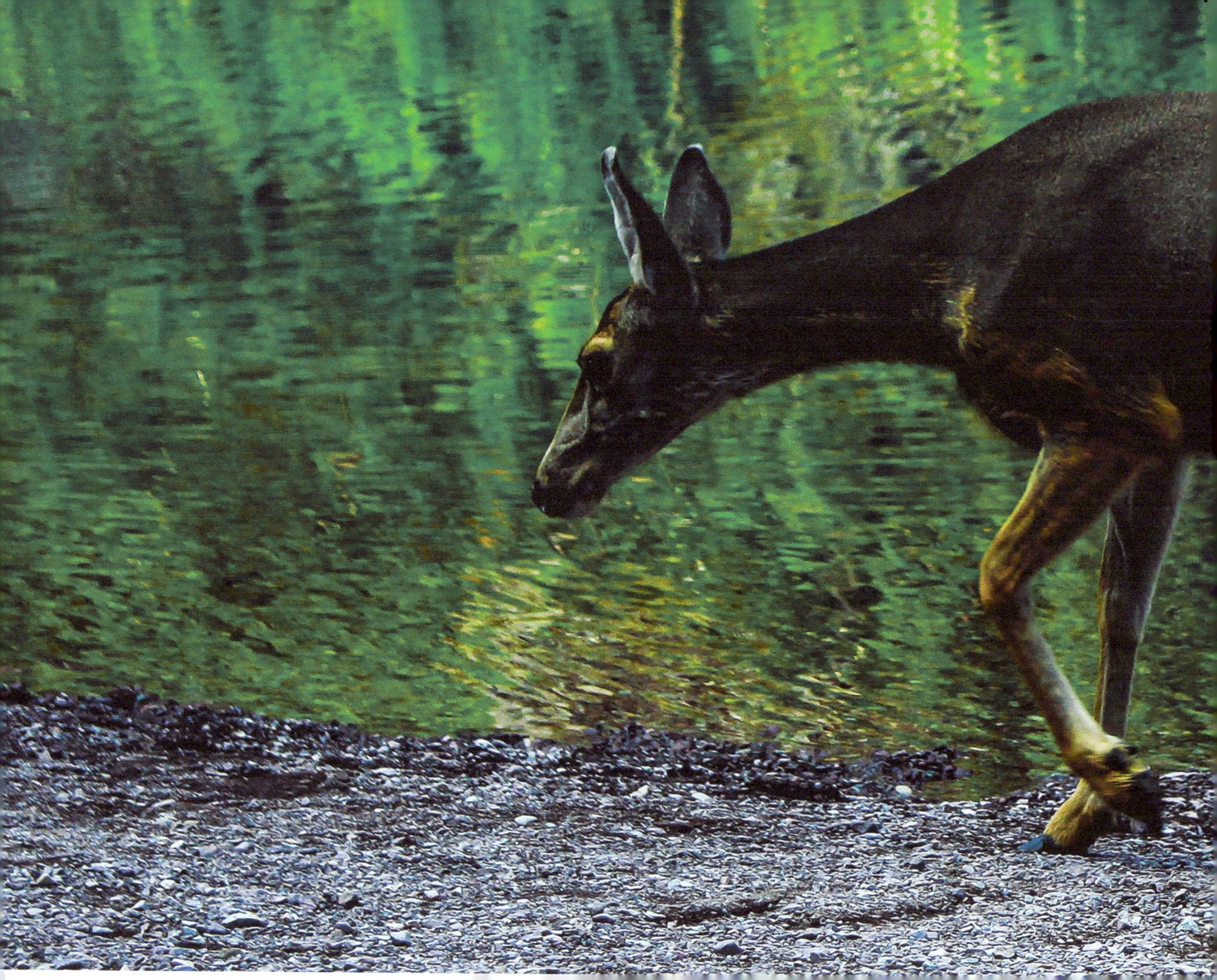

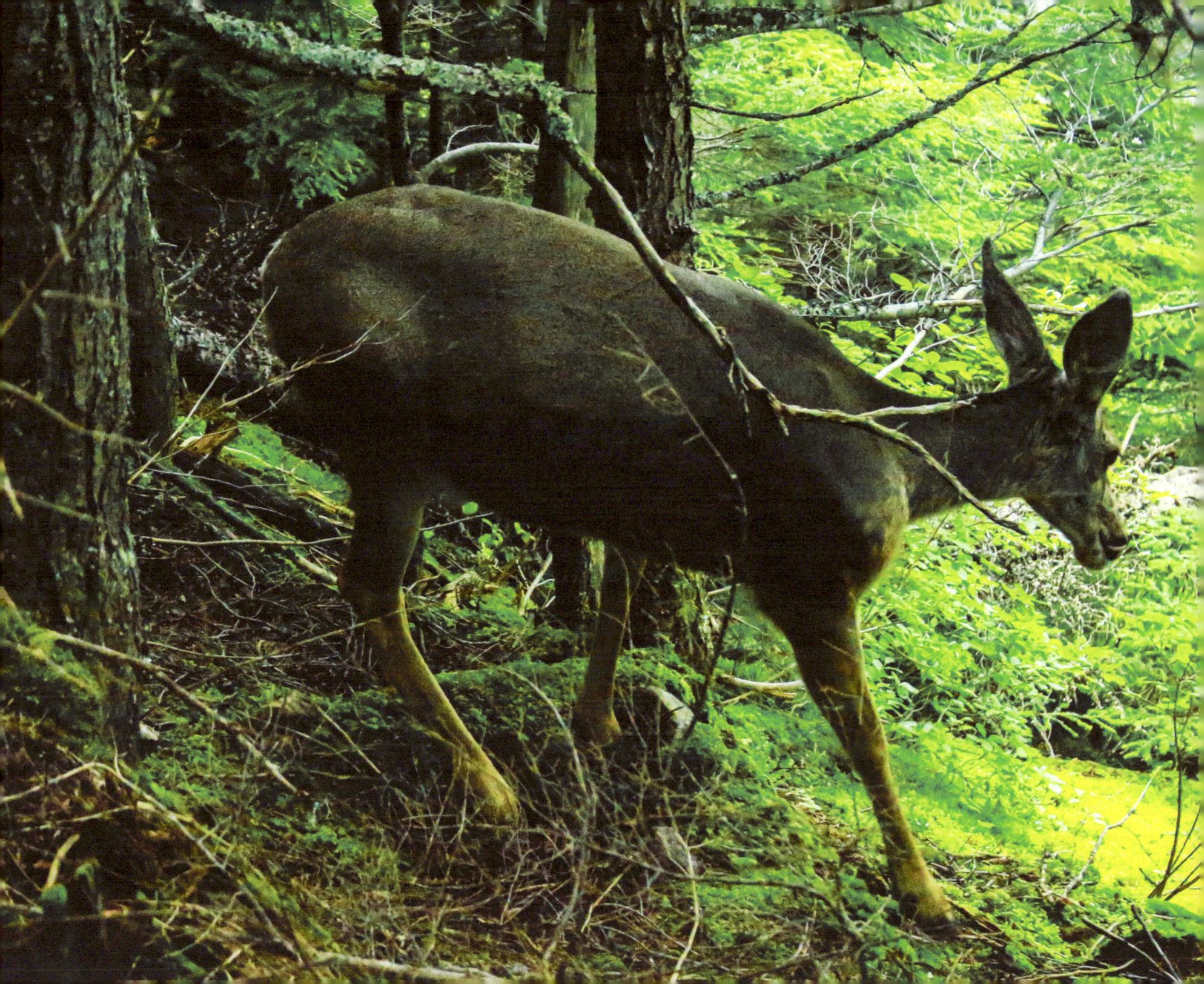

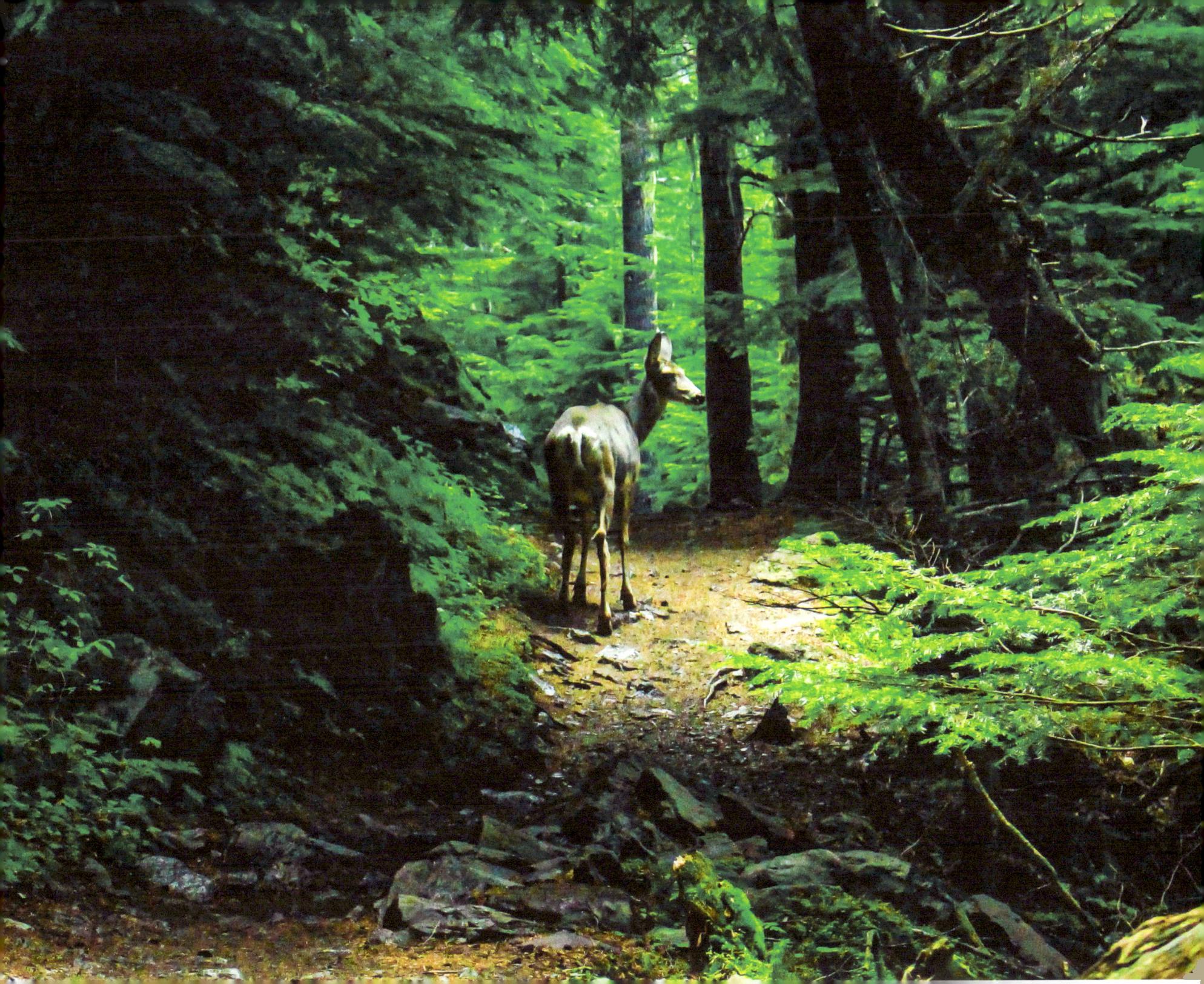

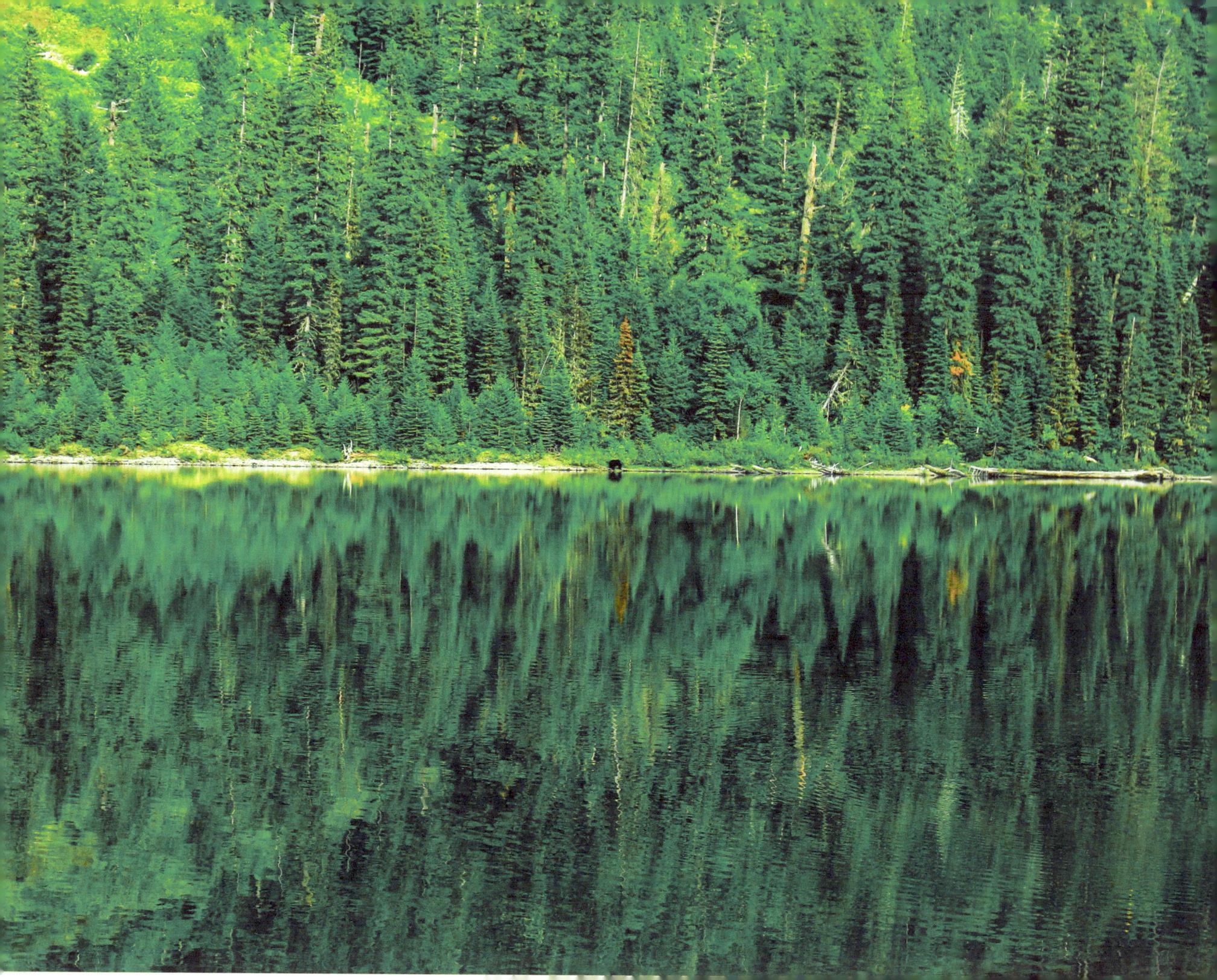

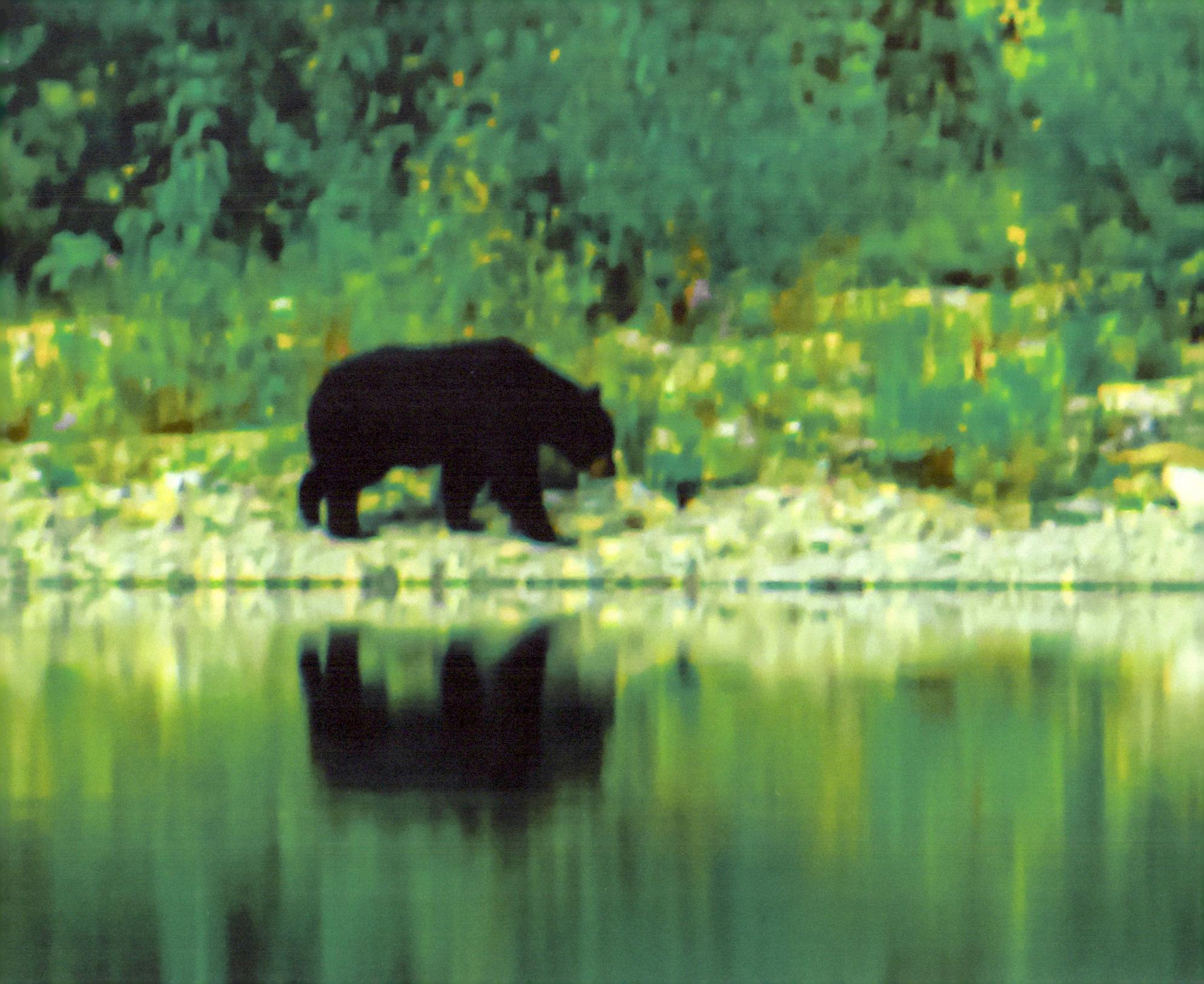

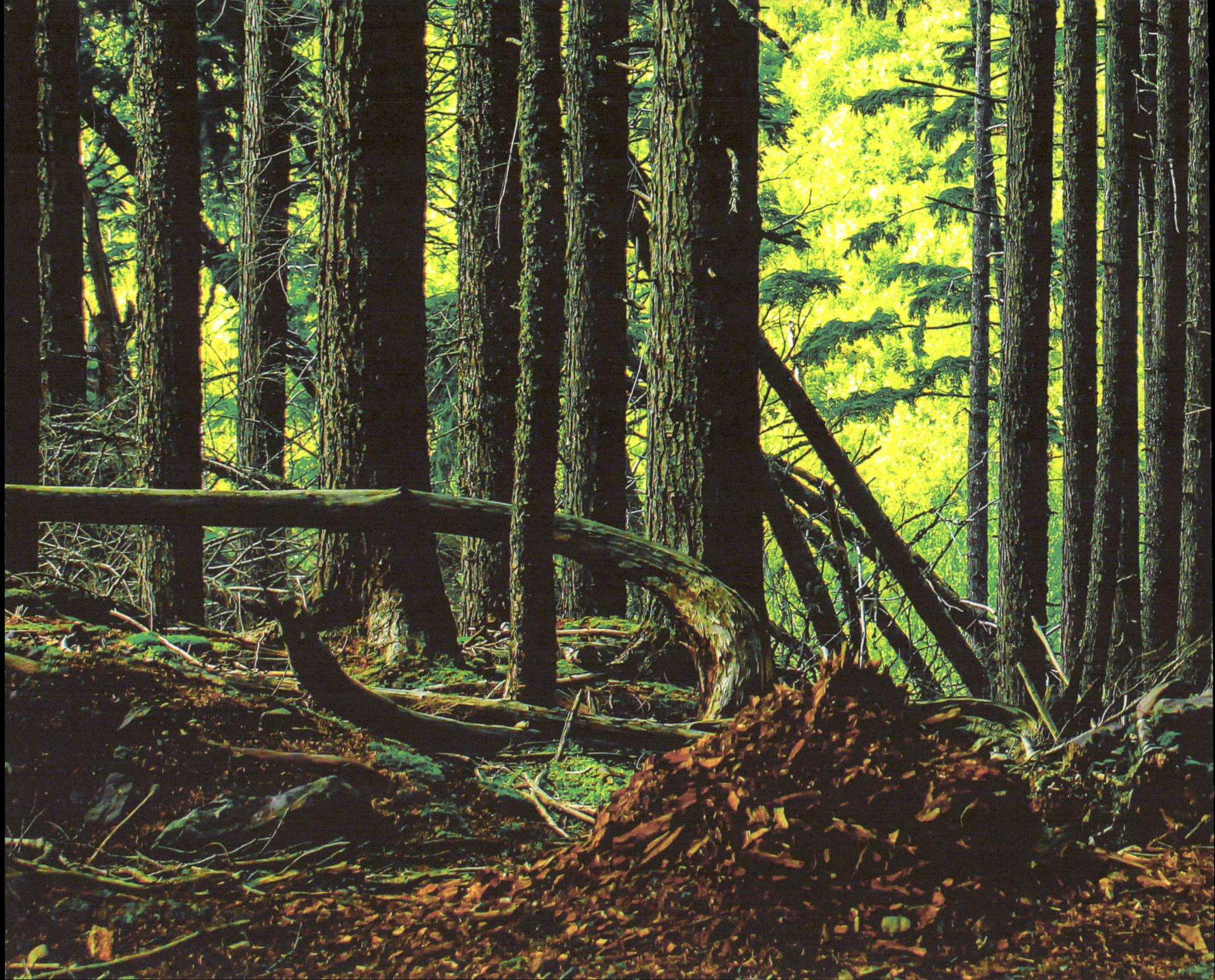

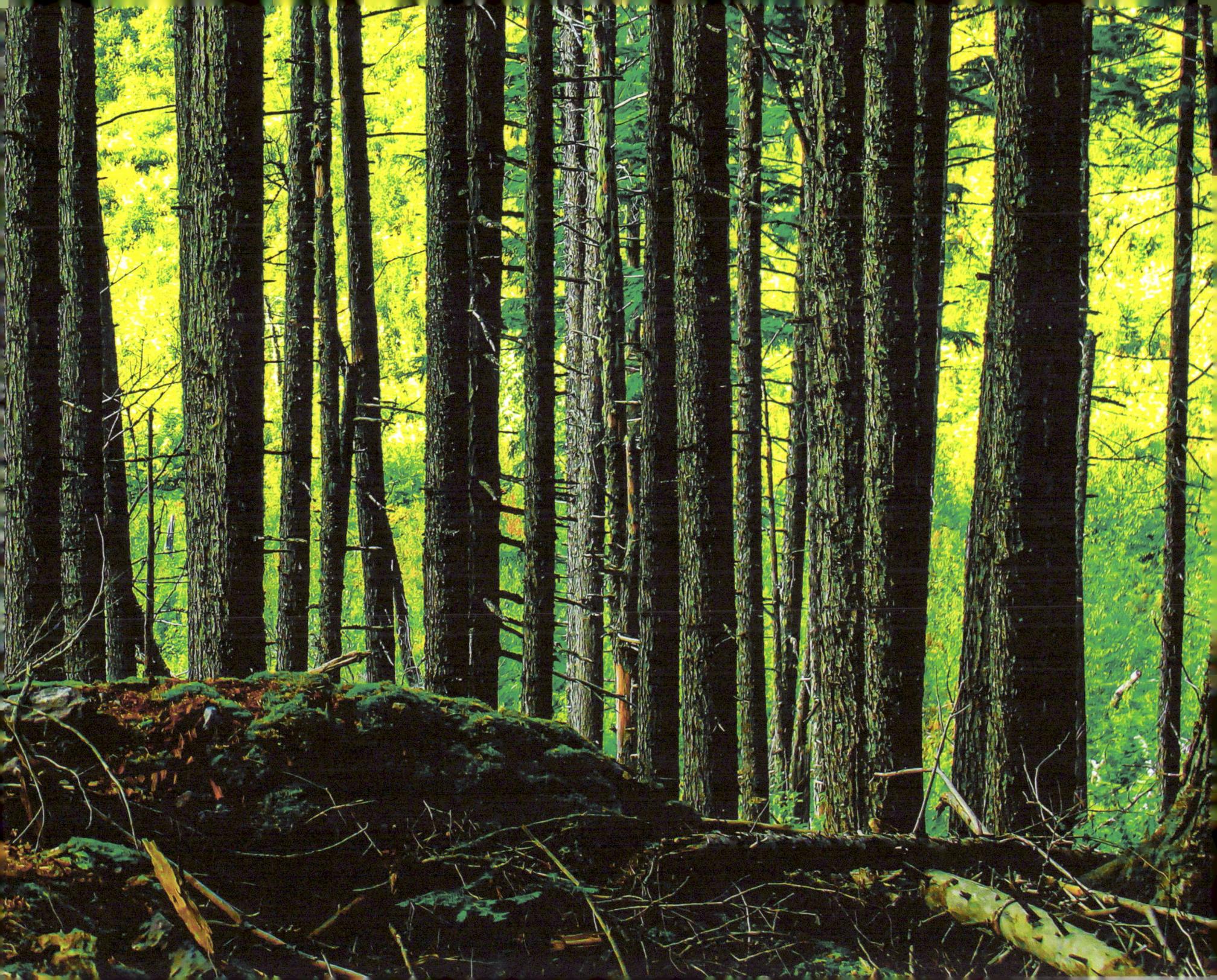

SAINT MARY LAKE

"Alas! Alas! why could not this simple life have continued? Why must the railroads, and the swarms of settlers have invaded that wonderful land, and robbed its lords of all that made life worth living? They knew not care, nor hunger, nor want of any kind. From my window here I hear the roar of the great city, and see the crowds hurrying by."
— James Williard Shultz

Rugged terrain, unrelenting cold winters, and trepidation towards native Americans dissuaded colonists in the east from migrating into the area that is now Glacier National Park, at least until the early 19th century. The adoption of the policy of manifest destiny by Thomas Jefferson resulted in the great expedition across North America by Lewis and Clark. They sought a waterway by which to cross North America. In their pursuit, Lewis and Clark came within 50 miles to the south of what is now Glacier National Park.

Trappers from France, England, and Spain were drawn to the region to make a living, but perhaps the first person of European descent to journey into the area was a young man named Hugh Monroe. Hugh was born in 1784 near Montreal, Canada. In 1802, at the age of 18, he traveled west with his half-brother under the employ of the Hudson Bay Company to work in the fur trade at Edmonton House, a fort on the Saskatchewan River, Canada.

Hugh was tasked with learning the Blackfoot language and establishing trade, which he accomplished. However, in 1806, Hugh married a Blackfoot woman and left the Hudson Bay Company to live with the Indians with whom he resided for the remainder of his life. He became known among the Blackfoot as "Rising Wolf" and lived with the Kootenais for many years. In 1836, accompanied by a party of Kootenais, he discovered and named Saint Mary Lake, and erected a large cross. Hugh became fluent in various Indian languages and was largely unequaled as a sign talker. Later in life, he moved to Two Medicine River in the southeastern portion of what is now the park where he eventually died in 1892 at the old age of 108.

In 1877, another notable eighteen-year-old man traveled from New York to Fort Conrad in the Montana Territory. His name was James Willard Shultz. With the right amount of adventurous spirit, courage, and curiosity, this young man became an avid explorer, fur trader, historian, the first professional guide-outfitter in the park region, and author of many articles and books about life in northwestern Montana. Shultz remained at Fort Conrad until 1885 and during this time established multiple trading posts to trade with the Pikuni, Blood, and Cree Indians.

He then moved closer to the eastern portion of what is now the park and spent much time in the regions of Two Medicine River and Saint Mary Lake where he served as a professional guide-outfitter into the nearby rugged terrain.

Inspired by an article from Shultz in Forest and Steam, the then editor of that magazine, George Bird Grinnell, travelled to the area and hired Shultz to guide a hunting expedition around Saint Mary Lake. It was on this otherwise unspectacular trip that George Grinnell killed a Bighorn Ram with a single shot by an otherwise unnamed mountain near upper Saint Mary Lake, which prompted Shultz to name it Single Shot Mountain. Incidentally, Shultz is also credited with the name Going to the Sun Mountain and many other features of what is now Glacier National Park.

Schultz lived much of his life with the Blackfoot who gave him the name Apikuni, which means "Spotted Robe". He authored many articles and later at age 48, began authoring books. His first book, a memoir entitled "My Life as an Indian", chronicled his first year living with the Pikuni tribe of Blackfoot Indians east of what is now park. Another of his books, "Rising Wolf-The White Blackfoot, Hugh Monroe's Story of His First Year on the Plains", documented the early experience of Hugh Monroe in the area.

Suffering from various injuries and from the rigors of years of guiding in the rugged terrain, his health declined in the last 30 years of his life. Shultz died in 1947 at the age of 88 and is buried in the Blackfeet Reservation east of Glacier National Park.

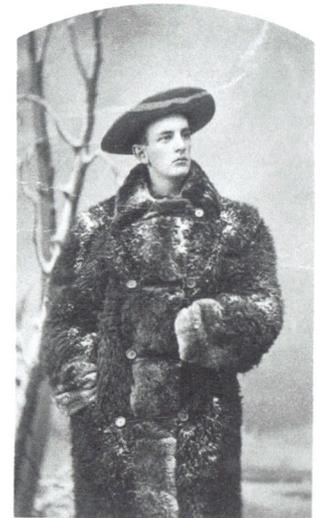

James Shultz, 1889

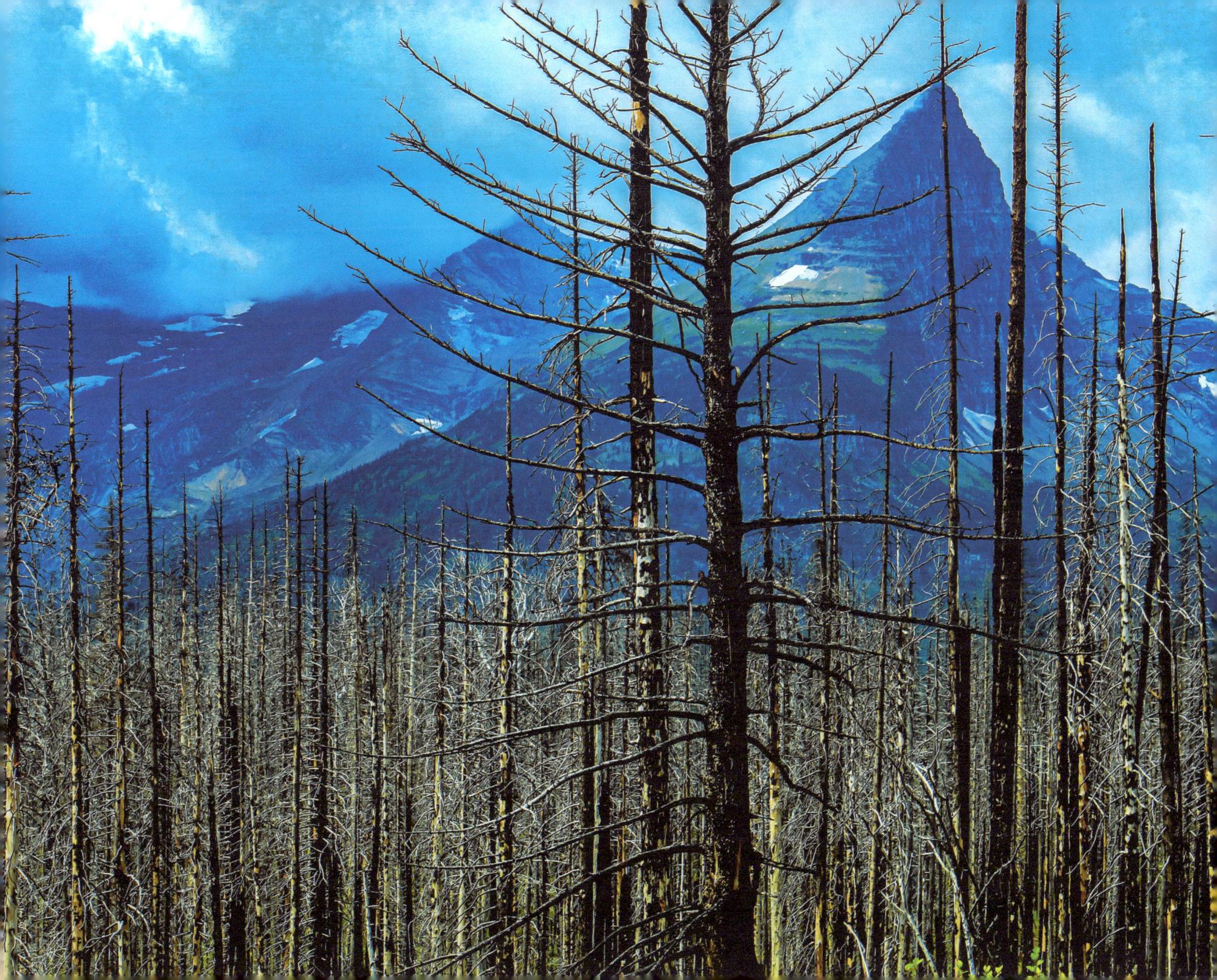

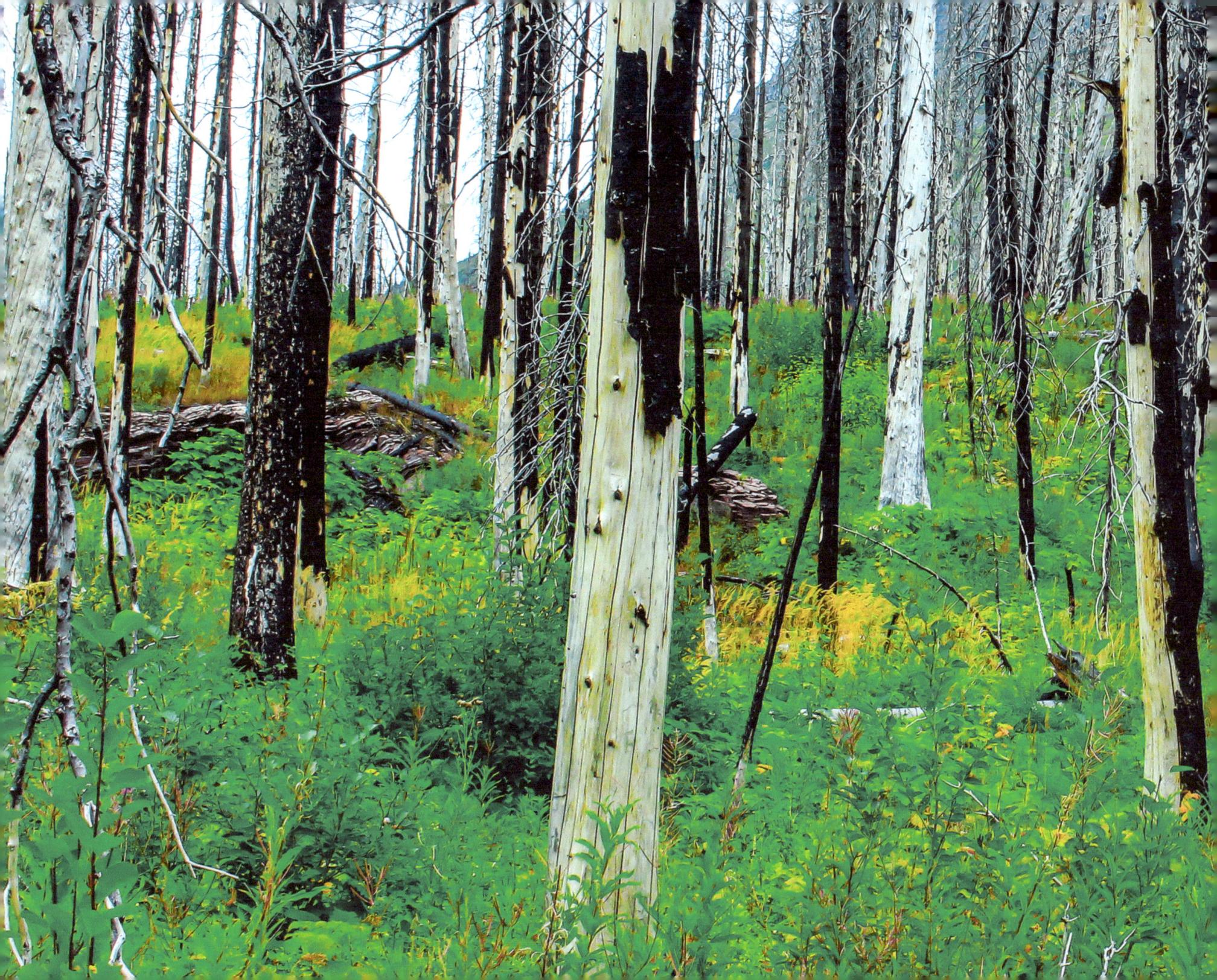

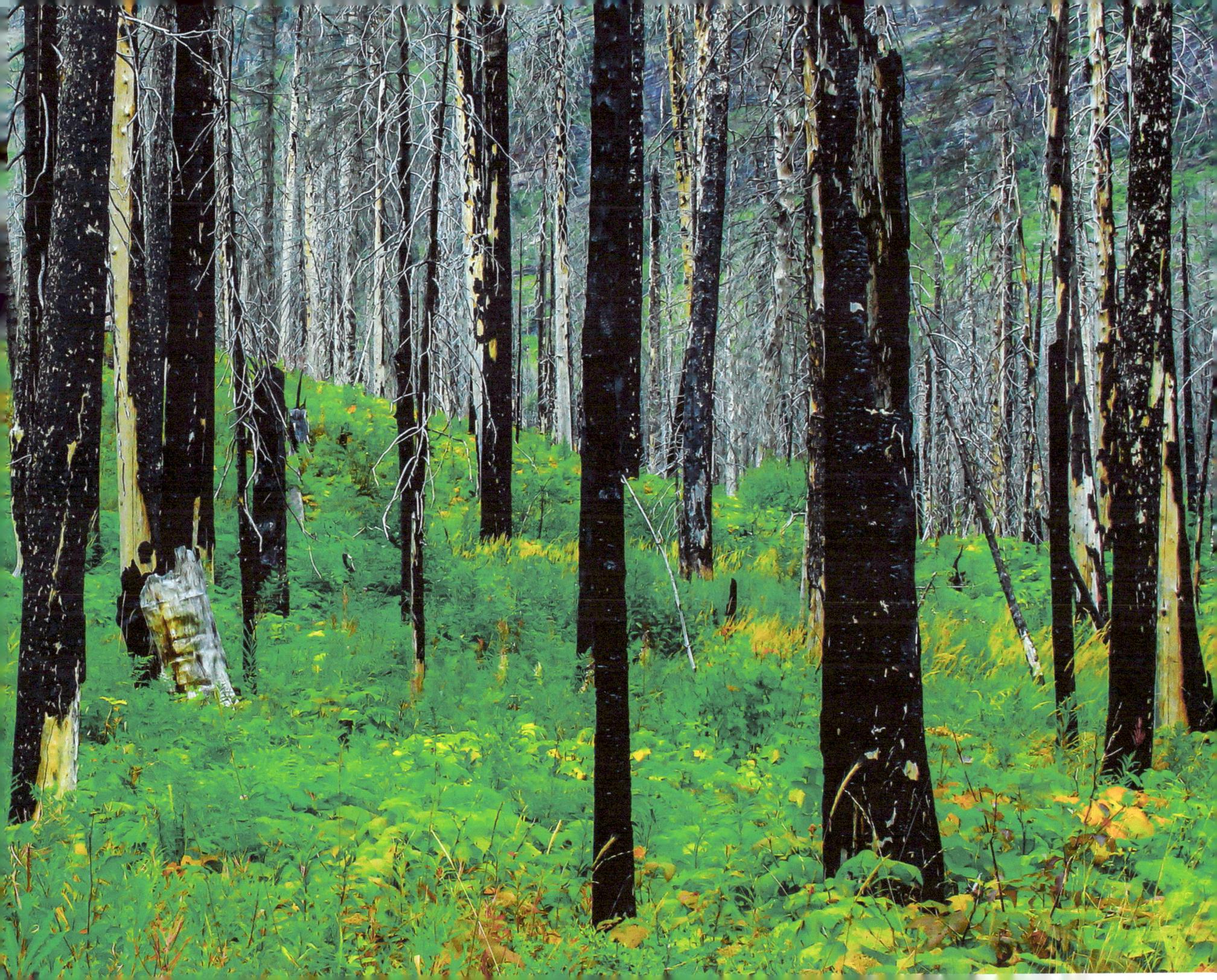

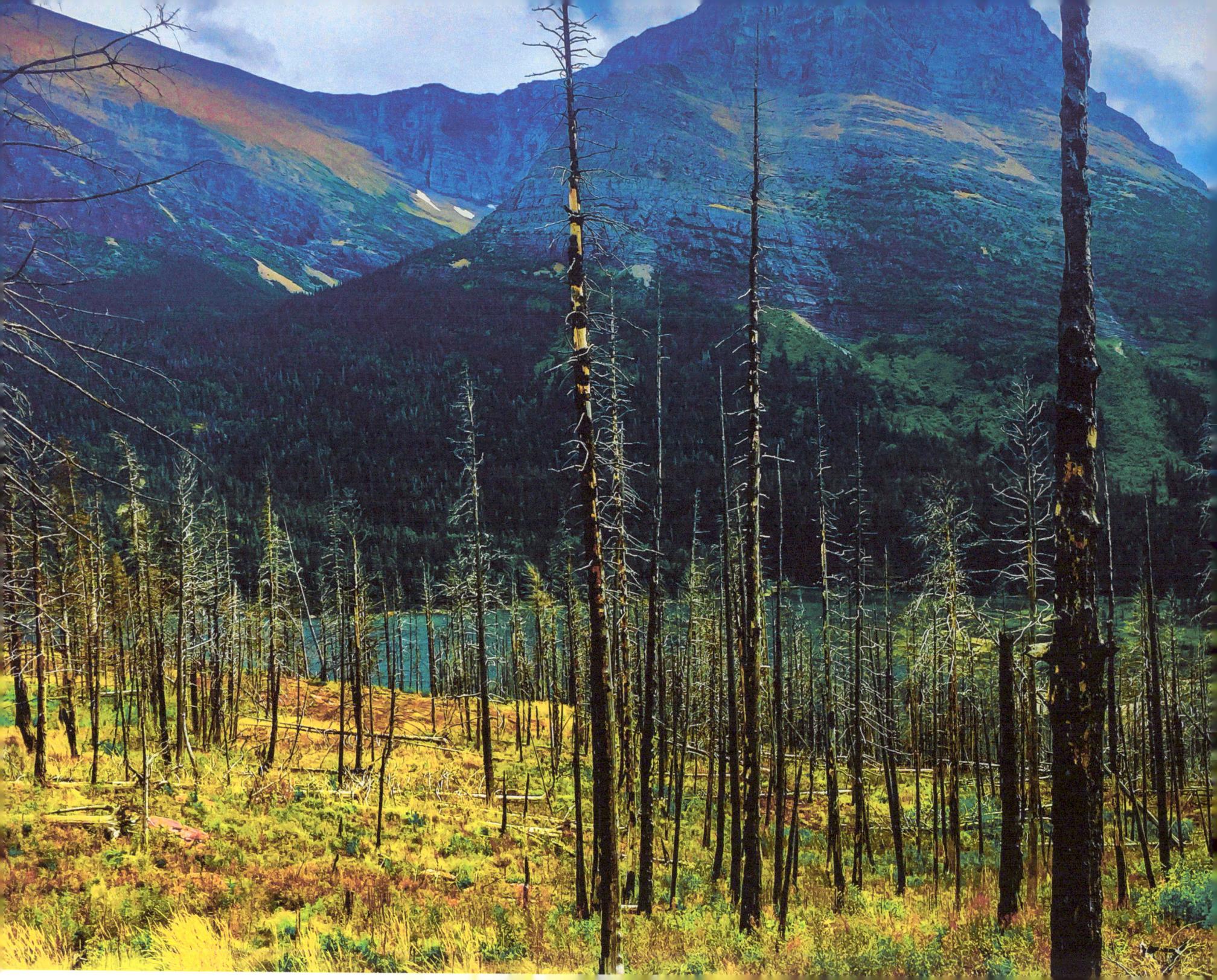

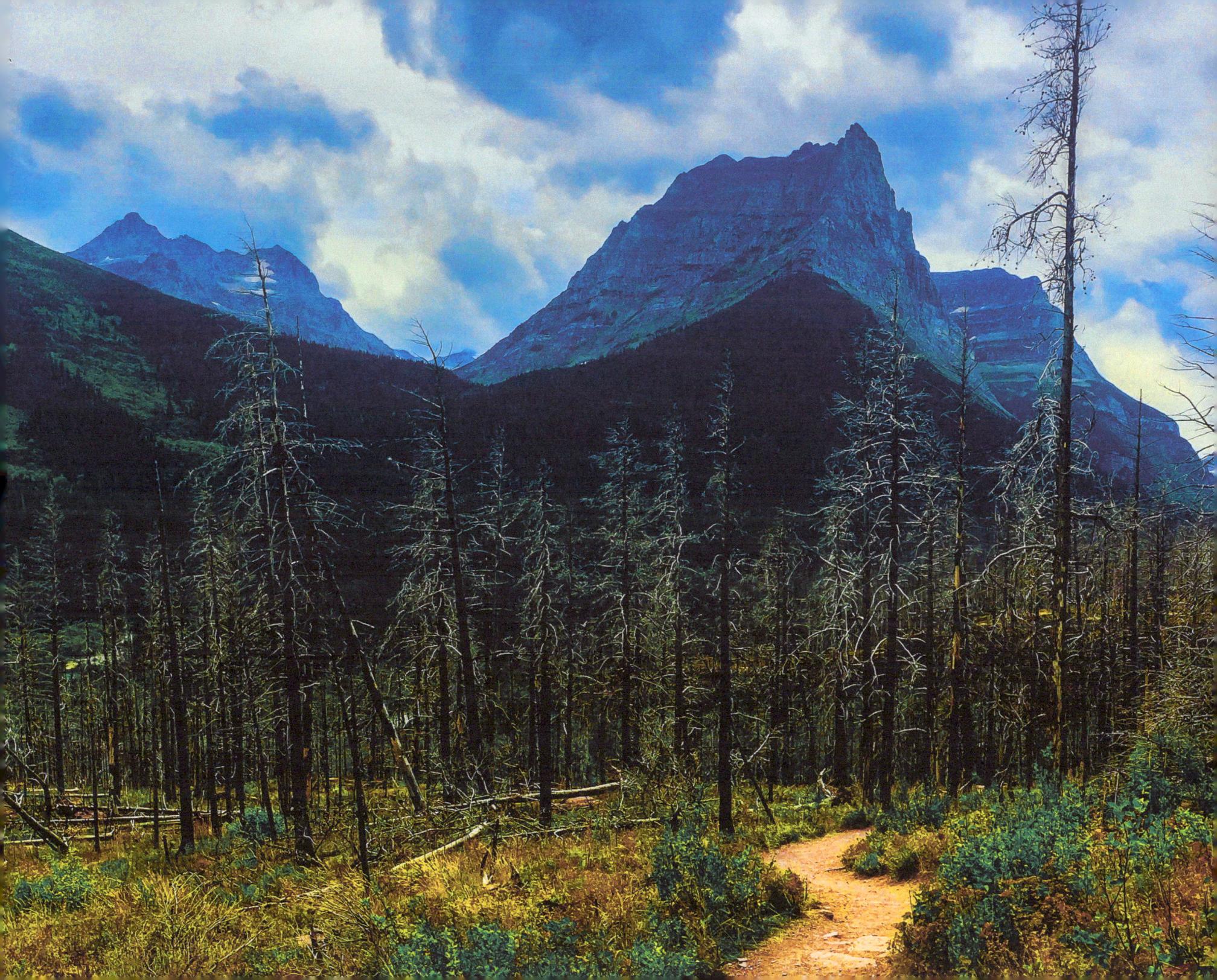

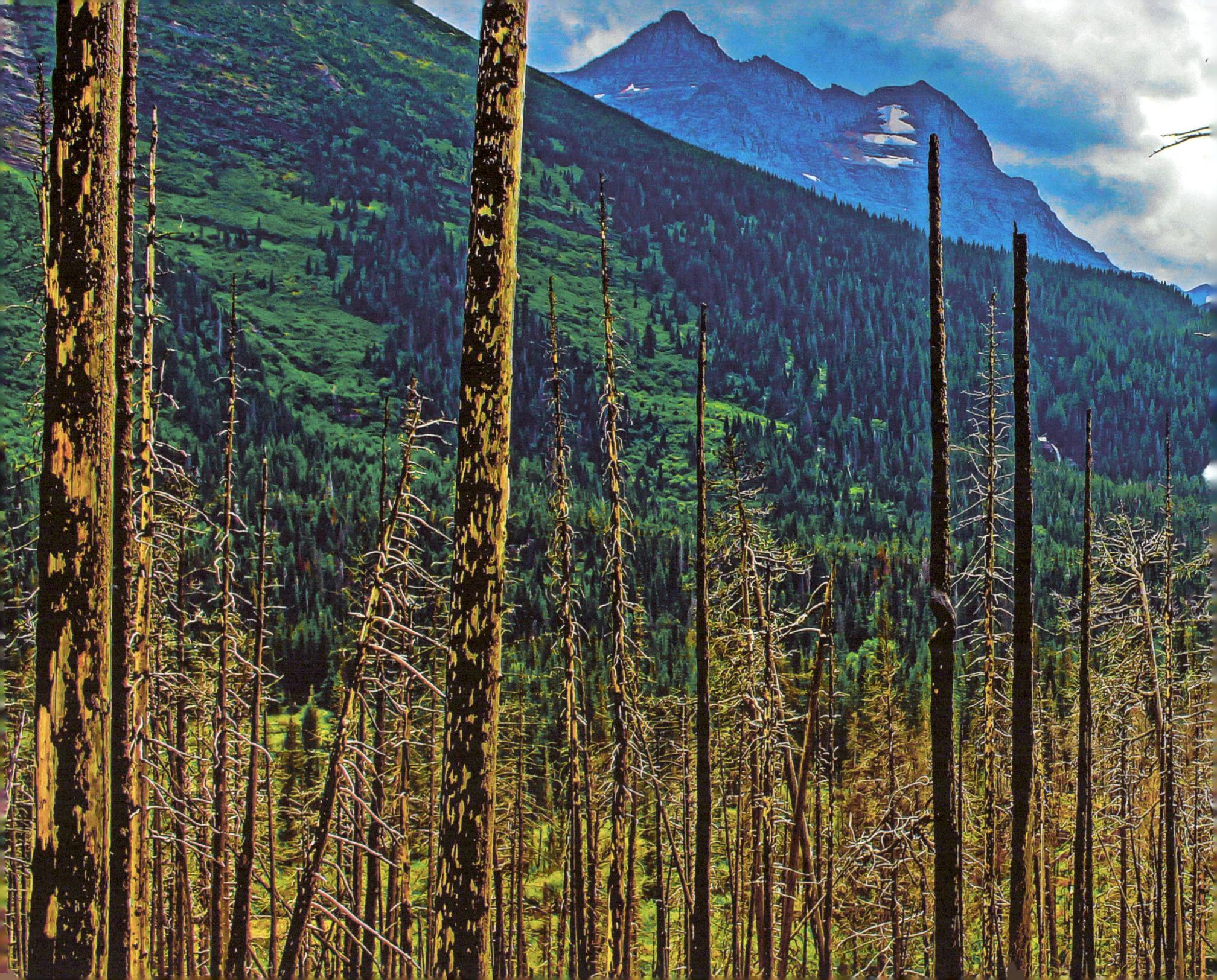

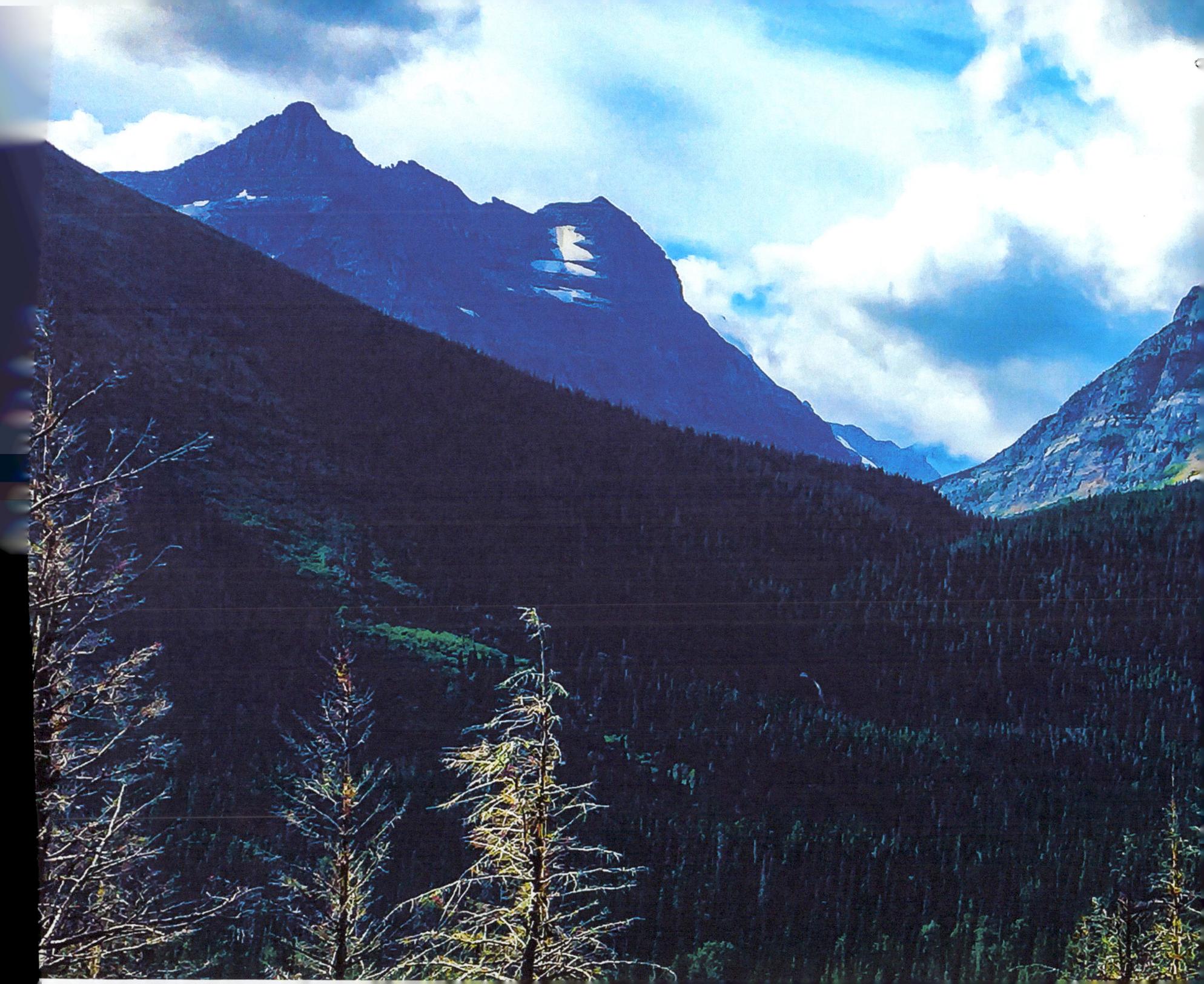

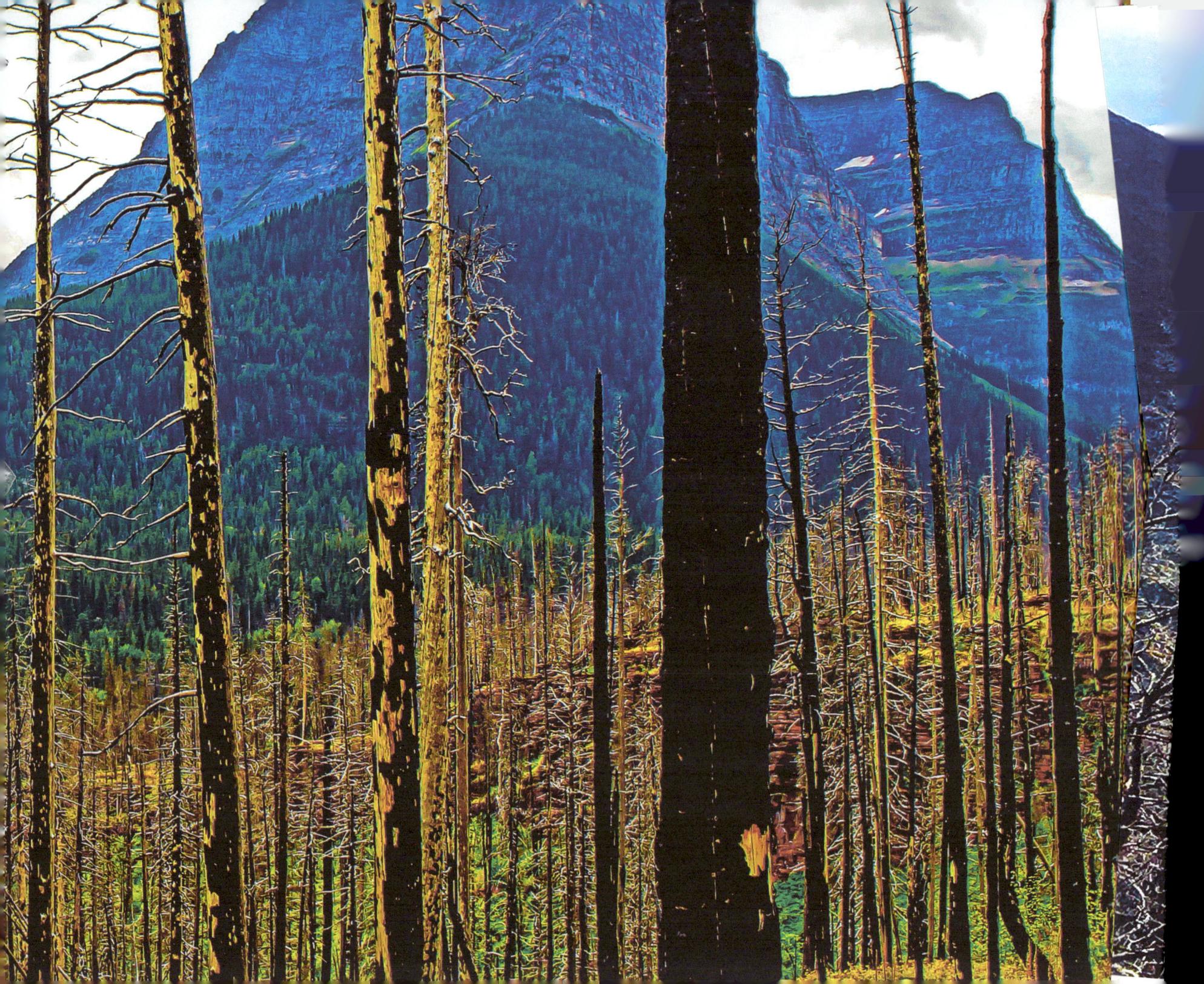

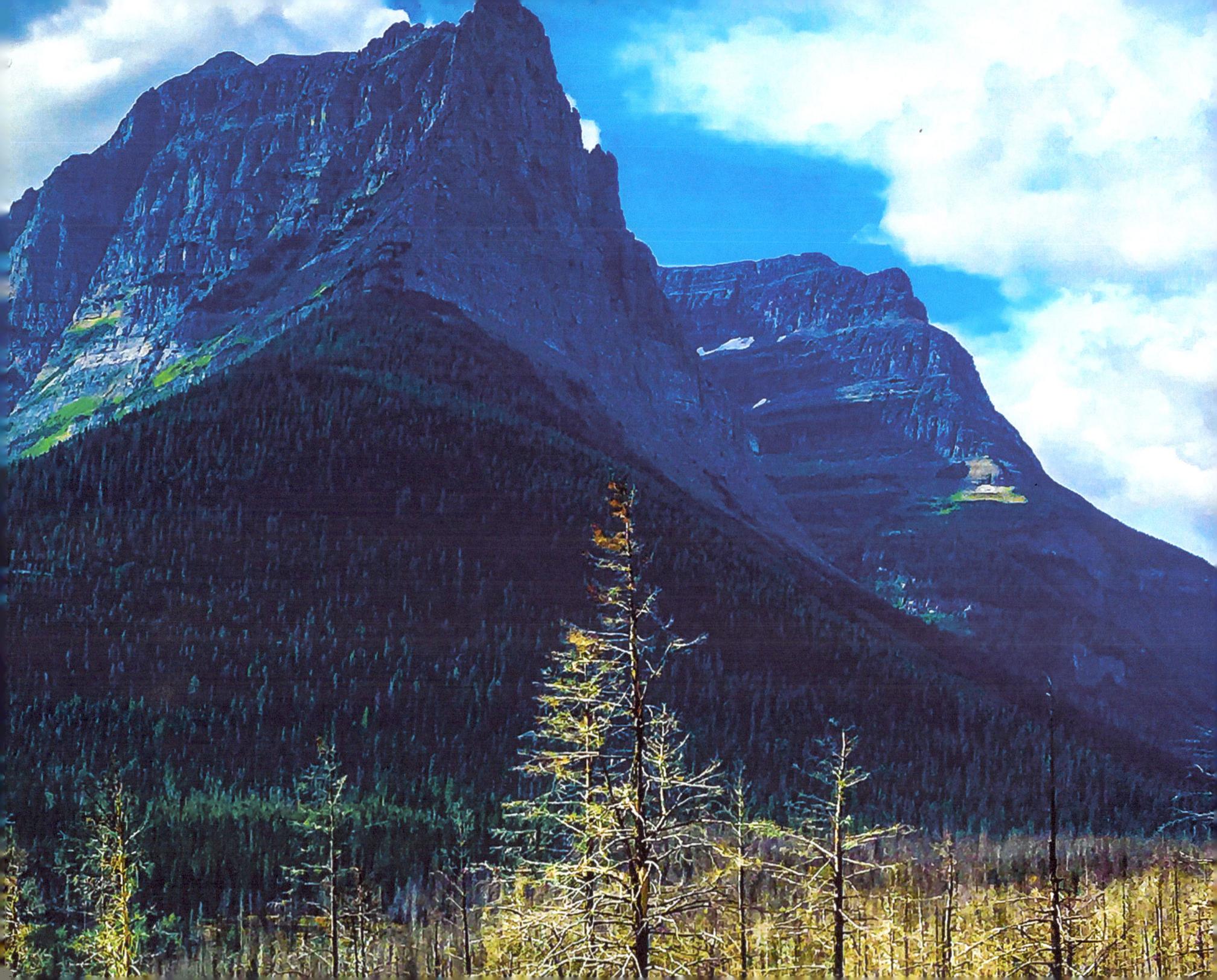

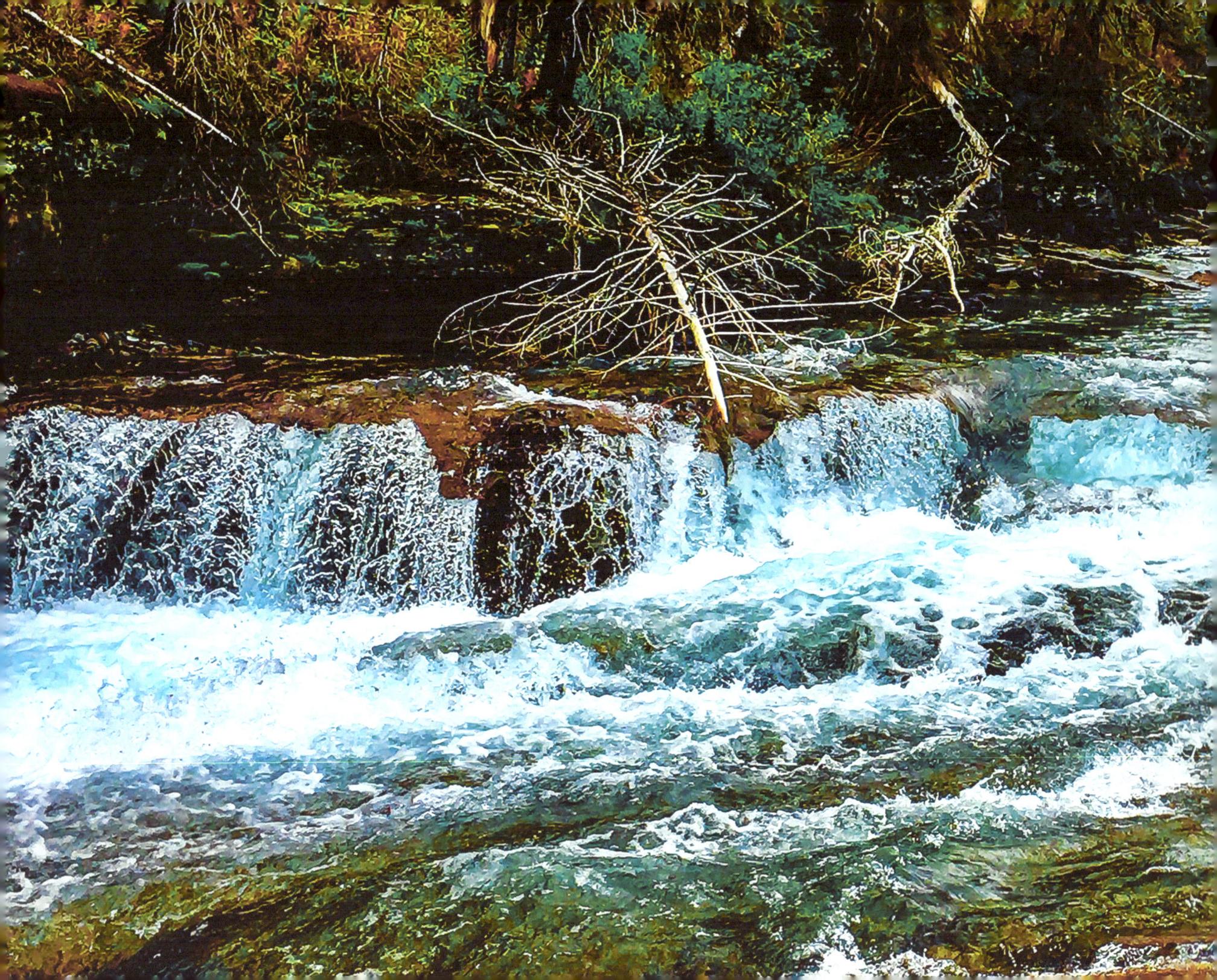

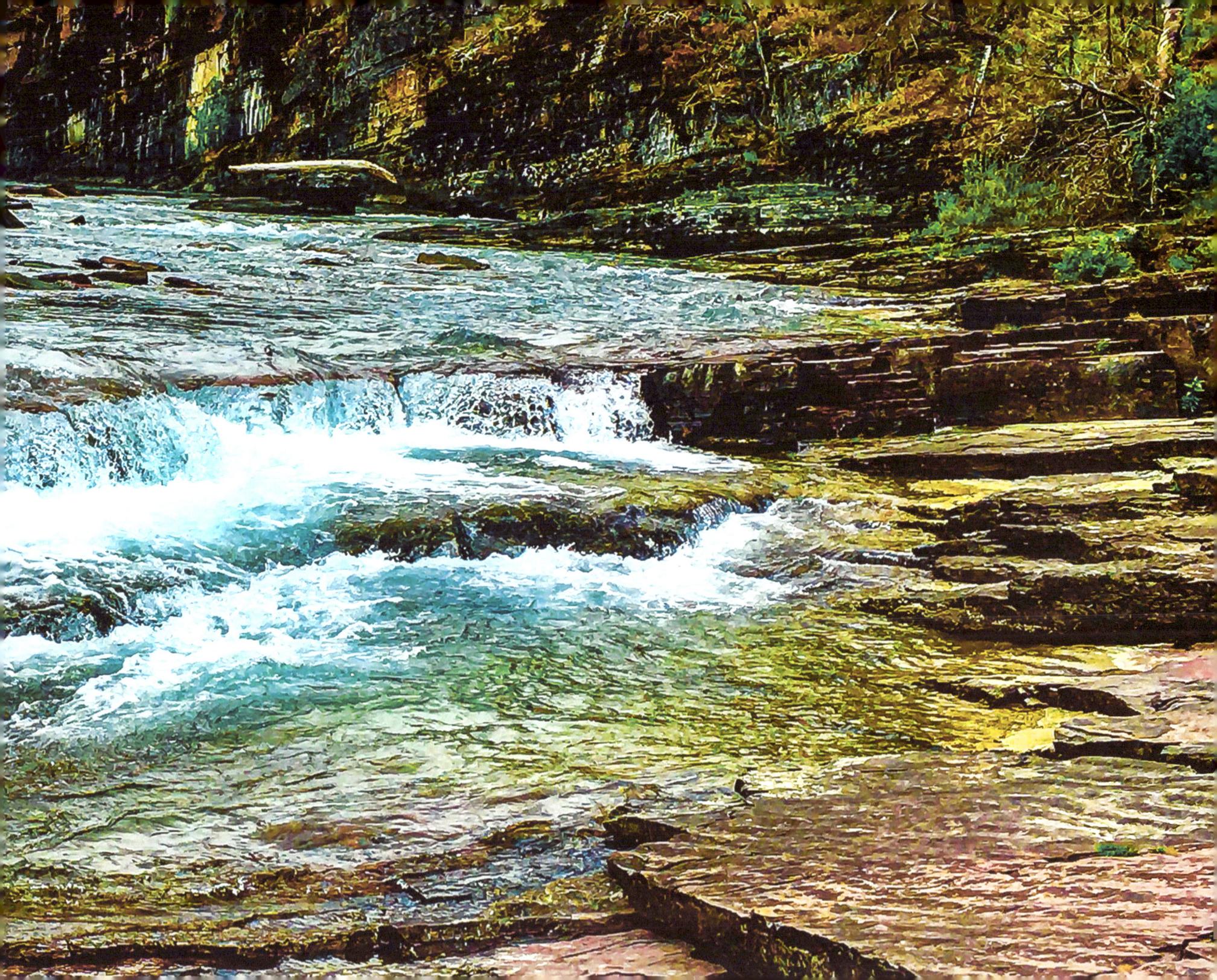

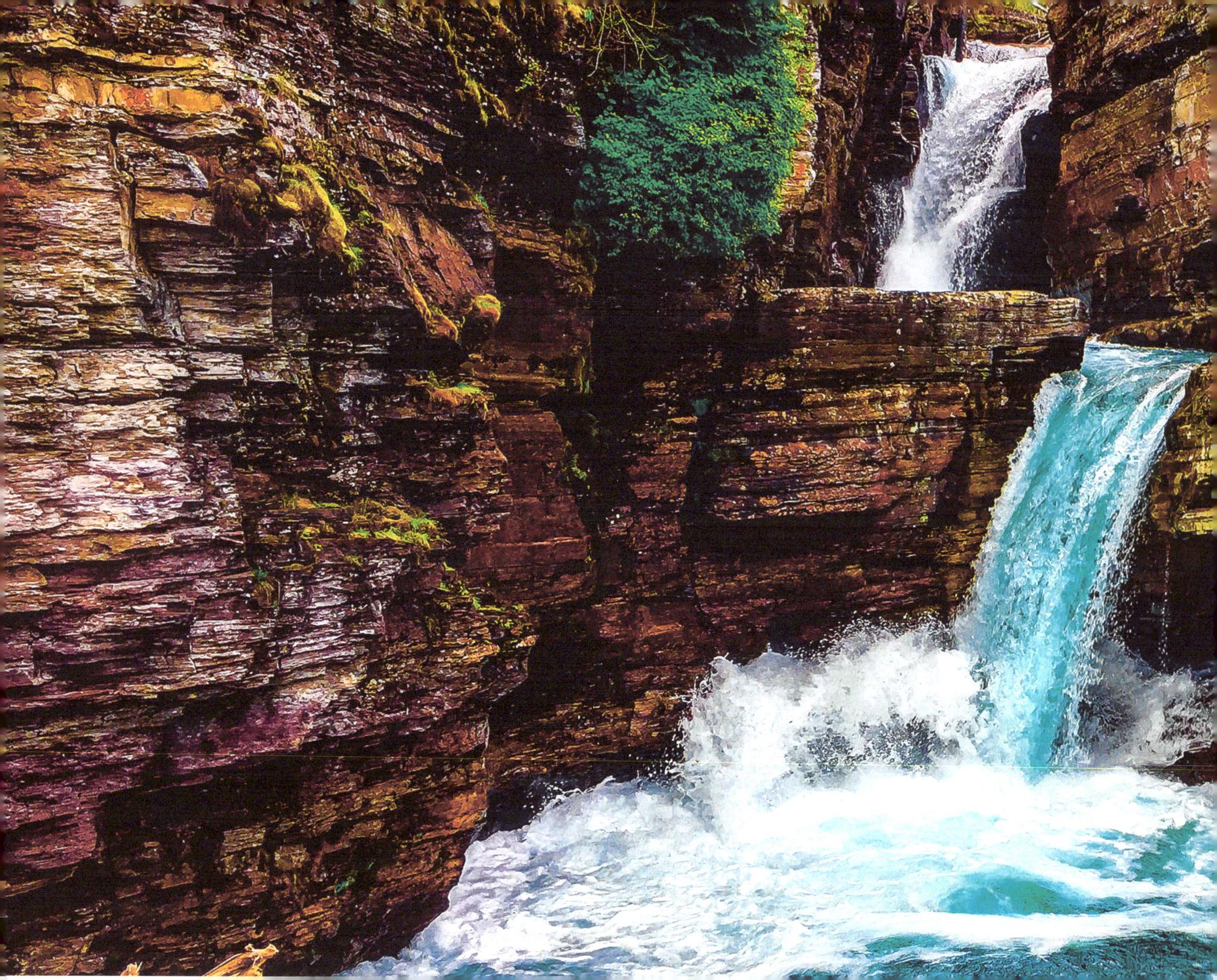

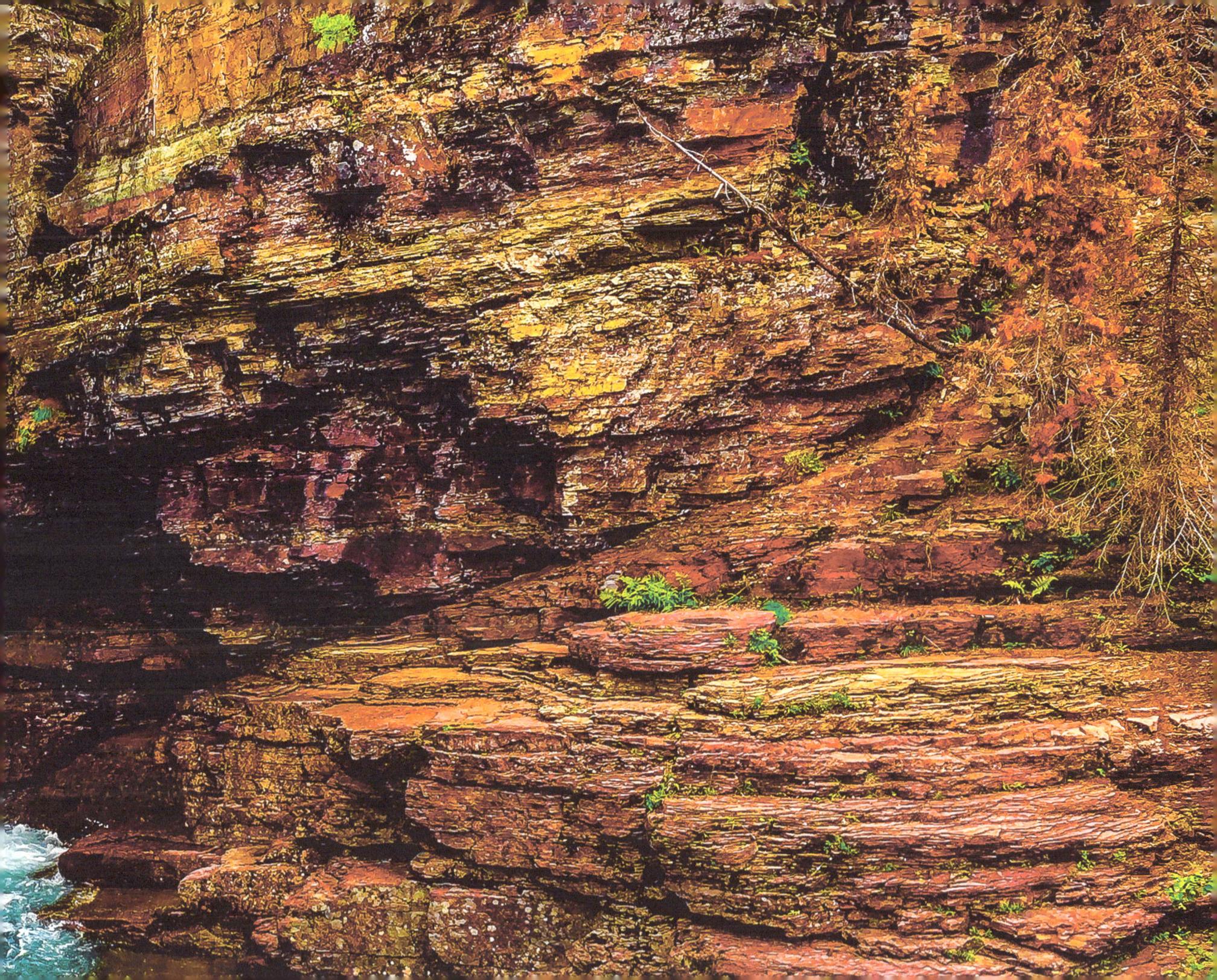

THE
FRUIT
OF
PERSISTENCE
IS
WONDER

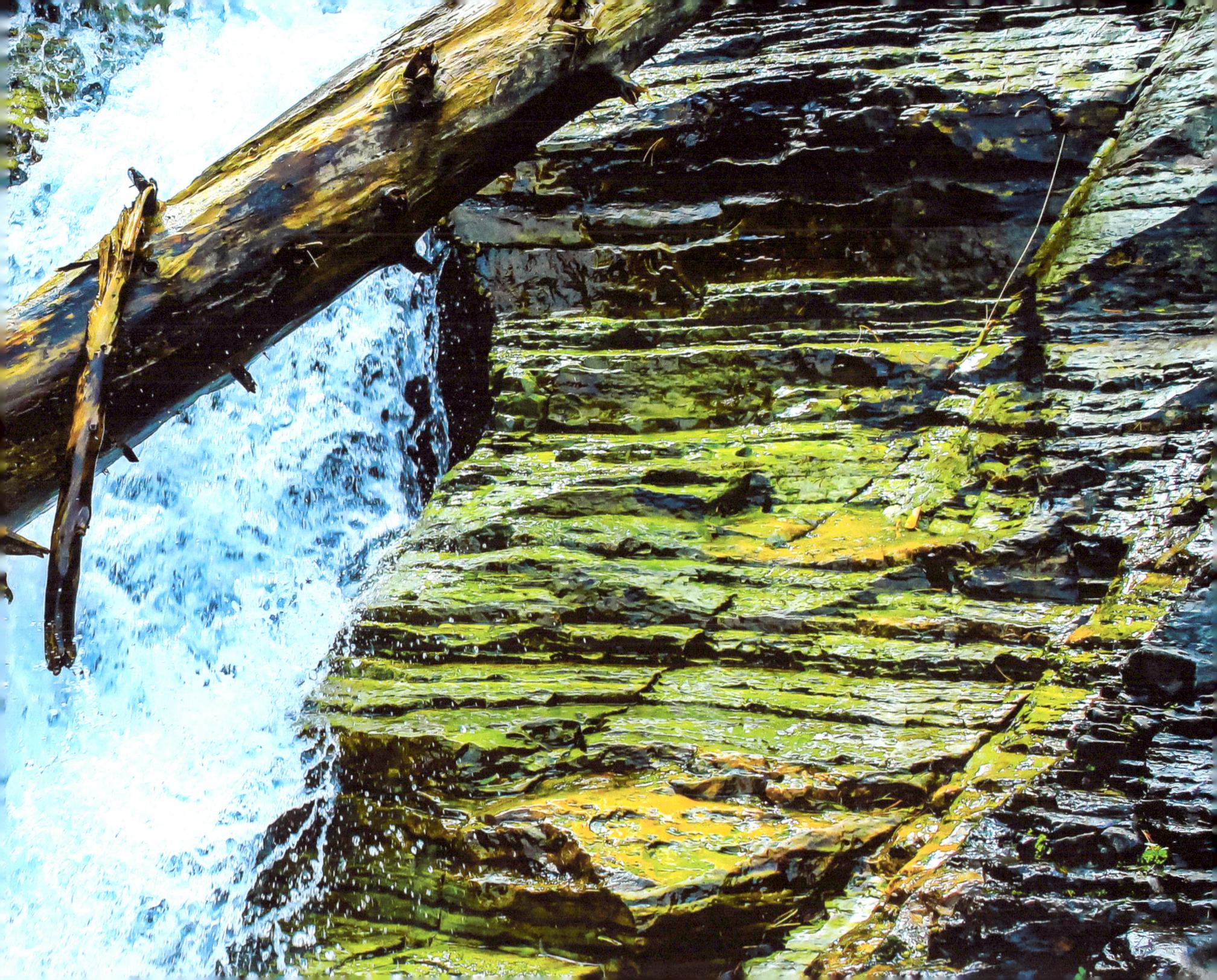

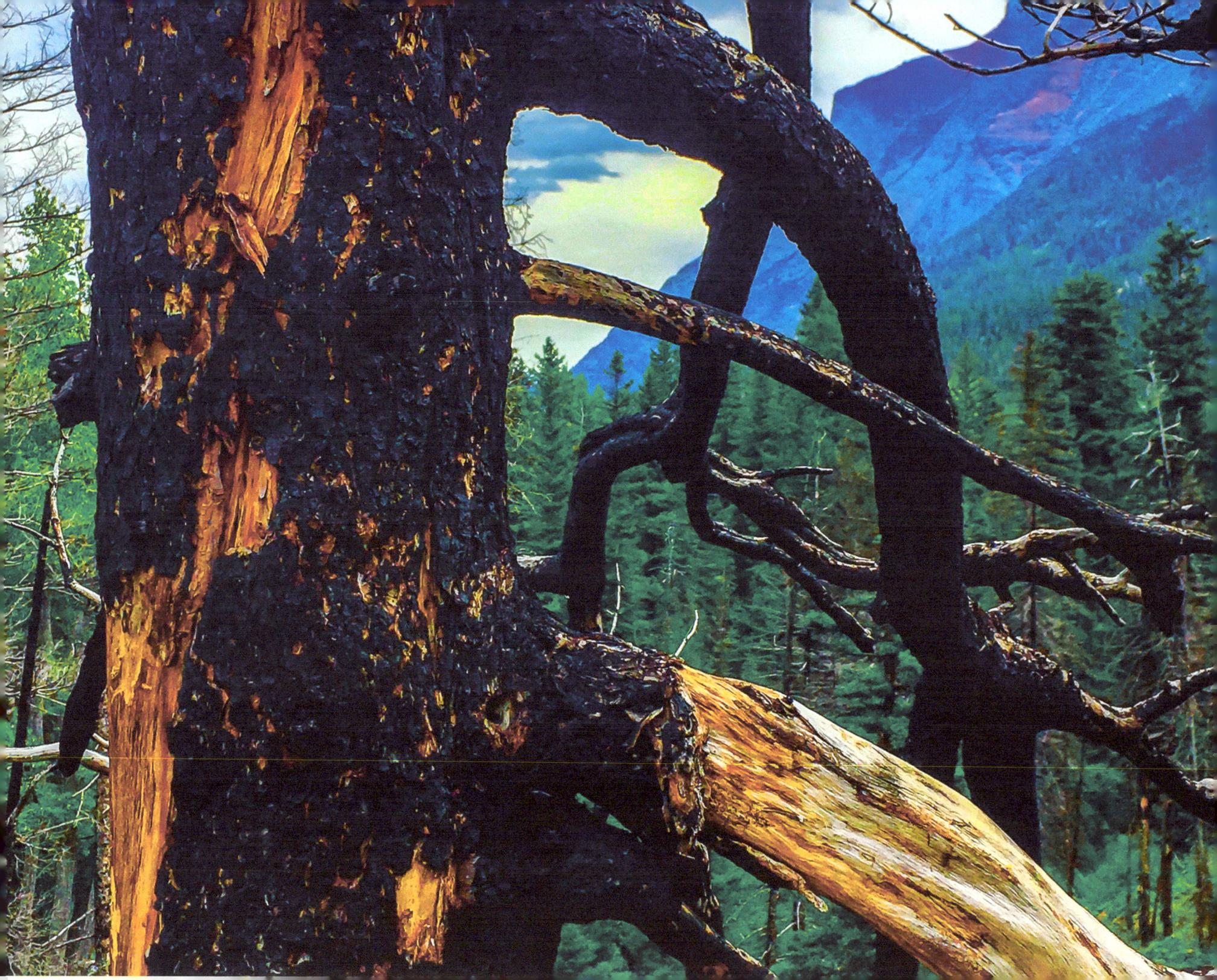

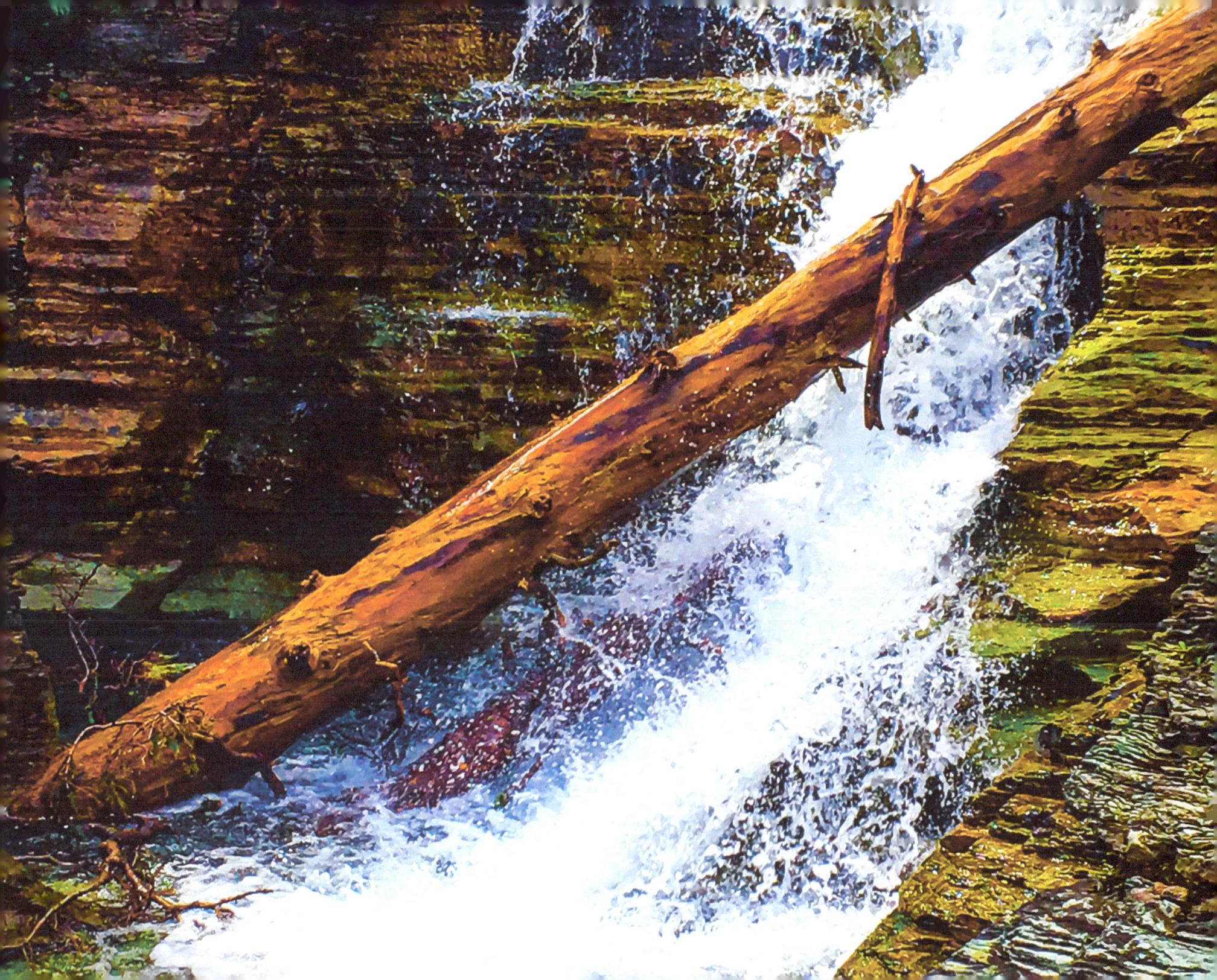

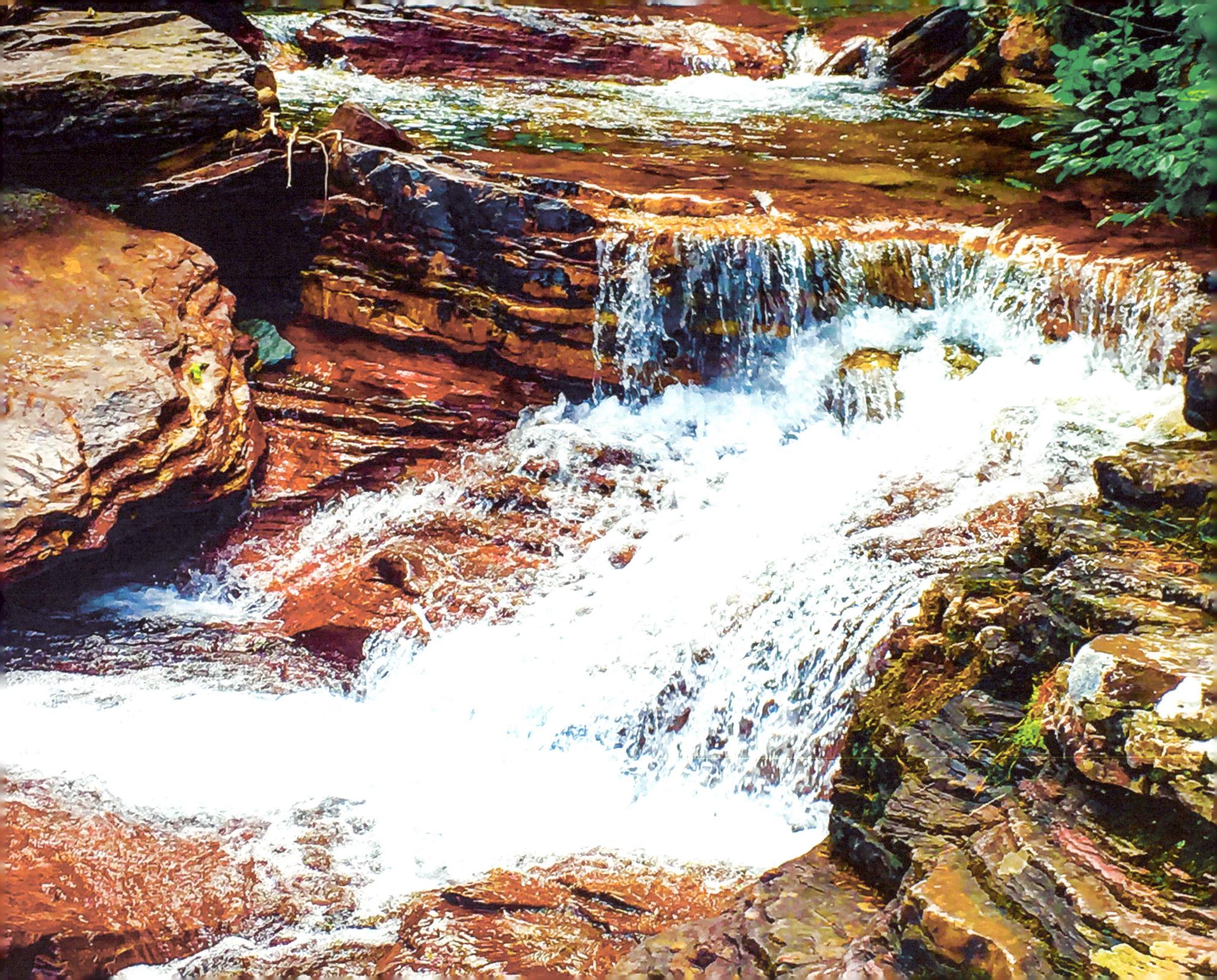

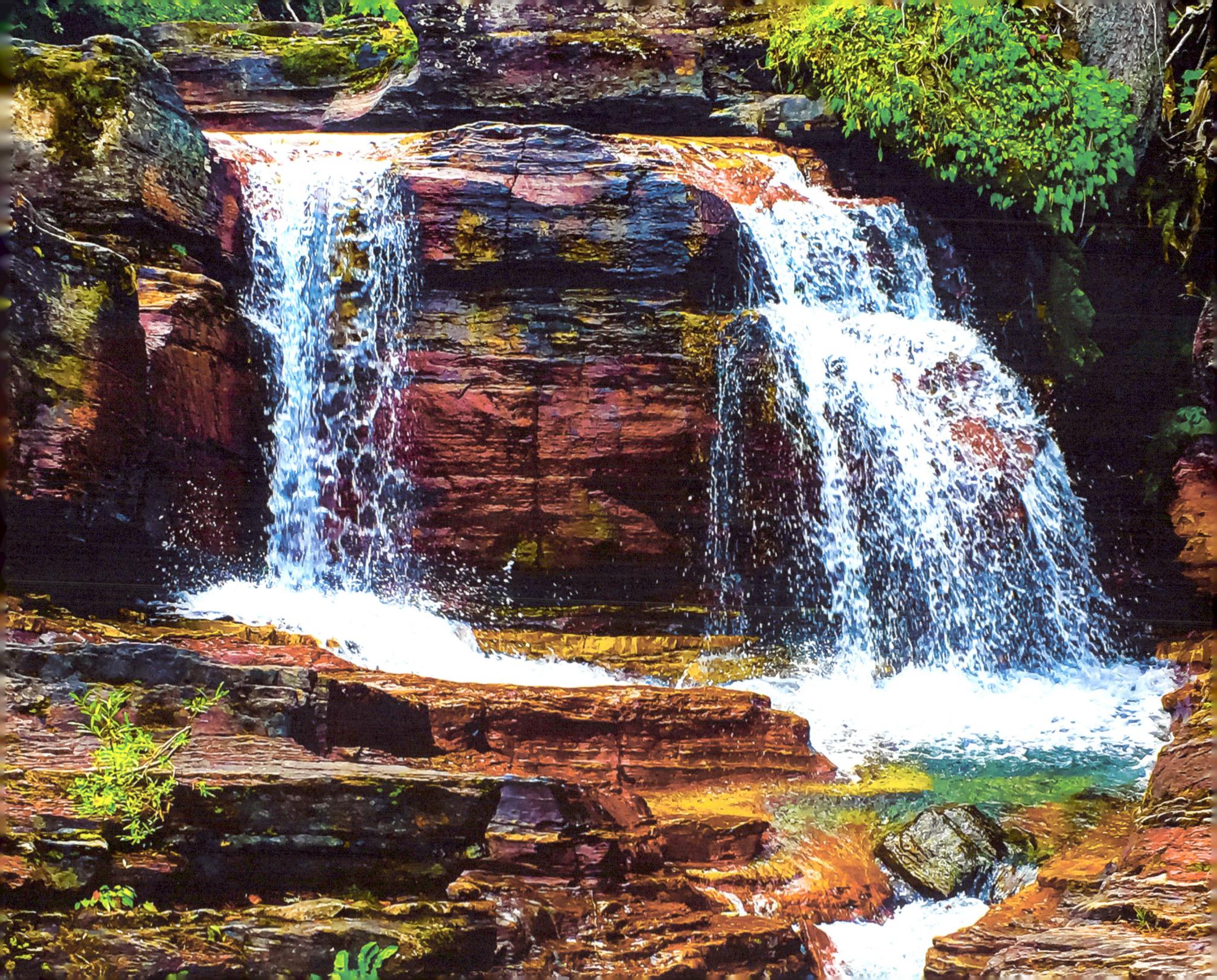

GRINNELL LAKE

"I'd rather be in the mountains thinking about God than in church thinking about the mountains"
— John Muir

With the area having been "discovered" by the mid-1800s, the hold over the area by the Blackfoot slowly declined, and the influence of settlers from the east increased, driven by the exploitation of the area's natural resources.

In 1891, railroad tracks were completed over Marias Pass which opened the door for much greater numbers of people to migrate to the area for mining, logging, oil, and later tourism. President Grover Cleveland appointed George Grinnell to work out a fair price with the Blackfoot, which resulted in the sale of what is now the eastern portion of Glacial National Park to the United States government. Gold prospecting resulted in the establishment of Saint Mary's Village in the eastern portion of this area. However, the rugged terrain and the minimal discoveries of precious minerals led to the decline and end of mining within a decade. Several mining shafts are still evident in various locations within the park. Attempts to drill for oil began in 1901 at Kintla Lake to the north, but within five years this too was abandoned.

The first homesteads were built in the area of Lake McDonald. With the land being impracticable to farm, early settlers relied upon hunting and trapping. However, they soon realized the potential for tourism, and by 1892, in the newly established village of Apgar on the west end of Lake McDonald, Milo Apgar and Charlie Howe began catering to tourists with rental cabins and guided horseback or boat tours.

If there was one person who was most influential in the history of Glacier National Park, it would unequivocally be George Grinnell, the same man who had hunted with James Shultz and who brokered the sale of what is now the east side of the park. George grew up on the shore of Manhattan Island. Always an explorer at heart, he was born at a time when most lands had already been explored and few secrets remained. However, later as editor of Forest and Stream magazine, he would read the article by James Shultz that changed the course of his life and ultimately led to the preservation of wilderness for all. His introduction to the area began as several hunting trips between 1885 and 1891 to the Saint Mary Lake area, guided by Shultz. It was during these trips he and Shultz named such features as Grinnell Glacier, Grinnell Mountain, and Grinnell Lake. It was these early trips that were the seeds of his desire to preserve wildlife and to conserve the wilderness against exploitation. He spent years promoting his dream to preserve this area that he called the "Crown of the Continent". As early as 1885, increased tourism led Congress to introduce a bill to establish a forest reserve in this area, and by 1891 Congress had authorized the establishment of forest reserves. However, it wasn't until 1910 Grinnell's dream became a reality when President Taft signed the bill to set aside one million acres of land as Glacier National Park.

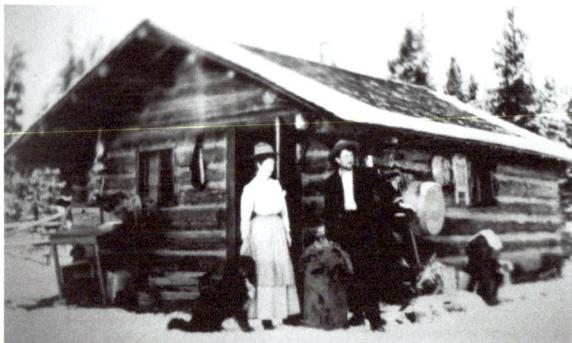

Jonnie Walsh homested at North Fork, 1909 (NPS)

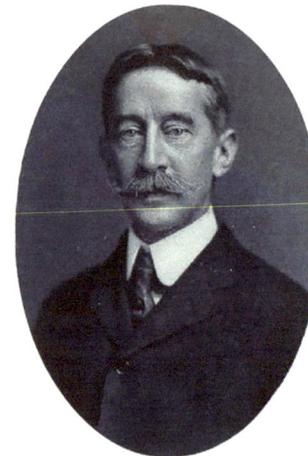

George Bird Grinnell

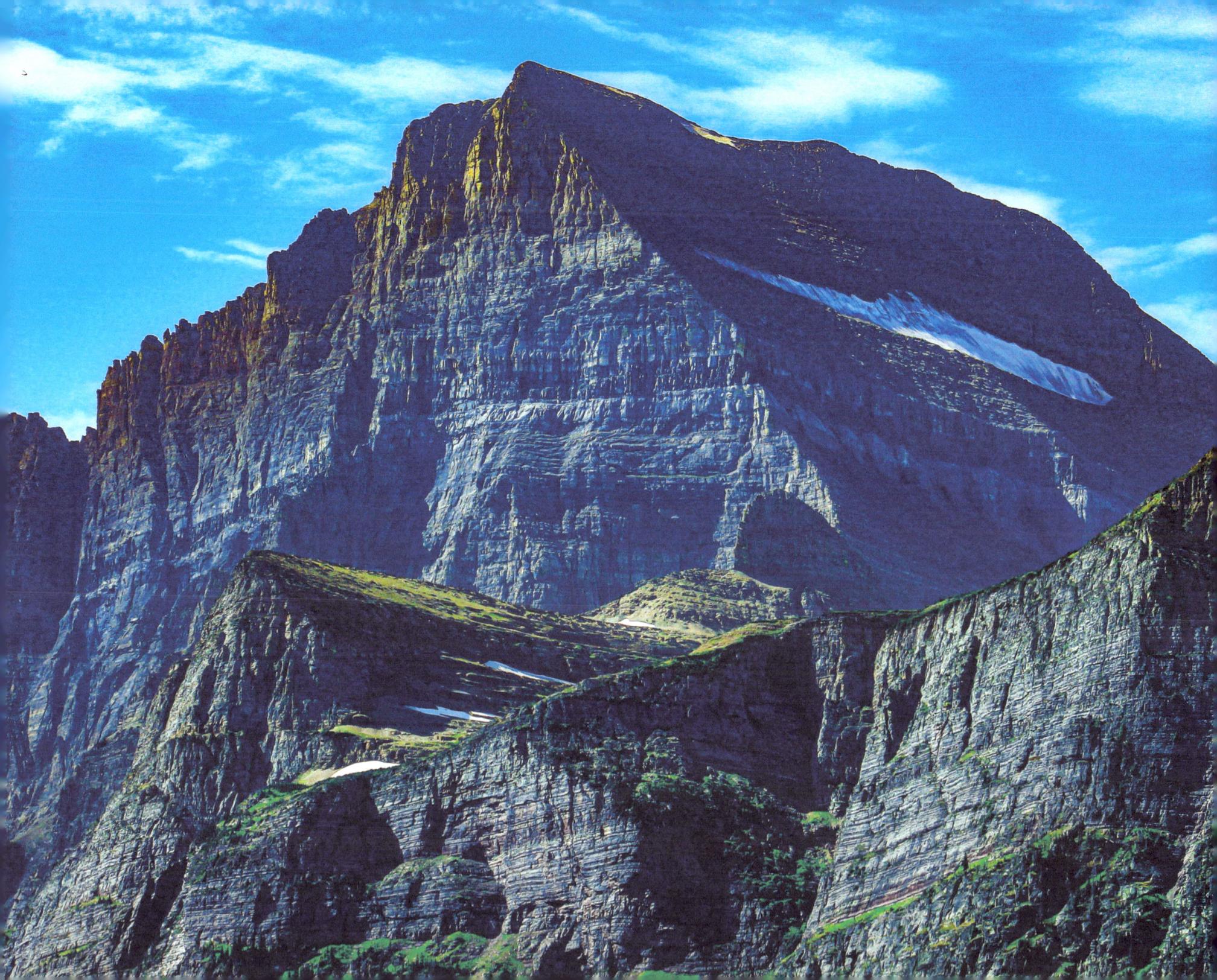

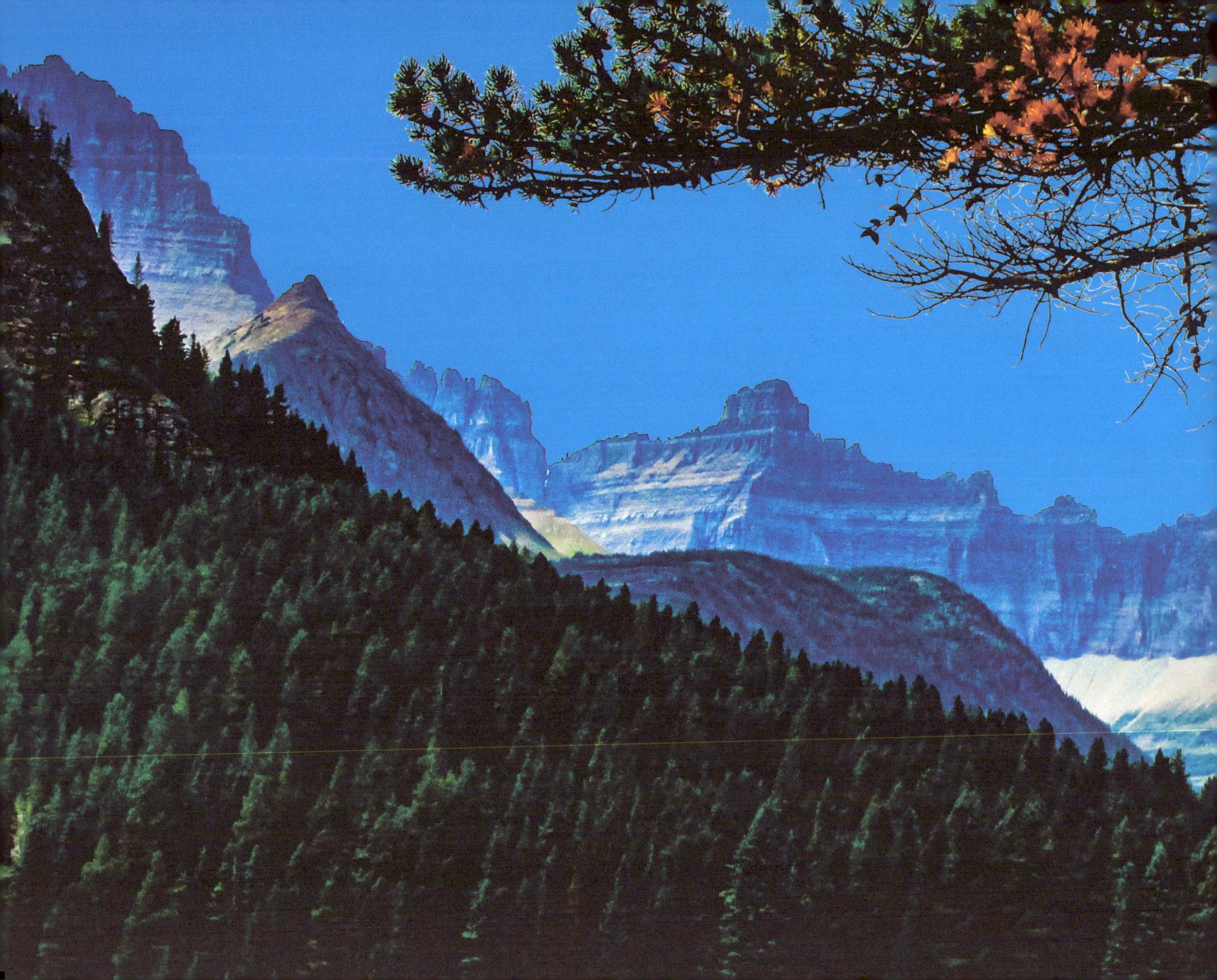

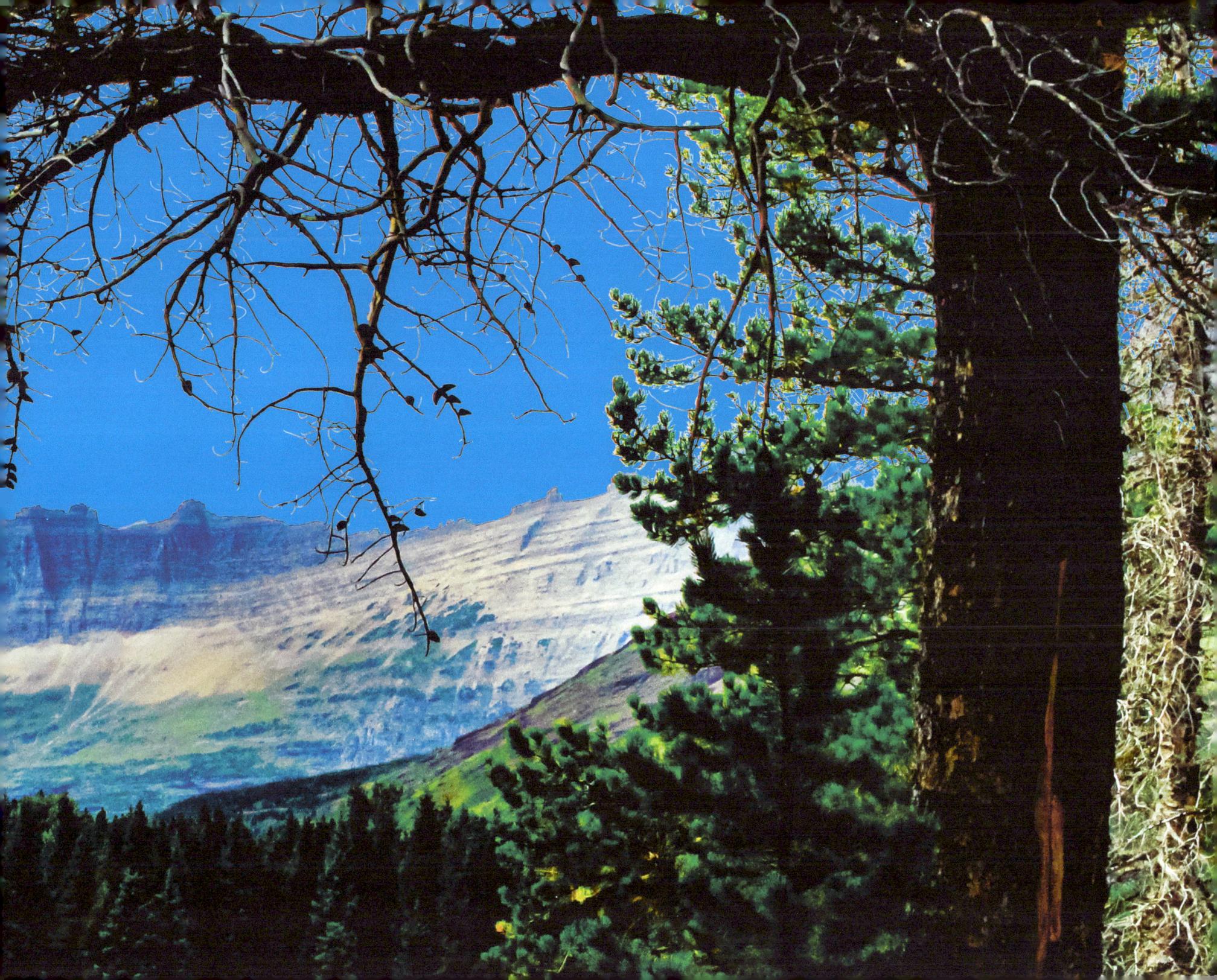

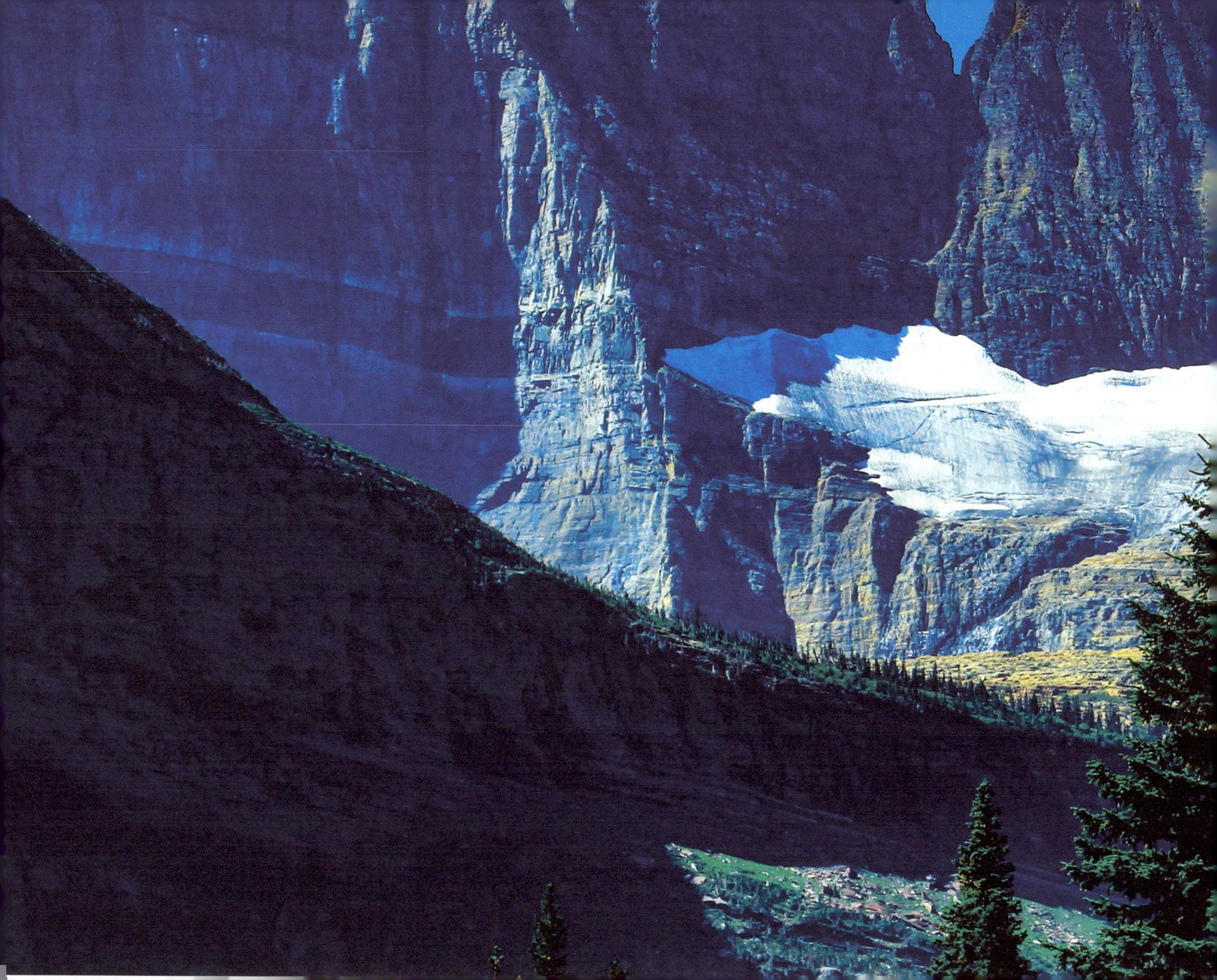

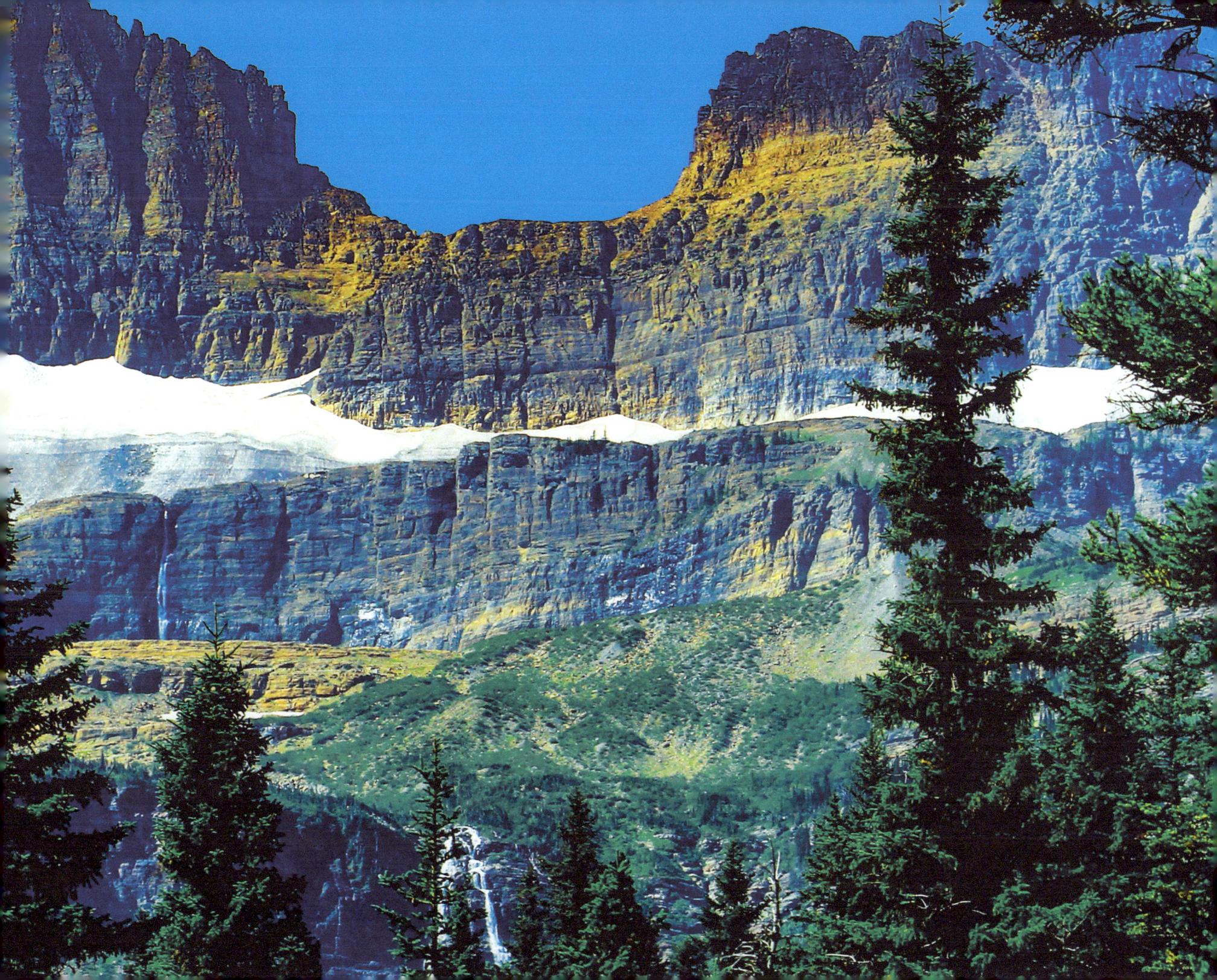

EACH STEP OF A
JOURNEY
TAKES US CLOSER TO
THAT WHICH WE
SEEK

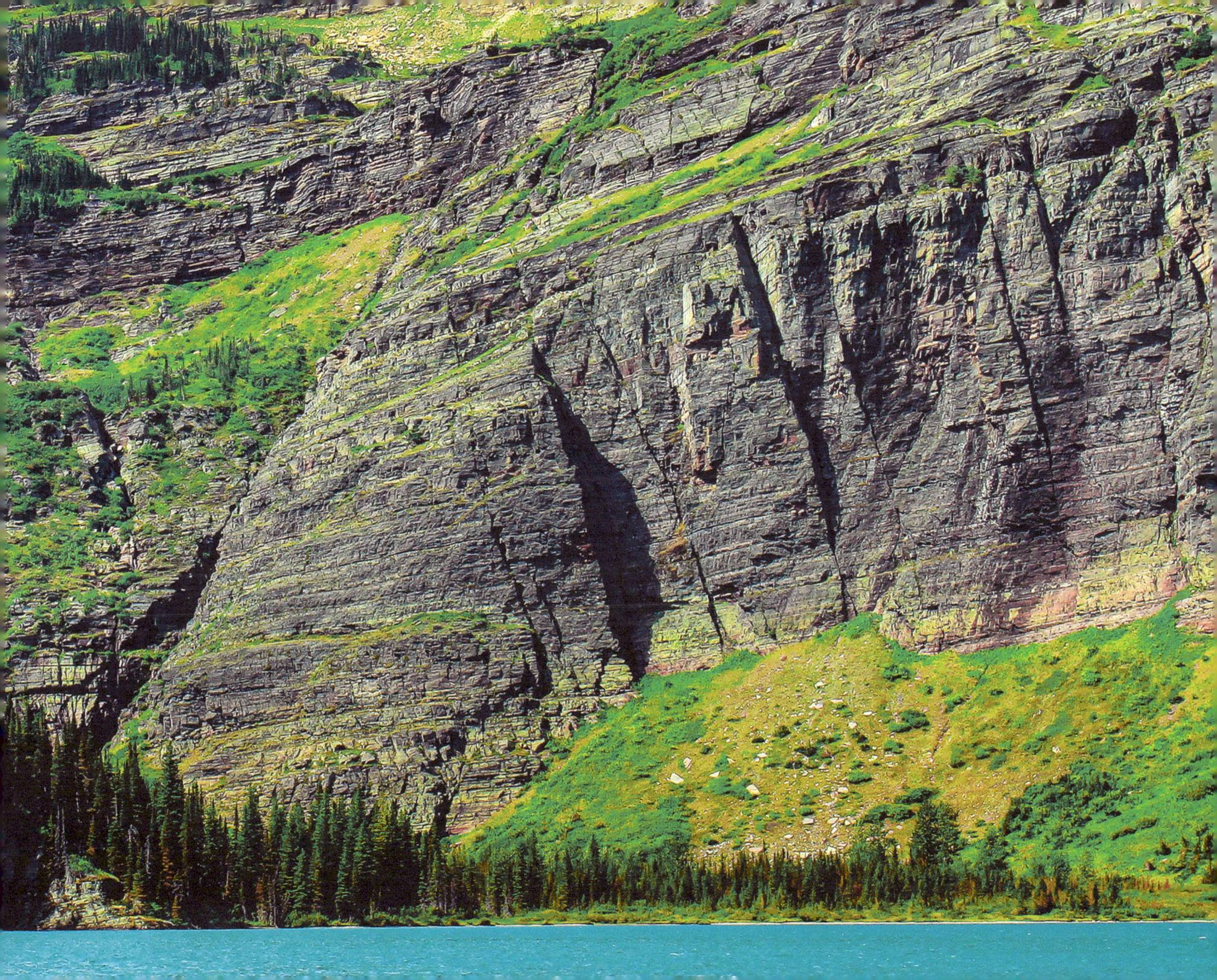

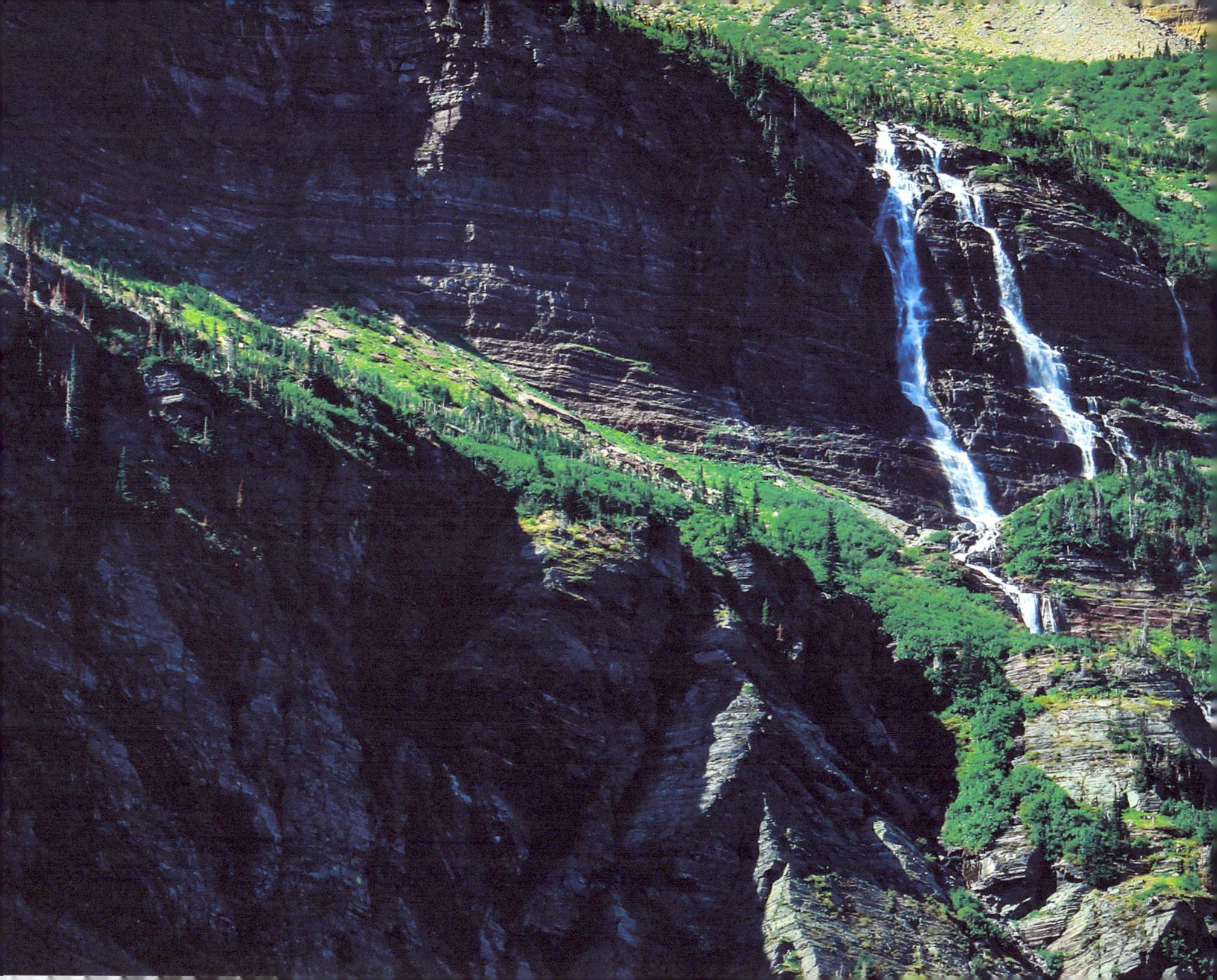

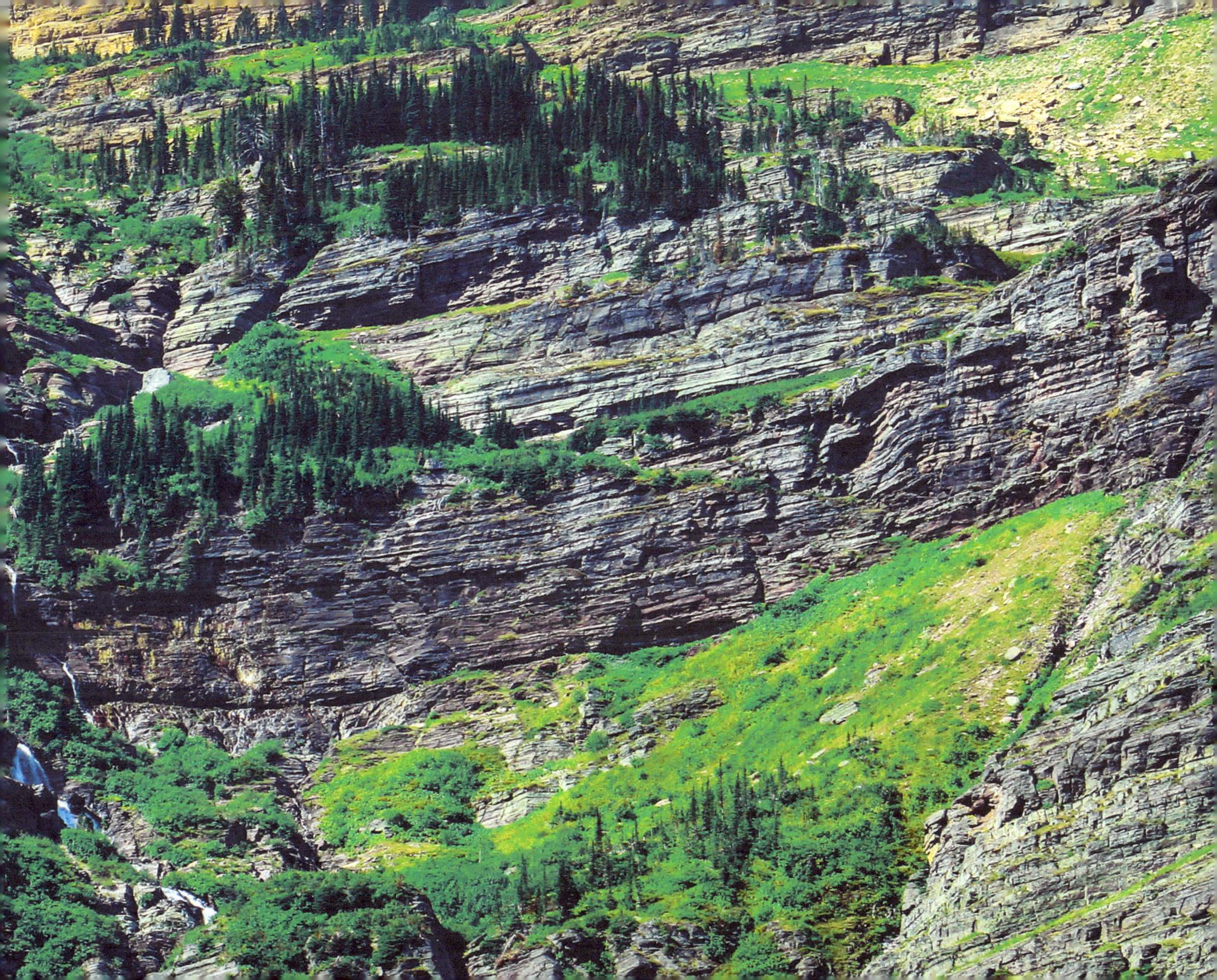